Sony SLT-A77

Carol F. Roullard has been an avid photographer since her high school years, where she first experimented with black-and-white artistic composition. Since then, she has continued photographing, mainly nature and architecture. Carol has used a variety of cameras covering a wide range of makes and models, from simple point-and-shoot cameras to complex professional-level cameras. Carol produces fine art photography and is utilizing her previous art business experience for her new online gallery.

As a former Project Management Quality and Compliance Engineer, Carol spent a number of years developing procedural and quality control methodology for IT projects. In addition, she has developed and conducted training sessions covering best practices for procedural and quality control, breaking down complex subjects into easy-to-use approaches to learning.

Dr. Brian Matsumoto is a retired research scientist who has worked for 30 years recording experiments with a wide range of film and digital cameras. He now spends his time photographing with a variety of cameras and lenses. He enjoys exploring how a camera's potential can be expanded by pairing it with specialized optics such as microscopes and telescopes. He carries a camera on all his hikes and enjoys photographing nature. In addition to the four books he has written for Rocky Nook, Dr. Matsumoto has published several articles and has had his photographs published in a number of periodicals. He is experienced in the technical aspects of photography and has taught courses on recording scientific experiments with digital cameras.

The Sony SLT-A77

The Unofficial Quintessential Guide

Carol F. Roullard
Brian Matsumoto

rockynook

Carol F. Roullard
Brian Matsumoto

Publisher: Gerhard Rossbach
Editor: Joan Dixon
Copyeditor: Cynthia Anderson
Layout and Type: Jan Marti, Command Z
Cover Design: Helmut Kraus, www.exclam.de
Printer: Sheridan Books, Inc.
Printed in USA

ISBN 978-1-937538-01-9

1st Edition 2012
© 2012 by Carol F. Roullard, Brian Matsumoto

Rocky Nook, Inc.
802 East Cota Street., 3rd Floor
Santa Barbara, CA 93103

www.rockynook.com

Library of Congress Cataloging-in-Publication Data

Roullard, Carol F.
The Sony SLT-a77 : the unofficial quintessential guide / by Carol F. Roullard and Brian Matsu-
moto. -- 1st ed.
 p. cm.
ISBN 978-1-937538-01-9 (softcover : alk. paper)
1. Sony digital cameras--Handbooks, manuals, etc. 2. Photography--Digital techniques--Hand-
books, manuals, etc. 3. Single-lens reflex cameras--Handbooks, manuals, etc. I. Matsumoto,
Brian. II. Title.
TR263.S66R68 2012
771.3--dc23
 2012010926

Distributed by O'Reilly Media
1005 Gravenstein Highway North
Sebastopol, CA 95472

To Sarah and Elizabeth, with much love.

Acknowledgements

Writing a book becomes a labor of love. It takes months of research, testing, discussion, writing, and rewriting. Nothing in this book was written without being tested, many times more than once. Several friends and business associates helped us by supplying additional accessories. We would like to extend special thanks to Farah Payan of Darkroom Print/Woodland Hills Camera and Stuart Warter for lending us equipment to expand our testing of the Sony A77. In addition, Matt Parnell of Sony Electronics, Inc. and Scott Dordick of Acratech, Inc. were very gracious in supplying product photos. Last, but not least, special thanks go to Andy Crisp, video production teacher, for sharing his expertise, and to Jim Solliday, President of the Microscopical Society of Southern California, for his evaluation of digital SLRs in microscope applications.

One of the benefits of producing this book was working with our publisher. We appreciate the Rocky Nook team not only for their help but also for their kindness and professionalism in support of our goal.

We have worked with Rocky Nook, Inc. on four books. As with the previous three books, their team has been invaluable in helping us complete this book. We have appreciated input and support from Gerhard Rossbach (Publisher, CEO), Joan Dixon (Managing Editor), and Matthias Rossmanith (Project Manager). A special thanks goes to Cynthia Anderson (Copyeditor) and Jan Marti (Layout). Everyone has been wonderful at fielding our questions and working diligently toward completing the project.

In addition, a special thanks to our families and friends for maintaining patience and understanding when our time with them was limited and our conversations were often single-minded about the Sony A77.

Carol Roullard
Brian Matsumoto

www.VistaFocus.net

Preface

With all nonfiction books, there is a point in time when the writing ends and the manuscript must be submitted to the publisher. For us, that time occurred when the Sony A77 firmware was on version 1.05. But life and camera development go on. There will be future updates to the Sony A77 firmware that will not be represented in this book. So as not to leave you behind, we will keep up with small to medium firmware changes through addendums posted on the publisher's website. In the event Sony releases a major firmware change, we will determine the feasibility of an addendum or other method at that time.

As you use the Sony A77, you will develop uniquely personal methods of using the camera. We have included many of our own experiences and recommendations throughout the book. They work for us, but depending on the type of shots you want to take and your own personal needs, you may develop some variations. Hopefully our experiences and recommendations will save you time and angst as you learn this complex camera.

The Sony A77 is truly a remarkable and complicated camera. It does so much and does it well. At first glance, all the buttons, dials, and menus can be intimidating. Many of the menu commands and functions are dependent on one another. Many of the buttons and dials have dual purposes. But, as you use the camera and become more familiar with it, you will pare down what you use and how you use it. Your use of the functions will take on a rhythm and will become something you know by heart—and you will consistently obtain high quality still pictures and videos. We encourage you to experiment with the creative aspects of this camera, such as the many creative style and picture effect options.

While writing this book, we continued to be thrilled with the camera's capabilities, sharpness, and ease of operation. This camera has transformed some of our photography practices and enabled us to capture fine art photography through the microscope with minimal effort. We have experimented with all of the shortcuts such as Auto HDR, DRO, and Hand-held Twilight. We are now converts, consistently using these and other simple Sony A77 tools and being satisfied with the results. We are sure you will feel the same way.

Enjoy your Sony A77 camera.

Carol Roullard
Brian Matsumoto

2	**Chapter 1: Getting Started**	28	**Chapter 2: Photography Basics and the A77's External Buttons**
3	Introduction—The Sony SLT-A77: New Features		
6	Using This Book	29	Introduction
8	Setting Up Your New Sony A77	31	File Formats
9	Battery	35	Shutter Button
10	Memory Card	35	Focusing
12	Setting Up the Camera	40	White Balance and the Appearance of Colors
13	Protecting the Lens		
13	Protecting the LCD Screen	40	Drive Mode Button
14	Viewing Menu Commands	42	Recording Movies
18	Error Messages		
19	Important Command Reset Capability		
19	Fn Button		
23	In-Camera Guide Button		
24	Cleaning the Sensor		
25	Setting the Area, Date, and Time		
26	Dual Viewing System		
27	Recommendations		

44 Chapter 3: Managing Your Images

45 Introduction
45 The LCD Screen
46 The Viewfinder
48 Top LCD Display Panel
49 Data Display Formats
52 Preview Images
54 Review Recorded Images
60 Evaluating Exposure with Histograms
62 Protecting Saved Pictures and Movies
62 Deleting Saved Pictures and Movies
63 Working Outside the Camera
68 Recommendations

70 Chapter 4: Automatic Settings

71 Introduction
71 Functions Available for Automatic Modes
82 Mode Dial
84 Auto Mode
84 Auto+ Mode
89 SCN Predefined Scene Modes
91 Recommendations

92 Chapter 5: Customizing the Camera

93 Introduction
93 Assigning Button Functionality
94 Memory Command
97 Utilizing Predefined Color Schemes
104 Customizing Camera Commands
106 Recommendations

108 Chapter 6: Taking Control of the Camera

109 Introduction
109 Exposure Compensation
124 Customizing Automatic Focusing
126 DRO/Auto HDR Function
130 Three Semi-automatic Modes: Shutter-Priority (S), Aperture-Priority (A), and Program (P)
134 Recommendations

136 Chapter 7: Manual Operation of the Camera

137 Introduction

142 Manual Focusing: Overriding Automatic Focusing

144 Fine Adjustment Screen for Color

145 Lens Compensation

146 Fine Tuning Autofocus

150 Recommendations

152 Chapter 8: Additional Features

153 Introduction

153 Panoramic Modes

162 Continuous Advance Priority AE Mode

165 GPS Feature

171 Recommendations

172 **Chapter 9: Using Accessories**

173 Introduction

173 Choosing A Kit Lens

176 Sony A-Mount Lenses

178 Buying New Third-party Lenses

178 Microscopes

181 Cable Release

181 Tripod

184 Telescopes

187 Recommendations

188 **Chapter 10: Flash Photography**

189 Introduction

189 Principles of Electronic Flash

192 Flash Artifact: Red-Eye

193 Flash Function

195 Using Flash in Auto and Auto+ Modes

196 Flash Options in P, A, S, or M Modes

207 Recommendation

208 Chapter 11: Recording Movies

209 Introduction
210 Glossary of Movie Terms
211 Choosing a File Format
213 Movie Quality
217 Additional Movie Controls
217 Framing and Starting the Movie
218 Movie Mode
219 Recommendation

**220 Appendix A—
 Menu Commands**

**246 Appendix B—
 Common Error/Warning
 Messages and Resolutions**

253 Index

Camera Body Reference

(Product photos throughout the book courtesy of Sony)

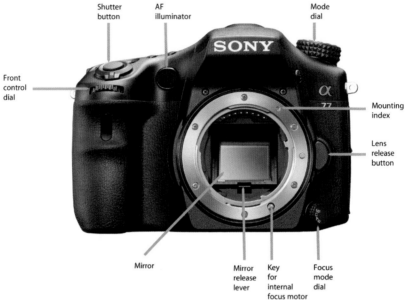

Figure A: Sony SLT-A77 camera front

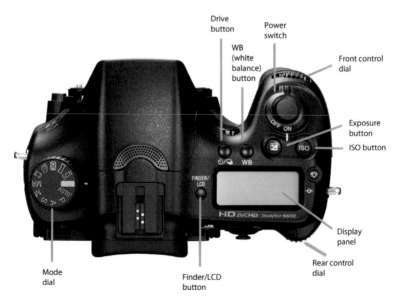

Figure B: Sony SLT-A77 camera top

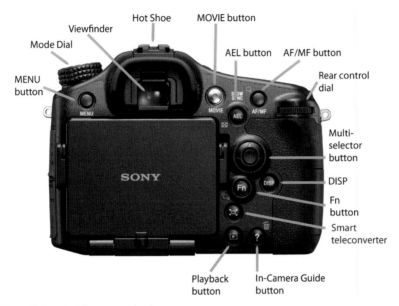

Figure C: Sony SLT-A77 camera back

Chapter 1: Getting Started

Introduction—The Sony SLT-A77: New Features

At the time of writing, the Sony SLT-A77 is the most advanced model in this company's lineup of fixed mirror interchangeable lens cameras. It is an update of the discontinued Sony A33 and A55 and is one of the best Advanced Photo System type-C (APS-C) cameras for taking both high-resolution still photographs and high-quality movies (see Movies vs. Videos box below).

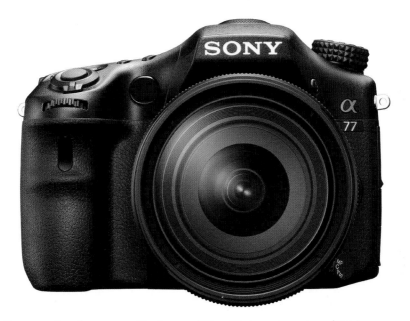

Figure 1-1: Sony A77 camera with 16-50 mm kit lens (Photograph courtesy of Sony)

Unlike a digital single lens reflex (DSLR) camera, which requires the mirror to be raised out of the optical light path to the sensor, the Sony A77 uses "translucent mirror technology" with the mirror fixed in position. SLT stands for "single-lens translucent," which is Sony's brand name for this technology. In essence, the translucent mirror is a beam splitter, diverting some of the light to the automatic focus detector and the majority of the light to the imaging sensor for real time viewing and recording of the subject. This combination of mirror and sensor allows for simultaneous focusing and movie recording. In addition, when taking still pictures and movies, the camera can focus extremely rapidly (figure 1-2). Among its unique features is a 24.3 megapixel sensor. At the time of writing, Sony is the only camera manufacturer selling an APS-C camera that can record at this high resolution.

Movies vs. Videos and Sensor Size

What is the difference? From a dictionary perspective, a movie is a captured series of pictures (e.g., in the motion picture industry) and a video is a series of images recorded onto videotape or some other electronic video recording device (e.g., for the television industry).

Both of these definitions ignore the camera's role in capturing the picture. Although we would prefer to refer to the recording of moving pictures on the Sony A77 as a "video," Sony has chosen to use the term "movie." To be in synch with Sony's terminology we will be utilizing the term "movie" when referring to the recording of moving pictures through the camera. There may be some cases where industry terminology is so strong that we will use "video" but those will be the exceptions rather than the rule.

What makes the Sony's sensor so advantageous for movie making is that it uses a sensor with an overall size that is greater than that found in camcorders. It is often referred to as an APS-C (Advanced Photo System). Its sensor is 23.5 mm x 15.6 mm, which is the size of sensors that is used in most digital SLRs. For video work this allows the camera to record with a much narrower depth of field and when shooting in low light levels, recording less noise.

Figure 1-2: Light path through the Sony A77 (Photograph courtesy of Sony)

The absence of a hinged mirror provides several advantages. Perhaps the most obvious is automatic focusing when recording movies. While other DSLRs can do this, only Sony uses a high-speed phase detection system. Other cameras, assuming they automatically focus while recording movies, use the slower contrast detection method.

A second advantage is a high burst rate: the camera can rapidly fire multiple shots with a single press of the shutter button. Most cameras have a mirror that must be swung out of the light path to the sensor and then returned to its rest position to again direct light to the optical viewfinder. This cycle limits how fast the camera can be fired.

Finally, an underappreciated aspect of translucent mirror technology is the inclusion of an electronic first curtain shutter. Because of the fixed mirror design and this shutter, there is no mechanical movement for initiating exposure. This means that the camera is virtually vibration-free, an advantage for discriminating users who do not want to sacrifice sharpness because of camera movement.

Sony replaced the optical viewfinder with an electronic one. Early designs of the electronic viewfinder were inadequate: they lacked sharpness, and movement appeared to flicker when viewing rapidly moving objects. Now, the A77's electronic viewfinder is sharp enough to be used for focusing, and subjects move smoothly across the screen. You can also see how settings affect the image before releasing the shutter.

The Sony 24.3 megapixel sensor works best at ISO 100, providing the greatest dynamic range and generating the least noise. The ISO can be reduced to 50 on bright days when you wish to use a long shutter speed to blur motion. Under lower light levels, the ISO can be increased to 1600, which provides an acceptable image. For surveillance work under extremely low lighting conditions, the ISO can be raised to a maximum of 16000. Because the A77 sensor's high pixel density requires using smaller photosites, the generation of sensor noise is theoretically greater. However, with the improvement in sensor design, the Sony A77 generates good images at ISO 1600. For us, this is not a limitation since we rarely go above this setting. Previously, when working with the A33 and the A55, the ISO's range was smaller, ranging from 100 to 12800, whereas the A77 has an expanded ISO range from 50 to 16000.

If you want one camera that can do an excellent job for still and movie work, this is the camera for you.

Using This Book

The Sony A77 works effectively for all users, regardless of their level of expertise. It can be used with automatic settings, so beginners can take pictures by simply pointing and shooting. As you become more proficient, you can alter the A77's exposure and focus settings. Eventually, you can take full control by setting the camera to manual and disregarding its recommendations. This allows you to elevate your picture taking to a new level and create images that depict the mood and results you intend.

This book has chapters for the beginner, the intermediate, and the expert. Beginners can find helpful information in chapter 4, "Automatic Settings"; intermediate photographers can turn to chapter 6, "Taking Control of the Camera"; and expert photographers can refer to chapter 7, "Manual Operation of the Camera." Regardless of your skill or interest level, this is an exciting camera to use.

At first, the abundance of commands and controls can make the Sony A77 confusing. The book starts with a description of the A77's automatic functions, then goes on to semiautomatic functions, and then to manual functions. We describe the camera's capabilities in simple terms to help you learn what the camera can do. We cover movie-making features, managing your still pictures and movies, and quick tips to help reduce errors and improve your use of the camera. In addition, we put it all together with some real-life scenarios, which is especially helpful for novice and intermediate users.

For the beginner, it makes sense to use the camera's automatic modes. After gaining experience, you can start using commands to override the camera's recommended settings. There are two fully automatic modes—Auto and Auto+—which make the camera a point-and-shoot instrument. The Auto option enables the camera to automatically adjust exposure and focus. The Auto+ option does the same thing, but goes further by attempting to identify the scene and set the aperture and shutter most appropriate for the subject. As in a point-and-shoot camera, you cannot override the camera's exposure recommendation in Auto or Auto+ modes.

The Sony A77 uses advanced image processing techniques to improve pictures by firing multiple shots. At times, the camera will automatically take several shots and combine them to render one superior image from the aggregate in Auto+ mode. It is not always easy to determine which mode to use. Auto will record a technically good photograph, which is sharp and well exposed; but Auto+ may do a better job when it successfully identifies the scene and employs advance multiple exposure techniques to improve the image.

1

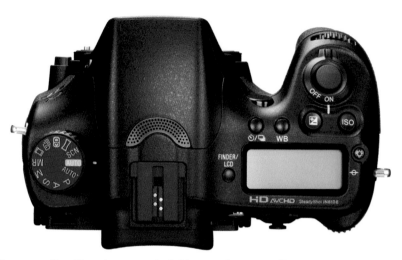

Figure 1-3a: Top of Sony A77 camera body (Photograph courtesy of Sony)

To get started, if you already have the fully-charged battery pack and memory card installed, turn on the camera and then switch on one of the automatic modes by moving the mode dial on the top right of the camera to AUTO or AUTO+ (figures 1-3 a–b). The Auto or Auto+ icon will display in the upper left corner of the LCD screen. All you need to do is find your subject, let the camera do its thing, and press the shutter button. It really is that simple.

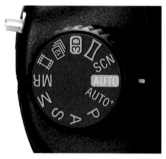

Figure 1-3b: Close-up of mode dial

Unfortunately, scene identification in the Auto+ mode can be imperfect. If the camera's intelligent software fails to correctly identify the type of scene, it uses a generic setting that captures a technically good image—just not necessarily the best.

To obtain accurate scene recognition, you can take an active role by turning the mode dial away from AUTO or AUTO+ to the SCN icon. Once there, the LCD screen will present a list of eight predefined scene modes: Daytime portraits, Evening portraits, Sports action, Hand-held twilight, Landscapes, Sunsets (and sunrises), Night, and Macro (figure 1-4). Scroll through the list and select the one that best fits your photographic subject. This ensures that the camera can fine-tune the focusing, exposure, and light sensitivity according to your selection and produce an excellent quality picture.

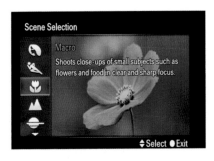

Figure 1-4: SCN predefined scene modes menu

The auto and predefined scene modes control the camera settings for you and require the least amount of input. Ultimately, you can take a step toward greater control by using semiautomatic settings (P, A, and S modes) where you select one exposure setting and the camera adjusts the rest automatically. For the most experienced users, the camera controls can be set manually (M mode), allowing you to rely on your experience and creativity to select the right settings. In this case, all of the camera menu and button controls are at your disposal. This gives you the opportunity to fully exercise your artistic creativity to capture unique images. Also, you can be confident when you set the white balance, shutter speed, or aperture that the camera will not override your settings.

Setting Up Your New Sony A77

When you take your camera out of the box, you will have the following components:
- Camera body: 23.4 effective megapixel Sony A77
- If purchased, one of the following lenses:
 - SLT-A77K/A77VK
 - DT18-55 mm zoom lens
 - Front and rear lens cap
 - Lens hood
 - SLT-A77Q/A77VQ
 - DT16-50 mm zoom lens
 - Front and rear lens cap
 - Lens hood
- Rechargeable NPFM500H "InfoLITHIUM" battery
- BC-VM10A battery charger
- Power cord (Not supplied in U.S. or Canada)
- Shoulder/neck strap
- Eyecup
- Battery case

- USB cable
- Body cap
- AV cable
- Accessory shoe cap
- CD-ROM featuring Image Data Converter and Picture Motion Browser (PMB)
- Camera manual

Make sure you have everything before assembling your new camera. It is very easy: fully charge your battery, attach the lens, and insert a memory card on which to store your pictures and movies. When you are done, you're ready to start.

Battery

The supplied "InfoLITHIUM" lithium ion battery needs to be fully charged before use. It can be damaged if allowed to drain completely. Use Sony certified batteries only. Noncertified batteries will void your warranty and may ruin your camera.

Why Use a Certified Battery?

Counterfeit batteries may not be assembled under the same guidelines and regulations as Sony certified batteries. They may not hold as much of a charge or may drain too quickly. Although they are less expensive, the money saved is not worth risking your investment in a high-end camera.

A battery charger is supplied with your camera. For U.S. and Canadian battery chargers, unfold the prongs on the charger and plug it directly into an electrical socket. For cameras sold outside of the U.S. and Canada, use the supplied cable to plug the battery charger into an electrical socket and then insert the battery into the charger. The charge indicator light glows while charging and extinguishes when it is complete. If the light flashes, this indicates there is a problem such as a defective battery. Sony estimates it takes 175 minutes to fully charge a completely depleted battery. Future charges will take less time, since there should always be some residual charge within the battery.

How many shots can you take on a fully charged battery? Well, that depends on how you use the camera, how much time you leave the camera powered on between shots, and your combination of movies, panorama pictures, and still pictures. Sony estimates that you can record approximately 470 images using the viewfinder and 530 images using the LCD screen. This may seem like a lot of recording, but it isn't. We can easily take this many pictures in one afternoon of photography. Keep in mind that if you are also recording movies, the number of images drops considerably.

Therefore, we recommend you get a second battery, keep it charged, and have it available in the event your camera's battery runs low on power.

Memory Card

You need a memory card to use with this camera. Unlike some point-and-shoot consumer cameras, there is no internal memory for storing images, and the camera will not operate without a memory card! You may already have a compatible memory card from another camera, which you can use for your new Sony A77 as long as it is an SD, SDHC, or SDXC card. If it isn't, you will have to purchase one. But what should you buy?

The A77 uses a Secure Digital (SD) memory card. These postage-stamp-sized cards come in many varieties, with various memory capacities and data transfer speeds. These cards are designated as SD, SDHC, or SDXC, which refer to the card's maximum memory capacity. Don't be too concerned about these designations as it is more important to know the memory capacity of the card (see the following "Memory Card" box) and its class rating.

At the time of writing, Sony sells an SDHC Class 10 card that holds 32 gigabytes (GB) of data for about $100. But you can opt for a 16 GB card (about $60) or an 8 GB card (about $40) instead. If you intend to record movies, you need to check the SD card's speed rating. Cards are categorized as belonging to classes (2, 4, 6, 8 and 10); the higher the class, the faster the memory card can receive and record data. According to Sony, the Class 4 card is the minimum speed needed for recording movies in AVCHD format.

Instead of using an SD card, you may decide to use Sony's Memory Stick. These are not as common as SD cards and are associated with Sony's point-and-shoot cameras. The Memory Stick PRO-HG Duo records still pictures and movies. If you use the Memory Stick PRO Duo to record both stills and movies, make sure it is the Mark 2 version.

You can use any manufacturer's SD, SDHC, or SDXC Class 4 or faster memory card of Class 4 or faster for both still pictures and movies. The size of the memory card you buy depends on how you will use the camera and how you plan to maintain the stored pictures and movies. If you plan to take a lot of movies, you will need a large amount of memory—at least 8 GB. If you are going to take mainly still photos, 4 GB should suffice.

At the end of each shooting day, we recommend you download the images from your camera to your computer. Once the files are downloaded, we erase the images on the card by using the camera commands to reformat. This allows you to start fresh the next day, minimizing the risk of running out of memory. It also enables you to use a smaller size memory card, thus saving money.

Although you can connect your camera to your computer with a cable and transfer the stored files directly, you can also download the files using a card reader. Remove the memory card from the camera and insert it into a card reader connected directly to your computer using a USB cable.

Many people keep several memory cards for those occasions when they will be doing a lot of recording and cannot download the contents to a computer. It's important to note that memory cards can fail, and having a backup will ensure that you can resume shooting if your primary card fails. For our own photography, we tend to use 16 GB cards since they provide plenty of space to accommodate a day's worth of shooting and movie recording.

Memory Cards

The Sony A77's user manual tells you approximately how many pictures or movies you can record on a memory card. The space used depends on the detail within the images and their file type.

Memory card criteria:

- SD memory card (8 MB to 2 GB)
- SDHC memory card (4 GB to 32 GB)
- SDXC memory card (48 GB to 64 GB)

Additional information:

- An SDHC memory card can be used with equipment that's compatible with the SDHC or SDXC memory cards.
- An SDXC memory card can be used only with equipment that's compatible with the SDXC memory card.

Setting Up the Camera

Once the battery is fully charged, insert it by inverting the camera body and opening the battery compartment. On the bottom-right side of the camera, there is a recess with a raised triangle. Slide the triangle in the direction indicated to open the battery door. The battery has a printed arrow indicating how to slide it into the compartment. Also, the battery is ridged so you can insert it only one way. You will hear a solid click when it is properly seated. You can now close the battery cover. To remove the battery, open the compartment to expose a small blue lever that blocks the battery's egress. Push the lever to the side, and the battery will pop out.

The memory card compartment is on the right side of the camera. To open it, slide the compartment door toward the back of the camera. When you insert the memory card, the end with the metallic reading bars goes in first. It will lock into position with a click. To remove it, push the top of the memory card inward to release the lock and the card will pop out for easy removal. If the memory card is defective or its contacts are dirty, a NO CARD message will be displayed on the LCD screen. If this occurs, remove the memory card and reinsert it. The message should go away. If it doesn't, the card may be defective and will have to be replaced. Check Appendix B, "Common Error/Warning Messages and Resolutions," for more information. To close the memory card compartment, reverse the process to slide the door back into place.

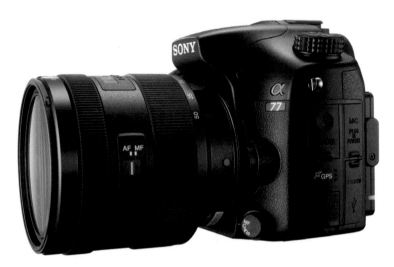

Figure 1-5: Attached lens, locked in position showing red alignment button

Next, attach the lens to the camera body. Remove the rear lens and camera body caps by turning them counterclockwise. Store both caps in a safe place for future use. Inserting the lens is a two-step process. There is a red bump at the base of the lens and a red dot on the rim of the camera body's lens mount. Align these two indicators, insert the lens, and then rotate it clockwise until you feel and hear a click. The lens is now locked in position and ready to use (figure 1-5).

Last but not least, attach the camera shoulder/neck strap. The strap should always be secured to the camera and placed either around your neck or over your shoulder when you're carrying or using the camera.

Protecting the Lens

There are several ways to protect your camera's lens against damage. The first and most obvious is to keep the lens cap on when not using your camera.

The second is to put the lens hood on when you are shooting. This helps to keep errant objects from hitting the lens. Another benefit is that the hood increases image contrast by blocking light from the side of the lens and keeping it from entering the camera.

The third way to protect your camera's lens is to use an ultraviolet (UV) filter. These threaded filters can be screwed onto the lens and serve as a clear optical lens cap. Sony sells these filters, but if you know the thread diameter of your lens, you can buy alternative brands from other retailers.

Using a UV filter as a lens protector is controversial. There are some who claim it's a good idea, while others claim the protection is minimal and the filter degrades image quality. We find inexpensive, off-brand UV filters to be problematic, so we buy and use only high-quality filters made by a reputable manufacturers. Tiffen, Hoya, and B+W UV filters are good and do not degrade lens performance. You may be surprised by the filter's expense, but considering it is optically precise disk of glass, the price for protecting your lens is reasonable. We routinely buy and mount high quality UV filters on our lenses. While there is a theoretical chance of losing some image sharpness, it's so slight that we don't notice it.

Protecting the LCD Screen

Although the Sony A77 LCD screen is made from a durable material, it can be scratched. This won't affect the camera's ability to take good pictures, but it can affect your ability to know when you have a great picture or when you need to improve the image's focus. We recommend that you purchase an LCD screen protector. Sony offers them for the A77 at a nominal cost.

Viewing Menu Commands

You are now ready to turn on your camera. The ON/OFF power switch is on the top right side of the camera circling the shutter button (figure 1-6). Move the lever so the indicator matches up with the ON option.

The first time you turn on your new camera, you will be asked if you want to set the camera's internal clock (see section 1.15). This information is recorded with each picture and movie. Before we cover setting the camera's clock information, let's first examine how to navigate through and set values for the camera's extensive menu commands.

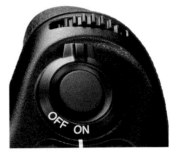

Figure 1-6: ON/OFF power switch on top of the camera

Menu Structure

The Sony A77 has an extensive list of commands. To access them, press the MENU button (figure 1-7) to display the camera's menu. Although you can use the view-finder to navigate through the menu structure, it is easier to use the LCD screen, and we will describe menu navigation from this perspective.

Although all of the commands are constantly displayed, you may see some of them disabled (grayed out). This is sometimes controlled by the selected mode dial option. For example, the Panorama: Size command is enabled when the mode dial is on Sweep Panorama mode and disabled when using all other modes. In a couple of cases, some commands are dependent on other command settings; for example, the Peaking Color command is disabled unless you first set the Peaking Level command to [High], [Med], or [Low].

The camera's menu may look complex at first, but it is actually set up very logically. The horizontal menu bar (figure 1-8) at the top depicts where you are within the menu structure. There are seven main menu options, each represented by an icon (table 1-1). Basically, these menu items deal with Still Shooting, Movie Shooting, Custom, Playback, Memory Card Tool, Clock Setup, and Setup.

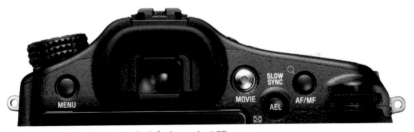

Figure 1-7: MENU button on the left above the LCD screen

Menu Icon	Menu Name
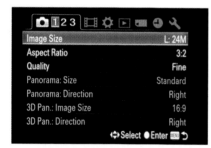	Still Shooting
	Movie Shooting
	Custom
	Playback
	Memory Card Tool
	Clock Setup
	Setup

Table 1-1: Main Menu options

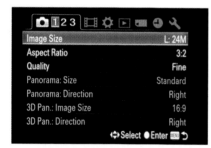

Figure 1-8: MENU screen with the main menu horizontal bar at the top. Here the option Image Size under Still Shooting is selected.

Each main menu option has a list of commands associated with it. Sony displays the commands as "pages." Up to seven commands can be displayed on a single page. Additional commands are displayed on a following page. The numbers next to the main menu options represent the page numbers. As you move through the main menu bar, the commands change. Figure 1-8 shows there are three pages under the menu option Still Shooting, and the options on page 1 are displayed.

Each command has an assigned value that you change to control the camera's operations. For now, we will only cover the menu structure and navigation basics. We will describe how to use specific commands as they arise throughout the book.

Menu Command Nomenclature

We refer to various Sony A77 camera commands throughout this book. To help you quickly locate them within the menu structure, we use the following notation:

MENU>main menu name (*page* #)>submenu command name >[value1], [value2]]

The ">" symbol separates menus and submenus, and the command's menu page is found within parentheses. If the submenus have subordinate commands, they are separated by > until the command being discussed is reached. We include command values in brackets when they pertain to the subject being covered.

For example, we identify the AF w/shutter command location as follows:

MENU>Still Shooting Menu (3)>AF w/shutter

Figure 1-9(a–c) shows a series of screen shots starting from left to right: page 1 of Still Shooting (figure 1-9a); page 3 of Still Shooting with the AF w/shutter command highlighted (figure 1-9b); and the AF w/shutter command's options displayed with the [On] value highlighted (figure 1-9c). Using our menu nomenclature, the AF w/shutter command and its options are displayed as:

MENU>Still Shooting Menu (3)>AF w/shutter>[On], [Off]

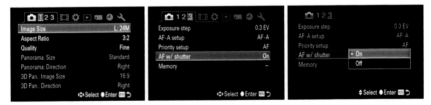

Figures 1-9(a–c): Main Menu flow to the AF w/shutter command

Menu Navigation

The camera utilizes a single button called the multi-selector (figure 1-10) to navigate through the camera's commands, functions, and other settings. The multi-selector works in two ways: you use it to navigate through the menu by toggling left, right, up, or down, and you push it in to select a value. There are faint directional arrows imprinted around the button indicating these toggle directions. As you navigate through the

Figure 1-10: Multi-selector button surrounded by directional arrows

menu, the camera's menu position is indicated by the option being highlighted on the LCD screen.

As an example, you press the multi-selector button to select a menu and then toggle the multi-selector up or down to scroll through the menu command's available values. Note that the cursor skips over any disabled commands and subsequent values.

Navigating with the Front and Rear Control Dials

Using the multi-selector is not for everyone. Instead, you can use the front and rear control dials (figures 1-11 a–b) to navigate through the menu commands and their associated values. To activate the front and rear control dials as menu and command navigation tools, you have to view the menu structure in some capacity—either by pressing the MENU button, the Fn button, or some specific command button. Otherwise, the front and rear control dials change the value of the camera's aperture opening or its shutter speed.

When the MENU button is pressed, use the rear control dial to cycle through the menu's horizontal bar options. You can go in either direction by turning the dial left or right. Use the multi-selector button to select a specific menu option. Then you can rotate the front control dial to move up and down through the available commands. Press the multi-selector button to enter a command's available values. The rear control dial allows you to exit the list of command values without selecting one and return to the command's position in the menu.

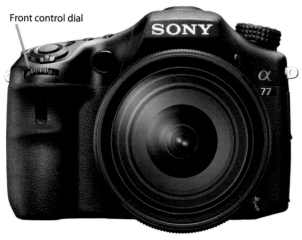

Front control dial

Figure 1-11a: Front control dial

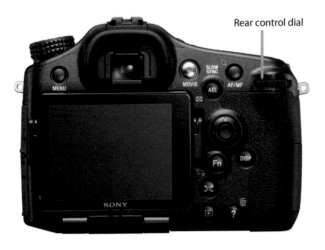

Figure 1-11b: Rear control dial

When you reach the end of viewing the menu structure, both the rear and front control dials allow you to cycle again through the list of menu pages and commands. But once you are viewing a specific command's list of available values, you can only scroll up and down through it. When you arrive at the end of that list, you have to turn the front control dial in reverse to go back up through the list.

This is an area where practice will help you become familiar with the camera's operations.

Recommendations for Menu Navigation

Spend some time exploring the main menu options. Use either the front and rear control dials or toggle the multi-selector to navigate through the menus, their commands, and the available values. Remember, press the multi-selector button to select a value. Experiment with moving in and out of commands and scrolling from page to page. A little practice now will help you find the navigation style best suited to you. We find using a combination of the front and rear control dials and toggling the multi-selector work well together. The dials enable you to move rapidly through the menu tree, while toggling the multi-selector provides more precision as you near the command you wish to activate.

Error Messages

The Sony A77 has a large number of self-explanatory information and error messages to help guide you through setting up and using the camera. There are also many error messages that need some additional information. See Appendix B for a list of these error messages and resolutions in alphabetical order.

Important Command Reset Capability

Sony has a single command to restore all of the A77's settings to their default values. As you use the camera, you will set, change, and reset command options frequently. At times, the camera may get confused, or you may find the need to start over with the camera's default values. Use the following command to reinitialize camera's settings:

MENU>Setup (3)>Initialize>[Reset Default], [Rec mode reset], [Custom reset]

The Setup Menu's Initialize command gives you three options to reset a group of commands back to their default values:
- Reset Default – Reset all of the Menu and Function commands to their default values.
- Rec mode reset – Reset Menu and Function commands for recording images to their default values.
- Custom reset – Reset only the Custom Menu command settings to their default values.

Note: Face Registration's faces and priorities are deleted when either the [Reset Default] or [Custom reset] option is selected. However, if your camera commands stop working, you might need to select the [Reset Default] option and end up loosing your stored face registration face information. Once lost, face registration information cannot be regained. One has to photograph and register the subject's face anew.

Fn Button

Not all of the camera's functions are managed through the MENU button. Many of them are managed using the buttons on the top and back of the camera. One of them is the Fn button. Whereas the other buttons manage just one function, the Fn button controls up to 15. The functions are displayed in two columns—one on the extreme left and the other on the extreme right of the display screen (figure 1-12).

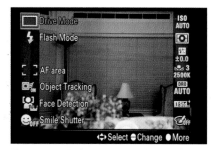

Figure 1-12: Fn button's two columns of functions

When you press the Fn button, the resulting display varies depending on the setting of the mode dial. Tables 1-2 (a–b) show each of the mode dial options along with the functions displayed when the Fn button is pressed. Some of the functions will be displayed as disabled, while a few will not be displayed at all.

Mode Dial Setting	Fn Button Menu Options — Left Column of Icons						
	SCN/ Memory Recall*	Drive Mode	Flash Mode	AF Area	Object Tracking	Face Detection	Smile Shutter
P		E	E	E	E	E	E
A		E	E	E	E	E	E
S		E	E	E	E	E	E
M		E	E	E	E	E	E
MR	MR1	E	E	E	E	E	E
	MR2	E	E	E	E	E	E
	MR3	E	E	E	E	E	E
Movie		E	D	E	E	E	
Continuous Advance Priority AE		D	E	E	D	D	D
3D		D	D	E	D	D	D
Panorama		D	D	E	D	D	D
SCN	Portrait	E	E	E	E	E	E
	Sports Action	E	E	E	E	E	E
	Macro	E	E	E	E	E	E
	Landscape	E	E	E	E	E	E
	Sunset	E	E	E	E	E	E
	Night Scene	E	D	E	E	E	E
	Hand-held Twilight	D	D	E	D	E	D
	Night Portrait	E	E	E	E	E	E
AUTO		E	E		E	E	E
AUTO+		E	E		E	E	E
*The selected SCN or Memory recall icon is displayed when mode dial is set to SCN or MR respectively							

Table 1-2a: Fn button's left column of functions. E = Enabled, D = Disabled, Grayed = Not listed

Mode Dial Setting	Fn Button Menu Options Right Column of Icons							
	SCN/ Memory Recall*	ISO	Metering Mode	Flash Comp	White Balance	DRO/ Auto HDR	Creative Style	Picture Effect
P		E	E	E	E	E	E	E
A		E	E	E	E	E	E	E
S		E	E	E	E	E	E	E
M		E	E	E	E	E	E	E
MR	MR1	E	E	E	E	E	E	E
	MR2	E	E	E	E	E	E	E
	MR3	E	E	E	E	E	E	E
Movie		E	E	E	E	E	E	E
Continuous Advance Priority AE		E	E	E	E	E	E	E
3D		D	E	D	E	D	E	D
Panorama		D	E	D	E	D	E	D
SCN	Portrait							
	Sports Action							
	Macro							
	Landscape							
	Sunset							
	Night Scene							
	Hand-held Twilight							
	Night Portrait							
AUTO								
AUTO+								
* The selected SCN or Memory Recall Icon is displayed when mode dial is set to SCN or MR respectively								

Table 1-2b: Fn button's right column of functions. E = Enabled, D = Disabled, Grayed = Not listed

So what is the difference between the menu commands and the functions handled by the Fn button? First, they are not duplicates. The Fn button contains commonly used settings for individual pictures and movies, while the menu commands are generally set for a series of picture and movie-taking scenarios. For example, the Fn button allows you to manage object tracking, which pertains to the immediate image in your camera's sights and not necessarily to the next picture you want to take. The MENU button manages commands such as AF w/shutter, which controls autofocus activation by pressing the shutter button. Most likely you will want to use this setting for taking several images throughout a photographic shoot.

Rather than covering each of the functions in this chapter, we will discuss them specifically throughout the book as we go. That way, their use will be more evident.

Fn Button Nomenclature

We use the same Menu nomenclature structure when referencing the path to an Fn button option, substituting right or left column for the page number:

Fn>function menu name (left/right column)>sub-function name>[value1], [value2]

For example, the path to the Fn button's DRO/Auto HDR function is identified as follows:

Fn>DRO/Auto HDR (right)>HDR>[AUTO], [1.0EV], [2.0EV], [3.0EV], [4.0EV], [5.0EV], [6.0EV]

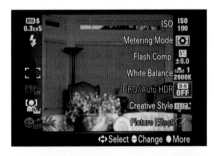

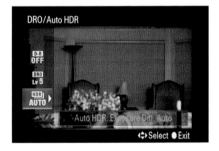

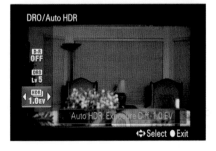

Figure 1-13(a-c): Fn button flow to the DRO/Auto HDR function

Figure 1-13(a–c) shows a series of screen shots illustrating this. From left to right: the Fn function displayed with DRO/Auto HDR highlighted (figure 1-13a); DRO/Auto HDR options displayed with AUTO value selected (figure 1-13b); [1.0EV] value selected by toggling the multi-selector to the right (figure 1-13c).

Fn Button Navigation

Navigating within the Fn button is a bit different from navigating through the Menu structure. Once you enter into a function's structure, you can scroll through its available options. If there is a set of available values within an option, only the first value is displayed; there are arrows indicating the direction to toggle the multi-selector to view the other available values (figure 1-13c).

Press the multi-selector button to select a specific Fn function. Toggle the multi-selector to navigate through the functions and associated values. Press the multi-selector button again to select a function's value.

In-Camera Guide Button

Everyone can use some extra help now and then. The In-Camera Guide button (figure 1-14) indicated with a ? works within the camera's menu or function structure. Press this button, and a brief description of the currently highlighted menu or function will be displayed. Press the button again, and you will be returned to the current menu or function. Note that when reviewing images, the In-Camera Guide button doubles as a Delete button (indicated with a trash can icon on the body of the camera).

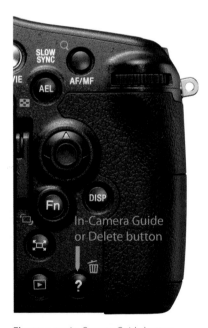

Figure 1-14: In-Camera Guide button

Cleaning the Sensor

When you change the camera's lens, dust particles can enter the camera body and land on the sensor. On the recorded image, these can be seen as blurred shadows. You can help prevent this by removing and replacing the lens quickly. However, the entry of some dust is inevitable. The Sony A77 removes sensor dirt by shaking it off at high speed. Each time you turn off the camera, it automatically "cleans" the sensor with ultrasonic vibrations. There may be times when you feel an extra cleaning is needed. You can accomplish this either by turning the camera off and then back on, or you can execute the following command:

MENU>Setup Menu (2)>Cleaning Mode

While these cleanings shake the dust and debris off the sensor, some foreign particles are resistant to being removed. You can take them off by doing a manual cleaning. First, take off the camera lens and raise the translucent mirror. There is a V mark at the bottom of the frame surrounding the mirror. This is a lock lever. Carefully push it and lift the frame of the mirror up with your finger without actually touching the mirror. Use a manual bulb blower to clean the image sensor surface. It is best to hold the camera with the lens opening facing down so the dust particles can fall out of the camera.

Do not use a pressurized can of gas to blow out the camera's interior as any dirt in the nozzle may be blown with enough force to damage the sensor. Also, if propellant is expelled, it can be difficult to remove from the sensor's surface. Do not touch the image sensor or mirror with your fingers or the blower. After completion, lower the mirror frame back into place, again not touching the mirror surface. Ensure that the mirror is locked firmly into place and reattach the lens. Note that the camera will not be able to autofocus if the mirror is not firmly locked down. In addition, the camera will not shoot if the mirror is inadvertently left in the up position.

Do not attempt to clean the mirror. Liquids can mar its surface, and it is fragile. If there is a little dust on it, ignore it. Dust on the mirror will be out-of-focus and invisible to the sensor.

Setting the Area, Date, and Time

When you turn your camera on for the first time, the Set Area/Date/Time message is displayed. You can enter the information later, but it is easiest to do so when the message is first displayed. The date and time stamp is a great way to keep track of when a picture or movie was taken. Make sure you set the Area field to your location. If you have an A77 that lacks a GPS, when you cross time zones while travelling, use the camera's world map to adjust the clock to the proper time zone.

 Setting the Area, Date, and Time is easy. The camera displays two menu options: [Date/Time Setup] and [Area Setting]. Press the multi-selector button to select one of the options. Toggle the multi-selector right or left or use the front control dial to move through the command fields. To make your selection, toggle up or down or rotate the rear control dial to move through the available values.

Maintaining the Camera's Date and Time Information
In addition to the replaceable battery pack needed to turn on and operate the camera, there is a small internal battery for maintaining the date and time settings. Inserting a fully charged battery pack recharges this internal battery. Even if the main battery is depleted, the internal battery has sufficient power for three months of operation.

If you decide to set the date and time information later, you can do so from the Clock Setup Menu. Execute the following steps:
- Select:

 MENU>Clock Setup (1)>[Date/Time Setup]

- Toggle to select the menu's values. Enter the current date and time information and press the multi-selector button to accept (figure 1-14).
- Select:

 MENU>Clock Setup (1)>[Area Setting]

- Toggle to move across the world map's available time zones.
- Stop on your current time zone and press the multi-selector button to accept.

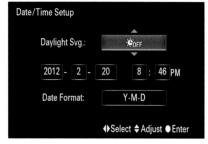

Figure 1-15: Date/Time Setup display screen with the clock's date and time set

Daylight Saving Time

Many areas within the United States observe daylight saving time. In the spring and fall, the time is set forward or backward one hour respectively. The Date/Time Setup command's [Daylight Svg.:] option allows you to specify if your current location is in daylight savings. If so, the camera takes this into account when calculating the current time. Unfortunately, as you travel in and out of daylight savings time zones or switch from daylight savings to regular time, you need to reset the [Daylight Svg.:] indicator to reflect the current situation and location.

Dual Viewing System

The Sony A77 has two electronic displays: an electronic viewfinder with an eyepiece and the movable LCD screen on the back of the camera. Most digital camera users are familiar with the latter. Unlike some early electronic viewfinders, the A77's finder is extremely sharp with a good refresh rate. It replaces the optical viewfinder on DSLRs. Thanks to translucent mirror technology, you can use this viewfinder when you record movies.

The electronic viewfinder and the LCD screen work sequentially. The viewfinder is enabled when the camera senses your face is close to the eyepiece. When you move your head away, the viewfinder turns off and the LCD screen turns on. This clever feature preserves battery life.

There are both advantages and drawbacks to each of the viewing displays. The Sony A77 has a few differences in how the camera settings are displayed versus what you see in the viewfinder or on the LCD screen. As you use the camera and become familiar with its settings and buttons, you will develop personal choices as to which viewing system works best for you. In chapter 3 we will cover details about the LCD screen and the viewfinder and how to display information on them.

Diopter Adjustment Dial

There is one more thing you need to know about the viewfinder: it has a magnifier that needs to be focused to match your vision. To the right of the eyepiece is a small wheel called the diopter adjustment dial (figure 1-16). Rotate the wheel back and forth until the objects in the viewfinder appear maximally sharp. If you share your camera with others, they must make sure that the viewfinder is in focus for their eyes. If you are nearsighted (myopic) and your photographer partner is farsighted (hyperopic), you will have to

Figure 1-16: The diopter adjustment dial to the left of the viewfinder

adjust this dial whenever the two of you use the camera. This dial ensures that the photographer, no matter if he is nearsighted or farsighted, will have a sharp image to view through the viewfinder.

Recommendations

We recommend that you use only Sony-certified batteries and appropriate memory cards to ensure high quality and equipment functionality. We also recommend that you always have a spare battery and memory card on hand.

Use an LCD screen protector and implement habits to protect your camera's lens. Doing both equates to very inexpensive insurance against damaging your camera.

It's best to set the camera's clock when you first turn on the camera. This way, all of your future images will contain the date and time stamp.

As you might have already noticed, the Sony A77 is very complex. There are well over 100 commands and options, 15 individual functions, and multiple buttons, levers, and dials. Many of the components function differently depending on the mode settings. Basically, there is a lot to learn. As you progress through this book, we recommend that you take time to explore each of the components before using them to take pictures and movies. There are multiple ways to execute many of the camera's functions. Through your exploration, you will develop your own personal style of using the camera—one that will help you capture the results you want with ease and panache.

Chapter 2: Photography Basics and the A77's External Buttons

Introduction

The Sony A77 camera is complex and can be daunting with its scores of menu com-mands, functions, and options. This book goes beyond just lists of these items and provides you with comprehensive steps to put it all together using colored screen shots and example images so you can get the most out of your new A77 camera. If you are an experienced camera user, this book helps you learn more about the camera's unique bells and whistles and how to further exploit the camera's capa-bilities. If you are a point-and-shoot photographer, this book guides you on how to use the camera's automatic features and then move beyond them to partially and then fully control your camera and impart your artistic interpretation of a scene.

With its automatic settings, the camera tries to generate razor-sharp images. But you may want to blur portions of the image—for example, turning a background with fine detail into a dreamlike backdrop that concentrates the viewer's attention on your subject. When you know how your camera settings change an image, you can think outside the box. As you gain control, you will learn commands that make the A77 more responsive when photographing fast-moving subjects and events.

This chapter describes the basics of exposure, depth of field, shutter speed, and sensor sensitivity and how camera settings affect these four items. In essence, our goal is to provide an intuitive rather than a scientific grasp of how the camera renders a sharp and detailed image. You will gain a sense of what the automatic settings are doing. By understanding them and taking pictures in automatic modes, you will learn how and why you may need to change camera settings.

In most automatic modes of the A77, there is very little you can change. You just have to accept the image the camera gives you. Eventually, as you view your pictures, you will develop an artistic sense of how to break the rules. For example, you can gain increased control by using the SCN mode, where you match your subject to a predefined scene category in the camera. This will select aperture and shutter speeds appropriate for sports activities, portraiture, or low light conditions. Switching to SCN mode will increase your percentage of keeper photographs. Eventually, you may want to take over the process entirely—looking at the scene, previsualizing the picture, and setting the controls to record your picture.

A digital image is a two-dimensional rendering of a three-dimensional object. The camera's light detector, called a sensor, is flat, and a lens projects light from the subject onto it. If the distance of the lens from the sensor is not adjusted precisely, the image will be blurred, causing a loss of definition. Furthermore, only one plane parallel to the sensor is rendered at maximum sharpness—in other words, the subject will be in focus only if it occupies this plane. Objects in front of or behind this plane become progressively blurred as their distance from the in-focus subject increases. Eventually the out-of-focus portions of the image appear as a complete blur.

By reducing the size of the lens aperture, the rate at which sharpness is lost with distance is reduced, and you can create an image where both near and far objects appear sharp. So, we have a control, the lens aperture, for extending or limiting the range of sharpness. By opening the aperture, we create a shallow depth of field and can selectively pick planes to be sharp while other areas are blurred. This is demonstrated in figure 2-1 with photographs of the same scene using two different aperture settings. The image on the left was shot using an aperture of f/2.8, which allowed only the balcony to be in sharp focus while the foreground leaves and distant blossoms are out of focus. The image on the right was shot with an aperture of f/22. Notice how the focus on close as well as distant objects was sharpened by using a smaller aperture.

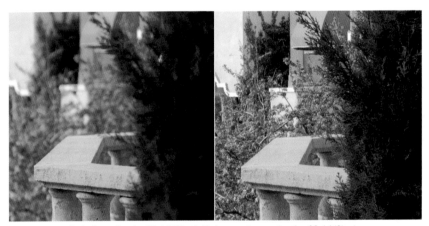

Figure 2-1: Left: shallow depth of field (f/2.8). Right: maximum depth of field (f/22).

The sensor can only record a limited intensity of light: too little, and you record a black photograph with no detail; too much, and your image is brilliant white with no detail. Provide the correct amount of light, and your sensor records a picture rich in details. Again, this differs from our visual perception of the world where we can view a much broader range of light intensities. To record these intensities, you have to adjust the amount of light reaching the sensor to ensure proper exposure.

Three things control exposure. The first is lens aperture, which regulates how much light enters the camera body. The second is shutter speed, which regulates how long the sensor is receptive to light. A short shutter speed of 1/1000 of a second provides less light to the sensor than a long shutter speed of 1 second. The final control is ISO, which is essentially an electrical adjustment to increase the signal from the sensor. Think of it as a sensitivity control—the higher the ISO, the more sensitive the sensor is to light.

2

> **What Are Sensors and Images?**
>
> Digital cameras use a solid-state device composed of millions of individual photosites for converting light into an electrical signal. The individual photosite is the physical basis of a pixel, the smallest unit for sensing light. In the A77, there are more than 24 million pixels in a 6000 x 4000 rectangular array. Signals from these sensors are transmitted to the camera's viewing screen. Together, they make up the mosaic of intensities and colors that become an image. The viewed image is a numerical expression that can be manipulated mathematically so the camera's computer can alter its appearance. Then, it can be stored on an internal memory card.

In summary, to record a technically sharp picture, you must focus the subject properly onto the sensor and ensure that the intensity of light collected lies within a prescribed range. You can define and describe how to set the camera's controls to get this result. This is what the camera does when set to automatic operation, which explains why point-and-shoot cameras work so well. Artistically, however, there is no universal setting that always renders a perfect image. An artistically satisfying image may require you to set the controls differently than the optimum for sharpness or exposure. For example, a running athlete can be photographed with a relatively long shutter speed to blur his arms and legs, creating the impression of movement.

File Formats

Your digital camera records your images on a memory card. Most likely you will eventually transfer these files to your computer. The file format (type) of your images or movies determines what you can do with them after transferring the files.

For still photography, the camera allows you to choose between recording your images as JPEG or RAW files. The type of format you select depends on what you are going to do with your pictures.

> **JPEG and RAW Definitions**
>
> **JPEG:** A JPEG image file is compressed using a method developed by the Joint Photographic Experts Group. This compression produces a loss of information from the original image file that cannot be restored. The file's name has the extension "jpg" (commonly used on Windows machines) or "jpeg" (commonly used on Macintosh computers).
>
> **RAW:** A RAW file is a digital camera file that is minimally processed. It retains all of the data originally captured by the imaging sensor. A Sony A77 RAW file has the filename extension "ARW."

When you start using your Sony A77, you will find that JPEG is the default file type. This is an easy-to-use file format that is readable and usable by almost any computing device. You can send JPEGs as email attachments and view them on your cell phone.

In contrast, the RAW format is more cumbersome and requires a large amount of storage space. It is a proprietary format specific to the camera manufacturer and it requires special software to open the file on your computer. But this is the format the majority of photographers use when working with programs such as Photoshop. Its inconveniences are accepted because the RAW format minimally processes the data within the camera (hence the name RAW) and gives the knowledgeable user greater flexibility in processing images on the computer.

So, which to use? Well, the simplest answer is to use both. The Sony A77 allows you to simultaneously record an image in both RAW and JPEG formats (table 2-1). This gives you the best of both worlds: the full image processing potential of a large RAW file, and the convenience of a generally accessible, small JPEG file. To record an image in both RAW and JPEG formats, press the MENU button and proceed to the following command:

MENU>Still Shooting Menu (1)>Quality>[RAW], [RAW & JPEG], [Extra fine], [Fine], [Standard]

Quality Value	File Type Information	File Extension
RAW	Uses RAW compression. The data is stored with minimal digital processing. Contains more data than any of the JPEG file types.	.ARW
RAW & JPEG	Two files are created: RAW and JPEG Fine. The RAW file uses RAW compression and is stored with minimal digital processing. The JPEG file is more compressed than RAW, and its data reflects the results of the camera's digital processing.	.ARW and .JPG
Extra fine	Extra fine has the lowest compression rate of the three JPEG file types and retains the most image detail.	.JPG
Fine	Fine is the JPEG default compression rate, with an intermediate degree of compression and retention of image detail.	.JPG
Standard	Standard has the highest compression rate of the three JPEG file types and can lose fine detail.	.JPG

Table 2-1: Quality values for still photographs

The disadvantage of recording in both RAW and JPEG formats is that it uses a lot of memory space. However, memory is inexpensive, and the convenience of having both files is compelling. One problem with this strategy is that Sony has several unique exposure techniques that require you to record in JPEG mode. These techniques make the camera a versatile tool for photographing panoramas and capturing images in high contrast or low light conditions.

In JPEG mode, you are given the choice of recording in [Extra fine], [Fine], or [Standard] qualities. Your choice will depend on how much detail you wish to retain in the image. To record the most detail, choose Extra Fine; to record the least detail, choose Standard. When the camera chooses its own file format in JPEG mode, the default is Fine.

There are two different file formats for taking movies: AVCHD and MP4. AVCHD stands for Advanced Video Coding High Definition. It provides the highest spatial and temporal resolution for recording your movies (1920 x 1080 pixels) and is the default mode with the Sony A77. There are two types of AVCHD: 60i/60p or 50i/50p. The one you see in your menu depends on your camera's country of origin.

The MP4 file format is simpler to work with on the computer, albeit at lower resolution. If you want to shoot in MP4 mode, you must select it to override the camera's default settings.

MENU>Movie Shooting Menu (1)>File Format>[AVCHD 60i/60p] or [AVCHD 50i/50p], [MP4]

Some manufacturers recommend using AVCHD formats for playback. There are two ways to do this: you can attach your camera to a high-definition TV, or you can make DVDs for playback on a DVD player.

Keep in mind that movie files can be massive. AVCHD files are highly compressed, and the degree of compression influences how easily they can be edited on your computer. Sony supplies software for doing this on Windows computers, but not for Apple computers.

Saving a movie in the MP4 format creates a larger, less compressed file that older computers can handle more easily. So, if you are working with the AVCHD format and find it difficult to use, you can switch to recording your movies as MP4 files which are easier to edit. These saved files can be attached to emails or inserted into Powerpoint presentations.

2

Both the AVCHD and MP4 file formats each have specific record settings. Table 2-2 contains AVCHD record setting values.

When File Format = [AVCHD 60i/60p]:

MENU>Movie Shooting Menu (1)>Record Setting>[[60i 24M(FX)], [60i 17M(FH)], [60p 28M(PS)], [24p 24M(FX)], [24p 24M(FH)]

Note: For some, you will be seeing "50" in place of "60" depending on your camera's location of origin.

File Format = [AVCHD 60i/60p]/[AVCHD 50i/50p]		
Record Setting Value	**Average Bit-Rate**	**Movie Recording Size and Frames/Second (fps)**
60i 24M(FX) / 50i 24M(FX)	24 Mbps	Records interlaced images at 1920 x 1080 size and 60i/50i fps movies. High quality recording.
60i 17M(FH) / 50i 17M(FH)	17 Mbps	Records interlaced images at1920 x 1080 size and 60i/50i fps movies. Standard quality recording due to greater compression.
60p 28M(PS) / 50p 28M(PS)	28 Mbps	Records progressive images at 1920 x 1080 size and 60p/50p fps movies. Highest quality image mode due to least compression.
24p 24M(FX) / 25p 24M(FX)	24 Mbps	Records progressive images at1920 x 1080 size to appear like cinema movies. High quality recording.
24p 24M(FH) / 25p 24M(FH)	17 Mbps	Records progressive images at1920 x 1080 size and 24p/25p fps cinema-like movies. Standard quality recording due to greater compression.

Table 2-2: Record Settings values for AVCHD files

Table 2-2 contains MP4 record setting values. There are two recording options for MP4: 1440 x 1080 pixels and 640 x 480 pixels (VGA). The numbers 12M and 3M indicate Mbps (Megabytes per second), the amount of data being streamed. The highest number, such as 28 Mbps, means more data is being transmitted and that there will be less compression and less loss of image quality. The lowest Mbps nmbers indicates less data is being transmitted and this indicates a higher compression is being employed, which reduces movie quality.

When File Format = [MP4],

MENU>Movie Shooting Menu (1)>Record Setting>[1440 x 1080 12M], [VGA 3M]

File Format = [MP4]		
Record Setting Value	**Average Bit-Rate**	**Movie Recording Size**
1440 x 1080 12M	12 Mbps	Records 1440 x 1080 size movies
VGA 3M	3 Mbps	Records VGA size movies

Table 2-3: Record Setting values for MP4 files

These two Record Settings for the MP4 format demonstrate the differences in data being sent. At 12 Mbps, each movie frame has 1440 x 1080 pixels. In contrast, when the bit rate is reduced to 3 Mbps, each movie frame is reduced in size (less data) and only 640 x 480 pixels is being processed. The effects of compression are seen in this case as a reduction in the overall pixels available for viewing so that the 3 Mbps provides a smaller size frame (640 x 480 pixels) compared to the 12 Mbps movie that provides a larger frame of 1440 x 1080 pixels.

Shutter Button

The shutter button is found on the camera's top right panel. When you press it down halfway, you will feel an increase in resistance. Even though the camera has not fired, you can stop there and hold this position: it is a control point that initiates many of the camera's settings. For example, it initiates focusing. When focus is obtained, the lens is locked and a green circle lights up on the lower left corner of the screen. As long as you maintain pressure on the shutter button, you can aim the camera to another area without changing focus. To take the picture, press the shutter button down fully. This is a useful technique to master because you can lock the focus onto your desired subject and shift the frame for improved composition.

Focusing

As mentioned earlier, the camera lens focuses the scene onto the sensor. You have to tell the A77 whether you wish to focus automatically or manually. For manual focusing, use the focus mode dial (figure 2-2) found below the lens. Turn it so the letters MF (Manual Focus) are opposite the index mark. Then look

Figure 2-2: Focus mode dial with MF selected

2

through the viewfinder or at the rear LCD screen and turn the lens focusing ring until the image is sharp.

More commonly, you can let the camera determine focus automatically by setting the focus mode dial to the C, A, or S options. If you select C (Continuous AF), the camera is always adjusting focus as the subject moves toward you or away from you. In contrast, if you select S (Single-shot AF), the camera finds focus and then locks the lens so the focus will not change. This is our favorite mode for still subjects. Finally, if you select A (Automatic AF), the camera will switch between S and C, using S if the subject is stationary and C if the subject is moving.

When focus is achieved, there will be two prompts. One is a solid green circle in the border of the display screen; the second is green-framed squares showing which portion of the screen the camera has decided to use as a focus point. If you have the camera set to C, you will also see a set of brackets surrounding the solid green circle. If you don't see the solid green circle or if it is blinking, the camera cannot find focus and it will not fire.

You might wonder how the camera determines where to focus. Suffice it to say that in the automatic shooting modes, the camera makes a judgment call on the desired area. As you gain more experience, you will probably want to override this automatic feature. You can tell where the focus point is by noting which of the focusing areas turn green just prior to the camera taking the exposure. In addition, focus indicators displayed on the screen further indicate the focus status (table 2-3). Manual focusing is discussed in detail in chapters 6 and 7.

Focus Indicator	Condition	Status
●	Lit	Focus is locked and the camera is ready to shoot.
(((●)))	Lit	Continuous AF is in operation and focus achieved.
(())	Lit	Camera is in Continuous AF and attempting to find focus. Camera is not ready to shoot and the shutter button is disabled.
●	Flashing	Camera cannot obtain focus and shutter button is locked.

Table 2-4: Display screen focus indicators

2

Advanced Focusing Features: Face Detection and Object Tracking
The camera has two advanced focusing features that may be useful. The first is Face Detection, where the camera identifies a person's face and then tries to use it for focusing and exposure. The Face Detection function is accessed through the Fn button.

Fn>Face Detection (left)>[Off], [On (Regist. Faces)], [On]

When you select [On] or [On (Regist. Faces)], you will see a frame or box surrounding each of the detected faces. The frame's color indicates the face detection status. A white frame indicates that the face can be focused; gray indicates that it cannot be focused. When you press the shutter button halfway, the white frame turns green, indicating focus is obtained on the face. You can remedy the appearance of gray-framed faces by recomposing the image slightly or by increasing the apparent size of the face by moving closer or zooming in with the lens.

The command [On (Regist. Faces)] is for faces you have taught the camera to recognize. When this command is used, the camera biases focus and exposure for these "preferred" people. Registering faces is discussed in chapter 4.

The other advanced focusing mode is Object Tracking. Here you tell the camera that you want a subject to be tracked or followed as it moves about within the display screen.

Fn>Object Tracking>[Off], [On]

When this command is activated, the camera attempts to follow an object for focusing. This can be a useful feature when you are photographing active children or pets. Object Tracking is initiated by pressing the multi-selector button. A targeting frame appears in the center of the display screen. Position your subject within the target frame and press the multi-selector button again. A larger frame will then surround your subject and move with it, tracking it through the display screen. You take the picture by pressing the shutter button. To deactivate tracking, press the multi-selector button again; it will turn off in a second or two.

2

Exposure (Shutter Speed, Aperture, ISO)

Capturing an image that shows all of the subject's details requires the sensor to collect all of the scene's light levels. This is done by adjusting the amount of light that falls on the sensor via the shutter speed and aperture opening. If these adjustments don't provide enough light, the signal from the sensor will be insufficient, and the recorded image will appear dark. This condition can be ameliorated by amplifying the output signal from the sensor so that the recorded image appears bright.

Aperture control means adusting the f-stop, which regulates the amount of light passing through the lens. The f-stop is the ratio of the diameter of the lens to its focal length. A lens set at f/5.6 transmits the same intensity of light whether it is a telephoto or a wide-angle.

Another way to regulate the amount of light falling on the sensor is by controlling its duration. This is the role of shutter; the shutter speed reflects the time the sensor is exposed to light. An exposure of 1/30 second allows twice as much light to be collected by the sensor as a shutter speed of 1/60 second. When the Sony A77 is used in Auto or Auto+ mode, shutter speeds can range from as long as 30 seconds to as short as 1/8000 second.

What Are F-Stop Numbers?

F-stop numbers represent the ratio of the lens opening to its focal length. They provide a measure of consistency when using lenses of different focal lengths or magnifications. A telephoto lens with a focal length of 400 mm and a wide-angle lens with a focal length of 14 mm both pass the same intensity of light when they are set to f/16.

There are advantages to using both ways of controlling how much light reaches the sensor. First, you can control over a much broader range of light intensities. Closing the aperture and shortening the shutter speed are additive and reduce the light's effect more than doing just one or the other. So, the intensities you can work with range from using the longest shutter speed with the widest aperture opening to the shortest shutter speed with the narrowest aperture.

In addition, multiple combinations of aperture and shutter speed settings can produce an equivalent exposure. For example, setting the aperture to f/2 and the shutter speed to 1 second is, in terms of exposure, the same as setting the aperture to f/16 and the shutter speed to 1/60 second. Equivalent exposures can be obtained by the judicious selection of aperture and shutter speed, allowing you to vary the appearance of a photograph.

For example, when using a fast shutter speed, flying birds can be rendered as tack sharp objects suspended in space; or, by using a slower shutter speed, their

flapping wings can appear blurred to give the impression of rapid movement. To obtain an equivalent exposure with these two shutter speeds, the faster one requires the lens aperture to be opened to admit more light, while the slower one requires the aperture to be closed down to admit less light.

Another advantage of varying the aperture is increasing or decreasing the depth of field. Closing down the aperture increases the depth of field, while opening the aperture decreases it. When using a small aperture to achieve greater depth of field, you will need a slower shutter speed so that enough light still reaches the sensor.

You can use depth of field to direct the viewer's attention to the subject. For a portrait with a model standing in front of a window, you can focus on the subject's face and blur the background by opening the aperture to provide a shallow depth of field. To offset the increase in aperture, you would use a shorter shutter speed to reduce the light falling on the sensor. Again, the dual control of shutter speed and aperture comes into play.

Occasionally, when working in a dim environment, you may need to raise the shutter speed or narrow the aperture, thereby further limiting the amount of light reaching the sensor. You can offset this by increasing the camera's ISO (International Standards Organization) rating. For digital cameras, raising the ISO increases the output from the sensor so that an image can still be recorded at low light intensities. The cost is some image degradation. Usually the range of light that the sensor can record (i.e., the dynamic range) is reduced, and the image becomes granular—areas that should be rendered as smooth tones become speckled with blotches of color so definition is decreased. This is referred to as image noise.

When used in automatic modes (Auto, Auto+ or SCN), the A77 sets its own ISO. To change the ISO, you need to assume more control of the camera. The necessary adjustments are discussed in chapters 6 and 7.

What Is ISO?

ISO stands for the International Standards Organization. Historically, this term referred to the sensitivity of film to light. Today, it is associated with digital cameras and refers to how much gain can be employed to generate a brighter image. Technically, a sensor's sensitivity to light does not vary—it generates a signal that is proportional to the amount of light falling on it. However, the sensor has an amplifier whereby a weak signal can be increased by adjusting the camera's ISO number. By raising the ISO, you can capture images in dim light. To obtain the highest image quality with the Sony A77, we recommend using ISO 100. We do not hesitate to raise the ISO when working in dim light; however, we prefer not to use an ISO greater than 1600. For us, the compromise in image quality is too great.

White Balance and the Appearance of Colors

We live in a world of color, with our eyes and brain working together to help us identify hues correctly in all lighting conditions. Our vision works so well that we don't expect an object's appearance to vary based on its location—whether in direct sunlight, shade, or indoors under a desk lamp.

But when you're using a digital camera, the recorded image reflects the object's changing appearance under varying lighting scenarios. If nothing is adjusted within the camera, the same object when recorded under different lighting conditions will be recorded with different color shades. For example, indoor light turns white objects ruddy, while outdoor light keeps white objects white. To match our visual impression of what the object should look like, digital cameras have AWB (Automatic White Balance), which adjusts the balance of colors so that an object's hues appear the same no matter the lighting condition.

When the Sony A77 is used in Auto, Auto+, or a predefined scene mode, the camera sets white balance (WB) to AWB so it can automatically compensate for variations in lighting. For the most part, it does a good job of ensuring that colors appear natural. But, as you gain experience, you may want to control WB by going outside the automatic modes and setting the camera to P, A, S, or M. Once there, you can enter the WB function either by pressing the Fn button and selecting WB or by pressing the WB button on top of the camera. We describe this process in more details in chapters 6 and 7.

For the most part, the Sony A77 does an excellent job of rendering the object's colors, and you can always alter the WB later with image processing software. If you choose to go this route, be sure to save your files in RAW format.

Drive Mode Button

When you're taking pictures, the camera will fire either one shot for each press of the shutter button or a continuous set of shots for as long as you hold down the shutter button. To select which of these modes to use, press the Drive Mode button. This button sits on the top right of the camera (figure 2-3). The Drive Mode options (table 2-4) are displayed on the rear LCD screen. Toggle

Figure 2-3: Drive Mode button

the multi-selector up and down to move through the available options and then press the multi-selector button to select a Drive Mode. You can also reach the Drive Mode options through the Fn button. In this chapter, we only discuss the one shot and multiple shot options. Additional Drive Mode options are covered in chapters 4 and 6.

Drive Mode Option	Name	Description	Toggle Multi-Selector
☐	Single	One shot per shutter press	Up/Down
🖳 Hi	Continuous	3 shots/second while shutter is depressed	Up/Down then Left/Right
🖳 Lo	Continuous	8 shots per shutter while shutter is depressed	Up/Down then Left/Right

Table 2-5: Drive Mode options

Single Shooting

With the Single Shooting option, the camera fires once upon depressing the shutter button. Automatic focusing occurs in the instant just prior to taking the photograph.

You can select this function with one of two procedures. The first is to press the Fn button and navigate through the function menu using the multi-selector button. Select Drive Mode and press the multi-selector button to see your choices. Toggle the multi-selector button up and down through the options and select Single Shooting.

Fn>Drive Mode (left)>[Single Shooting]

The other method is to press the Drive Mode button. Look at the LCD screen; you will find yourself immediately in the Drive Mode function. Toggle the multi-selector button to select [Single Shooting].

Continuous Shooting

You can set your camera to fire multiple shots per second, which can be advantageous for action photography. When the camera is set to [Hi], it will take approximately 8 shots per second (figure 2-4). If it is set to [Lo], it will take 3 shots per second.

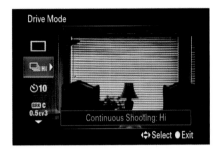

Figure 2-4: Continuous Shooting menu with Hi option selected

There are certain limitations. The image files are first transferred to an internal fast memory buffer and then passed to the removable memory card. This is a choke point, and the firing rate will sometimes slow until the memory buffer is cleared sufficiently to take the next shot. The rate of shooting can depend on how fast a memory card you have.

Fn>Drive Mode (left)>Continuous Shooting>[Hi], [Lo]

To select Continuous Shooting with the Fn button, find the option in the function menu and highlight it. Then select Continuous Shooting Hi or Continuous Shooting Lo by toggling the multi-selector button to the left or right.

Recording Movies

How to Take Movies

The Sony A77 is a hybrid, adept at taking either movies or still pictures. To start taking movies, press the MOVIE button and then release; you do not need to depress the button continuously. To stop recording, press the button again. Exposure via shutter speed, aperture, and ISO is set automatically.

The A77 also has a microphone positioned at the top of the camera to record sound, but noise from the focusing motor can also be picked up by the microphone. This is especially acute when using the older lenses from Minolta and Konica-Minolta whose focus is driven by a motor within the camera body. When using Autofocus, the noise from these lenses can be recorded on the soundtrack and drown out or interfere with the sound you want to record. To avoid this, turn the focus mode dial to MF. For modern Alpha lenses, the noise of the focusing motor is less obtrusive, but it can still be a problem. If it interferes with your sound recording, you can always switch to MF.

Transferring Movies to Your Computer

Before loading movies onto your computer, first install either Sony's PMB (Windows) or Apple's iMovie (Mac) software. Both of these programs work with high-resolution movies and can transcode high-definition AVCHD files.

If you don't have these programs, you can record your movies using the [MP4] option instead. You probably already have software on your computer that can view or work with MP4 files. On our Mac computers, we use QuickTime 7 Pro to work with MP4 files. QuickTime is also available for download to Windows computers.

MENU>Movie Shooting Menu (1)>File Format>[MP4]

Before you start to record movies, think about how you will be using them. If you intend to display them on your HDTV directly from the camera or burn them to a DVD or Blu-ray Disc, by all means record the files in AVCHD. If you are experienced videographer, this will be your preferred file format. If you are new to movies, we recommend you start out using either the PMB or iMovie programs. If you hook your camera to your computer with a USB cord, these programs will prompt you to download your movies.

If you intend to send your movie files to friends as email attachments or upload them to your web page, then follow Sony's recommendation to save the files as [MP4]. These files are not as highly compressed as AVCHD files, and, once transferred to your computer, they can be worked on easily.

Chapter 3: Managing Your Images

Introduction

The Sony A77's electronic display screens (LCD screen and viewfinder) serve two purposes. The first is to frame the subject, helping you to compose the image, check the focus, and ensure that the exposure and automatic modes are suitable for image capture. The second is to evaluate the picture or movie after it has been captured and then if needed, fine-tune the camera settings to ensure that subsequent images have the results you want.

Only one of the two display screens works at any one time. The viewfinder is enabled when the camera senses the presence of something, presumably your eye, near its window. When this happens, the viewfinder turns on and the LCD screen turns off. You can view either screen with the assurance that the battery is not being drained unnecessarily.

Although they both serve the same purpose, each display has its advantages. The LCD screen can swivel and extend out from the body of the camera. It allows you to view the subject conveniently while manipulating the camera's controls. The viewfinder blocks the outside light, enabling you to frame your subject when the lighting is too bright to view on the LCD screen. Be flexible and use whichever display provides the best results in a given situation.

This chapter covers how to preview and review your still pictures and movies, along with useful tools to evaluate your images and get the best results. As with everything associated with the A77, there is often more than one way of accomplishing your goals. It is best to experiment. Over time, you will develop preferences that work well for you.

The LCD Screen

The Sony A77 uses a large, high-quality liquid crystal display (LCD), composed of 921,600 dots, located on the back of the camera (figure 3-1). It has a diagonal measurement of three inches and is large enough to be viewed at arm's length. Unlike the viewfinder, you don't have to raise the camera up to your eye to see the LCD. Instead, you simply hold the camera, frame the picture, and press the shutter button.

The LCD screen's hinged display and ability to extend out from the camera body allow you to position the camera at almost any angle, an advantage when working in cramped or awkward locations. For example, to frame a creative photograph from ground level looking up, it may be necessary to rest the camera base on the ground. With the viewfinder, or even with a non-tilting LCD screen, you would have to lie down behind the camera. But the A77's tilting LCD screen can be adjusted so the screen faces up. Now you can comfortably view the screen from above and compose the photograph.

3

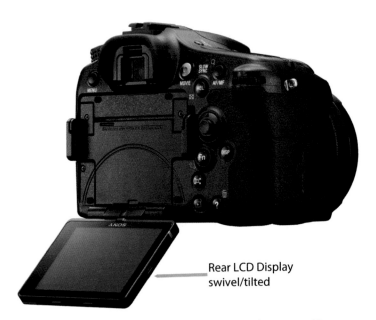

Rear LCD Display
swivel/tilted

Figure 3-1: Swivel capability of the LCD screen. Photograph courtesy of Sony.

You may find that extending the LCD screen out from the camera body gives you a better view of your subject. It is even possible to take a self-portrait by pointing the camera toward yourself and turning the LCD screen to face you.

Another advantage of the LCD screen is that you can see the camera commands and buttons simultaneously, making it much easier to navigate through the menu and function structure and to review stored pictures using the multi-selector. In addition, using the LCD screen often makes it easier to view your framed image when the camera is mounted on a tripod.

The Viewfinder

The Sony A77's electronic viewfinder consists of a small screen of 2,359,296 dots with a magnifier. It provides a Live View with the camera settings reflected in the image prior to taking the picture; its function corresponds to a DSLR optical viewfinder. In comparison, Sony's viewfinder provides an excellent, enlarged, and bright image, making composition easier. The viewfinder's magnifier allows you to conveniently view fine details. As described in chapter 1, you should focus the viewfinder to your eye by using the diopter adjustment dial.

 Unlike an optical viewfinder, you can display the camera's menu and function options in the A77's viewfinder, as well as graphical displays such as histograms. The multi-selector, plus the front and rear control dials, all function in the same manner as they do for the LCD screen. For example, when you review stored pictures and movies, you can use the multi-selector or the rear control dial to scroll through them. In most cases, when framing and reviewing pictures and movies, you will see the same data display formats as you do when you use the LCD screen.

3

 Unfortunately, viewing your subject on the LCD screen in bright light can be difficult. The controls for brightening the LCD screen are inadequate in full sunlight. Using the viewfinder is the way to go in such a situation. Since your eye is close to the viewfinder, your face shields the screen from bright light, enabling you to easily view your command options and subject. Another viewfinder advantage is the stability you gain by holding the camera against your face. This is invaluable when working with a long telephoto lens where the slightest tremor is magnified. Steadiness is even more critical when capturing movies, since every camera movement is recorded.

Viewing Pictures on the LCD Only

Some people find the A77's automatic switching from the LCD screen to the viewfinder annoying. For example, if your hand passes close to the viewfinder while setting commands, it may turn on the viewfinder and turn off the LCD. You can always turn off the automatic switching between the two display screens and have the LCD screen enabled exclusively. To do this, use the following command and set the value to [Manual]:

 MENU>Custom Menu (1)>FINDER/LCD Setting>[Auto], [Manual]

Press the FINDER/LCD button (top right of camera) to switch between using the LCD screen and the viewfinder.

Top LCD Display Panel

The camera has a second, smaller LCD screen called the Display panel on the top of the camera where you can quickly view several major camera settings (figure 3-2).

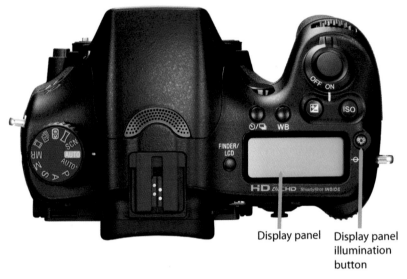

Display panel Display panel illumination button

Figure 3-2: Top of camera showing the Display panel and buttons

Some of the camera functions are also changeable through this panel by using the buttons on the top of the camera or by selecting them via the Fn button (table 3-1). When working in the dark, use the Display panel illumination button next to the panel to light the display.

Display Panel Data	
Display Data	**Control Data**
Shutter Speed	ISO Sensitivity
Aperture	Drive Mode
Flash Compensation	Exposure Compensation
Image Quality	White Balance
Remaining Battery	
Remaining Number of Recordable Images	
Image Quality	

Table 3-1: Display panel data

You have several options for navigating through the Display panel's control data. You can use the front and rear control dials to scroll through the function's available values. Their actions can vary. When selecting ISO for example, you will find that the rear control dial moves the ISO in 1/3 f-stop steps, while the front control dial moves in full f-stop steps. The rear control dial scrolls through each value one at a time, while the front control dial skips two values. Although this helps you get through the list quicker, you can end up passing over the value you want and having to switch back to the rear control dial to reclaim it. Instead, you might want to consider using the multi-selector to find and select your desired value.

Keep in mind that control data on the Display panel also shows on both the rear LCD and viewfinder display screens. For example, when you press the ISO button to change its value it can be altered by studying the changing values on either the Display panel or the rear LCD display screen.

Data Display Formats

Reviewing the camera settings prior to and after recording gives you the opportunity to adjust the settings and ultimately record a better image. The following sections cover data display formats prior to and after recording a still picture or movie. Become familiar with each format. You may find that different display formats work best with different scenarios.

Previewing Data Display Formats

The Sony A77 has two commands that control which data display formats are available on the LCD screen and viewfinder when previewing images prior to recording. DISP button(Monitor) controls the LCD screen and DISP button(Finder) controls the viewfinder.

> MENU>Custom Menu (2)>DISP Button(Monitor)>[Graphic Display], [Display All Info.], [No Disp. Info.], [Level], [Histogram], [For Viewfinder]

> MENU>Custom Menu (2)>DISP Button(Finder)>[Graphic Display], [Display All Info.], [No Disp. Info.], [Level], [Histogram]

3

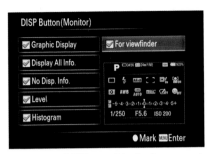

Figure 3-3a: DISP Button(Monitor) command positioned on [For Viewfinder]

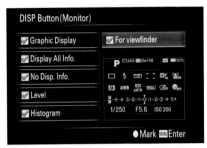

Figure 3-3b: DISP Button(Finder) command positioned on [Histogram]

Both commands show a list of data display formats with check boxes (figures 3-3(a-b). Toggle the multi-selector to move through the list. As you move through the available formats, a sample display screen shows in the lower right corner. Press the multi-selector button to check or uncheck an option. You can check from one to all of the options.

The following describes each of the data display formats:

- **Graphic Display**: Displays the full-size image plus two scales, shutter speed, and aperture, each with its current setting indicated on the scale as a vertical bar.
- **Display All Info.**: Displays the full-size image with the camera settings super-imposed around the border of the image.
- **No Disp. Info.**: Displays only the image.
- **Level**: Displays the full-size image plus the digital level gauge tool in the center of the screen. The gauge's indicator turns green when the camera is level hori-zontally and front to back.
- **Histogram**: Displays the full-size image plus the white live histogram in the lower right of the screen.
- **For viewfinder**: Displays only the camera settings without the image (figure 3-3a).

Once you select your data display formats, the DISP button controls cycling through them in order. For example, say you select [Display All Info.], [Level], and [Histogram] for the Monitor. Each time you press the DISP button while previewing a framed image, you will cycle through these three display formats. If you also select [No Disp. Info.], your framed image will be displayed on the LCD screen without any data the next time you press the DISP button after viewing [Display All Info.]. The display formats work the same way with the DISP Button(Finder) command except there is no [For Viewfinder] option.

Important points:
- The DISP button cycles through all of the checked DISP button options in order.
- The checked DISP options are not saved within a Memory group.
- Although DISP button command settings are utilized in all mode dial options, there are some exceptions:
 - The [Histogram] display format will be the same as [No. Disp. Info.] format for Movie, 3D Sweep Panorama, and Sweep Panorama mode dial options.
 - The [Graphic Design] display format will be the same as [No. Disp. Info.] format for 3D Sweep Panorama and Sweep Panorama mode dial options.
 - The [For viewfinder] display format will be the same as [Display All Info.] format for Movie, 3D Sweep Panorama, and Sweep Panorama mode dial options.

Reviewing Still Picture Data Display Formats

There are three data display formats available when reviewing your still pictures, including panoramas:
- With recording data (figure 3-4a)
- With histograms (figure 3-4b)
- Saved image only (figure 3-4c)

After you press the Playback button to review your saved pictures, press the DISP button to cycle through the three data display formats.

Figure 3-4a: Data display with recording data

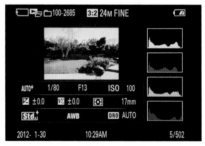

Figure 3-4b: Data display with histograms

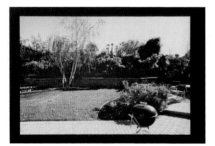

Figure 3-4c: Data display with saved image only

Each display layout has its benefits. The recording data superimposed around the edges of the image consists of the camera settings used to produce the image. This is invaluable when analyzing which camera settings work and which might need to be adjusted to improve the next shot.

The histograms view displays the intensity range of the color channels and the overall luminosity of the recorded picture. Thus, you are able to see if the overall light intensity, or one or more colors (red, green, or blue), is under- or overexposed. The last format gives you the opportunity to see the image without being distracted by superimposed data.

You will also see any overexposed, blown-out areas blinking from white to black and any underexposed, dark areas blinking from black to white. This is an excellent way to determine what part of the image was not recorded with the best exposure.

Reviewing Movie Data Display Formats
Unlike still pictures, only two data display formats are available when reviewing movies. After you press the Playback button, press the DISP button to cycle through the following formats:
- With recording data
- Saved movie only

The data display format is applied only on the first frame prior to playing the movie back. Once the movie is initiated, the display format disappears.

Preview Images

Compositional Controls
In addition to data, the camera can project lines and grids onto the screen to aid you in composition. These overlays can help you align and frame your pictures and movies. They are not recorded or visible when the file is played back.

Use the following command to set these lines and grids:

MENU>Custom Menu (2)>Grid Line>[Rule of 3rds Grid], [Square Grid], [Diag. + Square Grid], [Off]

The three grid line options each have specific patterns and benefits. The [Rule of 3rds Grid] pattern consists of a 3 x 3 array of rectangles (figure 3-5). This pattern allows you to position the main subject one-third or two-thirds of the way up from the bottom, down from the top, or from either side of the screen. The [Square Grid] pattern divides the screen into 6 x 4 squares to help you make sure the picture is well balanced and

not tilted. The final pattern, [Diag. + Square Grid], divides the screen into 4 × 4 rectangles with diagonal lines radiating from the center to each corner, which helps you center the image in the frame.

No grid lines show when the command is set to [Off].

All three grid patterns are useful in architectural photography and in scenic shots with a horizon. They help you avoid canting the subject by providing

Figure 3-5: Rule of 3rds grid superimposed on framed image

an alignment guide for buildings and the horizon. The pattern you use depends on where you wish to position the subject within your picture.

Magnifying Images During Preview

The Focus Magnifier button (figure 3-6) has two functions: magnifying the image to better select the framed detail and determine whether it is in focus; and magnifying the image to save a cropped version of the original. Both of these processes are controlled by the Smart Telecon. Button command:

> MENU>Custom Menu (3)>Smart Telecon. Button>[Smart Telecon.], [Focus Magnifier]

The first thing to keep in mind is that the [Smart Telecon.] option magnifies the previewed image only when the Quality command is set to a JPEG only format. If you are shooting in RAW or RAW&JPEG format, you must set the Smart Telecon. Button command to [Focus Magnifier]. In addition, the [Smart Telecon.] option magnifies the preview image considerably less than the [Focus Magnifier] option; plus, the [Smart Telecon.] option does not let you move around within the magnified image to view specific portions like you can with the [Focus Magnifier] option. These two features are covered in more detail in chapter 6.

Focus Magnifier (Smart teleconverter) button

Figure 3-6: Focus Magnifier and Image index buttons

Review Recorded Images

Displaying Recorded Images

Once you have recorded a still picture or movie, you should review the results. This will give you the opportunity to retake the picture or movie before moving on. There are a couple of tools to help you do this. Keep in mind that when we refer to still pictures, we include both types of panorama shots.

Auto Review or No Auto Review

The Auto Review command allows you to view a picture immediately after it is taken and before you take the next picture. You can choose to display the picture for 2, 5, or 10 seconds, or not at all by using the [Off] option.

> MENU>Custom Menu (2)>Auto Review>[10 Sec], [5 Sec], [2 Sec], [Off]

You are returned to Live View automatically when the display time has elapsed or when the shutter button is pressed.

There are times when you might find it advantageous to turn this command to [Off] so that the camera returns to Live View immediately after taking a picture. This saves battery power and eliminates any interruption from taking pictures.

Reviewing Files with the Playback Button

You can review your still pictures using either the Slide Show command, discussed later in this chapter, or the Playback button, which puts the camera in playback mode. Movies and MP4 files can only be reviewed through the Playback button.

The type of file displayed—i.e., still pictures or movies—depends on two controls. When you press the Playback button, the last type of image recorded dictates the images that will be displayed. If the last image recorded was a movie, only movies will display for your review. If the last image recorded was a still picture, then only still pictures will display.

To change which image type will be displayed the next time you press the Playback button, use the following menu command:

> MENU>Playback Menu (1)>View Mode>[Folder View(Still)], [Folder View(MP4)], [AVCHD View]

Initially, each value displays the selected group's saved images in groups of four. Toggle the multi-selector to navigate through the images. The vertical bar on the right side of the screen changes as you move through the images, indicating the relative position of the displayed images within the total number of images saved on the memory card. The vertical View Mode bar on the left side controls the View Mode. For example, if you are displaying movie files and now want to review still pictures, toggle to the View Mode bar and press the multi-selector button. When the View Mode menu displays, select the [Folder View(Still)] option. Press the Playback button to display saved still pictures instead of saved movies.

Of course, you can always just snap a still picture to reset the Playback button's image type. Either way, keep in mind that saved files are reviewed based on file type.

Playing Back Still Pictures

Once you know you are positioned to display still images, press the Playback button. Either the last recorded or the last played back still picture will be displayed first. Toggle the multi-selector right to display the next saved picture or left to move backwards through them. Note that the displayed images wrap around as you continue to toggle the button (i.e., they start from the beginning). Remember to use the DISP button to view the images' stored recorded data through the different data display formats.

Playing Back MP4 or AVCHD Movies

Only the first frame of a movie is seen as you cycle through the memory card files in playback mode. Press the multi-selector button to initiate the movie. Whatever data display screen format was selected disappears, and the selected movie plays. Pressing the DISP button toggles between just playing back the movie and playing back the movie with showing operational information including playback status, the playback bar indicating the playback's position, the number of seconds played, and icons representing rewind, pause, fast forward, etc. (table 3-2).

Keep in mind that playing back a movie can mean automatically playing back multiple specific View Mode movies stored on the memory card. For example, if you have three saved AVCHD movies and the camera is positioned on the first one, initiating playback will play it and the two subsequent movies in succession.

3

| MP4 and AVCHD Movie Playback Navigation Operations ||
Function	Multi-Selector/Front or Rear Control Dial Operation
Play/Pause	Press the multi-selector button to initiate playback of the movie. Continue to press the multi-selector button to switch between the Play and Pause functions.
Stop	Press the shutter button to terminate the movie playback.
Fast Forward	While the movie is playing, press the multi-selector button to pause it. Then toggle to the right. Note playback will continue through all of the movies after the current movie.
Fast Rewind	While the movie is playing, press the multi-selector button to pause it. Then toggle to the left. The movie plays back by skipping several frames at once and therefore has a jerking look. Note playback will continue through all of the movies before the current movie.
Slow Forward	While the movie is playing, press the multi-selector button to pause it. Then rotate the front or rear control dial to the right. Note playback will continue through all of the movies after the current movie.
Frame-by-Frame Rewind	While the movie is playing, press the multi-selector button to pause it. Then rotate the front or rear control dial to the left. The movie plays frame-by-frame backwards and has a jerking look. Note playback will continue through all of the movies before the current movie.
Reduce or Increase Volume Level	Toggle the multi-selector downward to initiate volume change. Once the volume control vertical bar is displayed on the right side of the screen, toggle the multi-selector downward to decrease the volume or toggle upward to increase the volume.
Display Operational Information	Press the DISP button to display movie information: playback status, playback bar, number of seconds played, date recorded, number of the movie file currently playing (out of the total number of movie files), and available operational controls. Note that different operational controls display depending on whether the movie is playing or paused.

Table 3-2: MP4 and AVCHD movie playback operations

Reviewing Multiple Pictures and Movies

You can view up to nine images within a folder at one time. Press the Image Index button (figure 3-6) while in playback mode. A group of four images displays on the screen. Press the DISP button once, and the group of displayed images increases to nine. Press the DISP button again to switch back to viewing only four images. If you wish to view a specific image's camera settings, toggle the multi-selector to

navigate to the image and then press the multi-selector button. The camera then shows only the selected image, and the DISP button cycles through the checked data display formats.

As with playback mode, images in the last recorded folder are displayed when you press the Image Index button. To change View Mode to another type of image, toggle to the left vertical bar and press the multi-selector button. The View Mode menu is then displayed with the current folder highlighted. Select another type of folder to display its recorded images.

Reviewing Still Pictures with the Slide Show Command

The Slide Show command plays all of your 2D still pictures on your camera or, using a connector cable, to a compatible TV in sequence starting with either the last played back or recorded still picture. This command is unavailable for AVCHD or MP4 movies and therefore is only enabled when the last image saved is a picture or when the View Mode command is set to [Folder View(Still)].

To build and execute a slide show, navigate to the following command:

MENU>Playback Menu (1)>Slide Show>[Repeat], [Interval], Image Type]

Once you enter the Slide Show command, you will see three submenus: the current settings for Repeat, Interval, and Image Type; the [Enter] menu option; and the [Cancel] menu option (figure 3-7).

Figure 3-7: Slide Show command options

The Repeat [On] option enables the slide show to loop back through the pictures continuously. The [Off] value executes the slide show only once and then exits to Live View.

> MENU>Playback Menu (1)>Slide Show>Repeat>[On], [Off]

The Interval option allows you to set the length of time each picture is displayed from 1 to 30 seconds.

> MENU>Playback Menu (1)>Slide Show>Interval>[1 Sec], [3 Sec], [5 Sec], [10 Sec], [30 Sec]

The Image Type option allows you to include either all of your still pictures or only the 3D Sweep Panorama images saved on your memory card.

> MENU>Playback Menu (1)>Slide Show>Image Type>[All], [Display 3D Only]

To initiate the slide show, select the [Enter] option and press the multi-selector button. Select the [Cancel] option to exit the Slide Show command.

Once a slide show begins, you have a couple of additional options. Toggle the multi-selector right and left to move forward or backward through the slide show. The slide show resumes with the selected interval once you stop toggling. There is no way to pause the slide show.

To terminate the slide show, either press the shutter button to return to Live View, or press the multi-selector button to stop the slide show and enter playback mode starting with the displayed image. At this point, the still picture data display formats are at your disposal when you press the DISP button.

Keep in mind that the Slide Show command only includes still images saved on the inserted memory card. Therefore if you need a permanent show, you must download your pictures to your computer and then use the PMB (Picture Motion Browser) or other third-party software to build a new slide show.

Zooming In on Recorded Images

Just reviewing a recorded picture is not always enough to determine if it's a keeper. Sometimes you need to zoom in to see if the fine details within the image are sharp. You can do so when the camera is in playback mode by pressing the AF/MF button, which becomes the Enlarger button (figure 3-8). Once the image is enlarged, a box containing a picture of the original image is superimposed in the lower quadrant of the screen. Within this is a small red box indicating the portion of the original image that is enlarged (figure 3-9).

Turn the rear control dial to zoom in or zoom out of the picture. Four arrows surrounding the enlarged image indicate the directions in which you can move the displayed portion by using the multi-selector.

3

AF/MF button

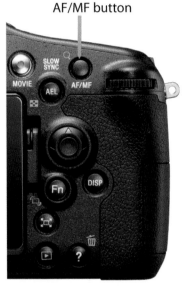

Figure 3-8: AF/MF (Enlarger) button. Note the magnifying glass icon

Figure 3-9: Magnified image with original image box superimposed

There may be times when you have taken multiple shots of the same image and you want to pick the sharpest of the bunch. You can zoom in on one image and then compare the same enlarged section in each of the other saved images. To do this, put the camera into playback mode, display the first image, and magnify the portion you want to review. Turn the front control dial to the right to advance to the next saved image or to the left to move to the previously saved image. In either case, the enlarged section remains constant as you view the preceding or succeeding image. Using the front control dial, you can change the magnification and/or move to another portion within the image, and the new position will be carried over to the next displayed image. This makes it easy to assess the sharpness of your images.

Evaluating Exposure with Histograms

The histogram is a tool that helps you evaluate your images' exposures. It's a graphical representation of the distribution of light intensities recorded by the sensor. Intensity values are represented on the horizontal axis (black to white), while the numbers of pixels are represented on the vertical axis.

Theoretically, the histogram has the shape of a classic bell curve whose maximum is near the center, indicating that most of the image's pixels have a brightness level in the middle—not too bright, not too dark. Figure 3-10 shows three histogram plots taken from the Sony A77 LCD screen.

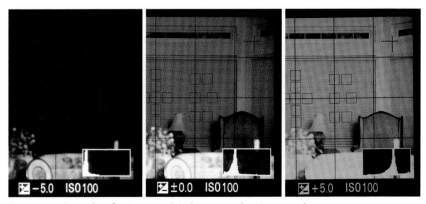

Figure 3-10: Examples of an image with its histogram showing an underexposure, a proper exposure, and an overexposure

The far left histogram indicates that the image is underexposed, meaning not enough light is hitting the sensor; the middle histogram belongs to a properly exposed image; and the far right histogram indicates that the image is overexposed, meaning too much light is hitting the sensor.

As you do more photography, you will notice that many histograms have multiple peaks, none of which are centered on the horizontal axis. This does not necessarily indicate poor exposure. Instead, you should watch for large numbers of pixels appearing at either end of the graph, which would indicate an out-of-balance lighting situation that might need to be fixed to get a properly exposed picture. A large number of pixels pushed up against the extreme right or left of the graph (i.e., clipped), indicates maximum intensity or minimum intensity respectively. Either way, you will have problems—at the extreme right, the image will have burned-out highlights, and at the extreme left, the image will have black shadows that lack detail.

To display the histogram during preview, make sure the Histogram data display format box (figure 3-11) is checked in both of the following commands:

MENU>Custom Menu (2)>DISP Button(Monitor)

MENU>Custom Menu (2)>DISP Button(Finder)

As stated earlier, the histogram will not be displayed when previewing movies or panoramas.

Figure 3-11: Histogram box checked

Keep in mind that the histogram represents how the camera is measuring light at the current moment. The histogram will most likely change when the lighting changes, or when you change the camera's settings or reframe the image. In addition, you may find that image results cannot always be determined by previewing the histogram when you are using flash or dealing with low light situations.

Histograms also allow you to evaluate an image's exposure in playback mode, after it has been recorded. Here along with the overall white histogram, you will have additional color channel histograms (red, green and blue) to better determine the image's exposure. When you view individual color channel histograms, look for the curve shifted to the left or the right. This will let you know if a specific color is under- or overexposed, respectively.

Studying color channels is important because red, green, and blue channels have different sensitivities to light. If one channel goes into over- or underexposure, as evidenced by its histogram, your picture may take on a color cast. The luminosity (white) histogram may miss this detail. Luminosity is at best an averaging of light intensities, which is made up of intensities from the red, green, and blue photo sites. For example, underexposed images show intensity values accumulating and spiking on the left border of the graph. This can be corrected by reshooting with an increased exposure. The reverse is true for overexposure.

Protecting Saved Pictures and Movies

Have you ever intended to save a picture and inadvertently deleted it? It's pretty upsetting when that happens. The Protect command allows you to indicate which images cannot be deleted by the camera's Delete functionality.

MENU>Playback Menu (1)>Protect>[Multiple Img.], [Cancel All Images]

1. Use the [Multiple Img.] option to select images to protect. The saved images are displayed with a check box on the left side.
2. Scroll through the images using the multi-selector. Press the multi-selector button to indicate that the image should be protected. A check mark is entered in the box. To uncheck, press the multi-selector button again.
3. Press the MENU button to exit the displayed images. Select [OK] to save the Protect indicators; select [Cancel] to return to the displayed images.

To unprotect images, either re-enter the Protect command and uncheck the boxes one at a time, or execute the [Cancel All Images] option to clear all of the Protect indicators.
Important points:
• The Protect command is enabled only if there is at least one image stored on the memory card.
• Protected images are deleted when reformatting the memory card using the Format command.

Deleting Saved Pictures and Movies

Not every picture or movie is going to be a keeper. As you view the saved images on the camera, you may want to delete one or more.
There are multiple ways to delete files.
1. While in playback mode, use the Delete button to delete one image at a time. The Delete function menu will be displayed with [Delete] and [Cancel] options. Select [Delete] to delete the file. [Cancel] will close the Delete function menu.
2. Use the Delete command in the Playback menu to delete multiple images:

MENU>Playback Menu (1)>Delete>[Multiple Img.], [All in Folder]

The [Multiple Img.] option will display saved images one at a time with a check box on the left side of the screen if the file is unprotected. Use the multi-selector or rear control dial to scroll through the saved images. Press the multi-selector button to insert a check within the box to mark the saved image for deletion. Press the MENU button when done. Select [OK] to complete the deletion process; [Cancel] to return to the Delete process.

When the [All in Folder] option is selected, the follow message will be displayed: "Delete all images in this folder?" [Delete], [Cancel]

The folder represents still pictures, AVCHD, or MP4 movie files. Select [Delete] to delete all of the images in the displayed folder. Select [Cancel] to exit the Delete process. The Delete function pertains only to unprotected, saved files on the memory card.

3. Reformat the memory card to delete all saved files:

MENU>Memory Card Tool Menu (1)>Format>[Enter], [Cancel]

Executing this command will delete all stored files (even protected files) on the memory card.

Important points:
- The Delete command is enabled only if there is at least one image stored on the memory card.
- When you delete a saved file, it is permanently gone from the memory card.

Working Outside the Camera

Overview

There are many ways to view and manage your pictures and movies outside the camera. You can play them as slide shows on your computer or TV, print the pictures, email them, and add them to your personal website. As technology evolves and new inventions are developed, you will most likely want to move your pictures and movies to those new arenas.

The technology you use depends on your available equipment and software, as well as your level of knowledge. Rather than go into the details of how to use various technologies, we recommend that you consult your other equipment and software manuals, along with their corresponding websites, for specific information on how to accomplish your goals.

Downloading Pictures and Movies to Your Computer

Eventually you will want to download your pictures and movies from your camera's memory card to another device, most likely your computer, and then delete them from your memory card. Sony supplies Image Data Converter and PMB software to help you manage your files on your computer and create lasting files for you to share and view. Of course, you can use third-party software instead, such as Apple iLife or Adobe Photoshop Elements.

There are two ways to download your picture and movie files to your computer. The first way is to use the supplied USB cable. Insert the cable into the mini-USB port on the camera and into the USB port of your computer. Typically, if you have installed Sony's Image Data Converter and PMB software on your computer, a prompt will pop up on your computer monitor with options to copy the camera files to your computer. This is a straightforward process, but it uses the camera's battery to move the files. If you deplete your battery during the download, you may corrupt and lose your files. So, if you use this download method, make sure you have a fully charged battery.

The second way is to download the files directly from the memory card. You can remove the card from your camera and insert into a card reader connected to your computer's USB port. Card readers are devices that have a slot for one or more types of memory cards. Sometimes you don't even need a card reader; many laptop computers have an SD card reader built into the chassis. You simply insert the memory card into your computer and start your download. Again, if you have a PC with Image Data Converter and PMB software, you will see prompts to save your files onto your computer. After the files are downloaded, you can organize them, edit them, and display them.

If you want to process your files and use more advanced controls than those provided by the Sony software, you can use proprietary software. Apple's Aperture and Adobe Lightroom are two programs that provide a way of organizing and manipulating images. For the most advanced user, one might wish to buy Adobe Photoshop. These programs cost at least $200 and if one wishes to use an inexpensive package (less than $100) one should consider Adobe's Elements ($80) or Apple's iPhoto '11. There are even two free choices for either Windows or Macintosh computers: Picasa (http://picasa.google.com) and GIMP (www.gimp.org).

Delivered Sony A77 Software

Your Sony A77 camera is delivered with a CD containing two software applications: Image Data Converter and Picture Motion Browser (PMB). Both applications work with RAW and JPEG files, but to varying degrees. Image Data Converter works mainly with RAW files and allows some minor image processing of JPEG still pictures. PMB works mainly with JPEG files plus AVCHD and MP4 movies, while allowing some very minor manipulation of RAW files.

Image Data Converter works on either PCs or Macs, while PMB is only for PCs. To use either program, you will need to install the software onto your computer. If you are not already using third-party image processing programs, try these out and see if they suit your needs.

We prefer using third-party software for working with our images, since such programs execute commands faster than Image Data Converter. However, if you're shooting in RAW format, Image Data Converter allows you to get the best quality images from your Sony A77 as soon as you receive the camera. With third-party software, you first need to make sure your software is current and capable of translating your Sony RAW files.

Image Data Converter

Image Data Converter is image-processing software that works with Sony RAW so you can adjust ISO, WB, and DRO. You can also apply Creative Styles and add shading compensation, sharpness, and noise reduction along with some other image processing functions. The software also lets you do some minor image processing to JPEG files, such as rotating an image and adjusting its tone curve.

If you are not already familiar with a third-party image-processing program, Image Data Converter is definitely something to try out. We find it capable of producing excellent results, but also find it to be very slow and not as easy to use as Photoshop or Aperture. Then again, Image Data Converter comes with the camera at no additional cost. We have worked with it on a Dell computer with a quad core processor (i5) and a MacBook Pro with a dual core processor. In both instances, the program was workable, but it took a second or two to execute a function or open a pull-down menu.

Picture Motion Browser (PMB)

You can download your images (pictures and movies) onto your computer using PMB software. The program lets you organize and maintain files in folders. Not only can you view your files by name or file type, or as thumbnails, but also you can organize your files via a calendar structure.

PMB is intended mainly for image processing JPEG and movie (AVCHD and MP4) files. You can adjust brightness, color saturation, image sharpness, tone curve, and

red-eye reduction, plus you can crop and rotate your JPEG still pictures. You can add date information and visually organize your saved files by date on a calendar. The software even allows you to view GPS locations captured with the camera. In regard to movies, PMB allows you to combine and/or edit both AVCHD and MP4 files.

Although you can download your RAW files in PMB, it allows for only minor manipulations. Instead, PMB supplies a direct link to Image Data Converter so you can conduct more complex image processing tasks on your RAW files there.

One more important PMB feature is that you can create slide shows consisting of still pictures and movies, all of which can be viewed on your computer, exported, or written to discs.

Playing Pictures and Movies on Your TV Screen

The Sony A77 can be connected directly to your TV. Use the supplied AV cable to connect to a non-HDTV or purchase an HDMI cable to connect to an HDTV. The way in which you link the camera to the TV depends on the age, brand, and type of TV you have. We recommend that you consult both the camera and TV manuals, as well as the manufacturers' websites, to get up-to-date information.

After the camera is connected, you can play your slide shows on your TV. One advantage of viewing your slide show on a wide-screen HDTV is the huge screen size as compared to the camera's LCD screen. This makes it possible to comfortably show your pictures and movies to several friends at once. You will be able to better appreciate the definition, color, and contrast of your pictures and movies when they are viewed on a large screen rather than on the small LCD screen on the back of the camera.

To view 3D Sweep Panorama images, you must connect your camera to a 3D-capable TV and have 3D glasses available. Once connected, initiate 3D play-back with the following command:

MENU>Playback Menu (1)>[3D Viewing]

Initiate playing back your 3D images by pressing the multi-selector button, and then toggle right and left to advance to the next image or return to the previous image. Toggle down to exit the 3D playback.

Things you should know:

- [3D Viewing] is not enabled unless the camera is connected to a 3D-capable TV.
- Only 3D Sweep Panorama images play back with this command.

Printing Your Pictures

You can manage printing your images on your own with third-party software or utilize the Specify Printing command in the Sony A77:

MENU>Playback Menu (1)>Specify Printing>[DPOF Setup], [Date Imprint]

This command formats your selected images utilizing the common DPOF (Digital Print Order Format) protocol. The [DPOF Setup] option displays a check box on the left side on each eligible saved image. Still pictures saved as RAW files and movies are not eligible for printing. Using DPOF is advantageous if you do not have a computer or a printer. You can take your memory card to a printing service and they can use the information directly from the card to generate your selected prints. It should be noted that the memory card can be inserted directly into some manufacturers' inkjet printers and use the DPOF data to generate your selected prints. Utilizing this function is straightforward with the following steps:

1. Enter MENU>Playback Menu (1)>Specify Printing>DPOF Setup>[Multiple Img].
2. Select [Enter] option to initiate the process; [Cancel] to exit.
3. The memory card's first saved image is displayed on the screen. Only DPOF-printable images have a check box displayed on the left side of the screen.
4. Toggle the multi-selector right or left to scroll through the displayed images. When you identify an image you wish to print, press the multi-selector button. A check mark will appear within the box. Press the button again to uncheck the box if you change your mind.
5. Once you identify all of the images you want to print, press the MENU button. Select [OK] to save the DPOF indicators; [Cancel] to exit back to the displayed images with the DPOF indicators.
6. Enter MENU>Playback Menu (1)>Specify Printing>Date Imprint>[On] if you wish to include the image's recorded date on the prints.
7. Select the [Enter] option to initiate the process, and press the shutter button halfway to exit; select [Cancel] to exit.

Important points:
- DPOF specifications will be visible on your saved images after printing. To re-move them, either re-enter the Specify Printing command and uncheck the print indicator at the individual image level, or execute MENU>Playback Menu (1)>Specify Printing>DPOF Setup>[Cancel All] to erase all DPOF specifications.
- The Specify Printing command is available only for JPEG still pictures.
- You cannot select RAW files.
- You cannot specify the number of prints at the image level.
- The Specify Printing command is enabled only if there is at least one image stored on the memory card.

Recommendations

We leave automatic switching [On] from the LCD screen to the viewfinder and back. This way, we can quickly switch between the two display screens without making a change through the menu structure or pressing the LCD/FINDER button.

We usually set the Auto Review command to [Off]. Most of the time, we shoot a series of pictures and then review them as a group. Some of the pictures take only a second to review; some take longer. Setting Auto Review to [Off] puts the review process in our hands, plus it eliminates the constant drain on the battery.

It might seem like overkill, but we have concluded that it is best to select all of the data display formats for previewing the images. Although we have our preferences, we find that we use each of the display formats at least occasionally. Therefore, checking them all gives us the flexibility to use what we want. If we decide we need the Level gauge, it is already available. All we have to do is press the DISP button to get to the desired format.

We recommend that you review the histograms frequently. They are excellent windows into your image's exposure, both before and after recording. We use histograms often, especially in the camera's semi-automatic and manual modes.

We set the grid line command to the [Rule of 3rds Grid] option. This option helps us balance the image's composition with a minimal number of lines. The grid lines are prominent enough to see when you want and faint enough to overlook when you don't.

We are judicious about deleting files while photographing in the field. We occasionally weed out unacceptable images via the camera but find it much easier to do this cleanup process later, when we view the images on our computer. To minimize the chance of being caught short on memory, we download the pictures to our computer after each photo shoot and then do a bulk erasure or reformat the memory card. This saves us time and camera battery power.

It is amazing how quickly you can fill up a memory card, especially if you are taking movies. Since memory card costs keep decreasing, we recommend having a second or even a third memory card available. Without an extra card, you may end up having to spend your time reviewing and deleting saved images instead of taking pictures.

Most likely you are going to rely on your computer to manage your photos and movies. This may sound obvious, but get in the habit of downloading your pictures and movies to your computer soon after they are recorded when your memory is still fresh.

Last, but not least, use your computer to build slide shows using either Sony's Image Data Converter and PMB software or third-party software. Then store the results on a DVD so you can play back your saved memories on your computer or TV. An added benefit is that you can make copies of your DVDs to share with friends and family.

3

Chapter 4: Automatic Settings

Introduction

The way in which you use the Sony A77 depends on your level of expertise, your desire to control various aspects of picture taking, and the degree of creativity you want to introduce. You can take technically excellent pictures and movies using the Auto and Auto+ modes with minimal knowledge and no prior photographic experience. The camera's software allows you to point and shoot while the camera automatically determines the most efficient aperture, shutter speed, ISO, and autofocus mode.

Auto+ Mode goes a couple of steps further than Auto mode. Auto+ mode automatically tries to identify whether the subject belongs within a list of scene types and then determines the proper aperture, shutter speed, ISO, and autofocus mode. In addition, Auto+ mode identifies the best shooting function for the scene and automatically applies the settings. These two additional features give Auto+ a big edge over Auto mode.

Essentially, in Auto+ mode the camera identifies the scene type in order to optimize camera settings. For example, a person sitting indoors is photographed with the focus set on the face and with red-eye flash reduction, while a landscape is photographed with a slow ISO, small aperture, and slow shutter speed to record an expansive view with maximum fidelity.

While Auto+ Mode does its best, scene recognition is not 100 percent accurate. You may decide to take over and use the camera's predefined scene modes. Turn the mode dial to SCN and select a scene type for the camera's software to apply.

This chapter covers the camera's automatic modes: Auto, Auto+, and SCN. But first, we cover several functions available through the Fn button (page xv, figure C). When you press the Fn button, two columns of functions display: one on the right side and one of the left (figure 4-1). The functions displayed on the left side (excluding the AF area, which is discussed in chapter 6) are available in all of the automatic modes, making this the best time to discuss them.

Figure 4-1: Fn button's displayed function icons

Functions Available for Automatic Modes

Only 5 of the 15 functions accessible through the Fn button are available when the mode dial is set to Auto, Auto+, or SCN. In some cases, not all of the options within each function are available. Although we cover them here for continuity, we refer to them again in chapters 6 and 7 when discussing P, A, S, and M modes.

Drive Mode Function

The function seen on the top left is Drive Mode. This function allows you to specify how the camera will act when you press the shutter button fully. You can also initiate the function using the Drive Mode button on the top of the camera (see figure B page xiv).

There are many available options in Drive Mode, each with a specific use. Several of the options have submenus of their own. Table 4-1 lists each option along with a brief description.

Drive Mode Option	Option Name	Description
▢	Single Shooting	Camera fires one shot per press of the shutter button.
⧉⧘	Continuous Shooting	Camera shoots continuously as long as the shutter button is held down and the memory card has room to store the images. Camera maintains the selected firing rate until the buffer is filled. At that time, the buffer throughput constraints will determine how fast the camera fires.
Sub-Options	Hi	Rate = 8 pictures/sec. The camera is not in Live View mode between pictures. Instead, it displays the previously recorded image in between shots.
	Lo	Rate = 3 pictures/sec. The camera is in Llive View mode between shots.
⟳	Self-Timer	Delays firing the camera after the shutter button is pressed.
Sub-Options	10	10-second delay. Use this option when you need to get into a group shot.
	2	2-second delay. Use this option when you don't have a cable release and you want to ensure that camera shake caused by pressing the shutter does not affect your picture.
BRK C	Continuous Bracket	To activate, press and hold down the shutter button. This function takes a series of 3 or 5 shots with the EV (f-stop) varied +/ - by the selected amount. The sequence of shots is determined by the MENU>Custom Menu (4)>Bracket order value. When Flash is activated, this option automatically operates as Single Bracket in order for the flash to adjust properly.
Sub-Options	nEV3 where n = 0.3, 0.5, 0.7, 2.0, or 3.0	3 shots are taken with the n EV increment.
	nEV5 where n = 0.3, 0.5, or 0.7	5 shots are taken with the n EV increment. Note: there is no 5-shot option with the 2.0 or 3.0 EV interval.

Drive Mode Option	Option Name	Description
BRK S	Single Bracket	This function takes 3 or 5 shots based on the same exposure step and bracket order values as Continuous Bracket—with one major difference. Instead of holding down the shutter button, you must press the shutter button once for each shot.
Sub-Options	nEV3 where n = 0.3, 0.5, 0.7, 2.0, or 3.0	3 shots total are taken with the n EV increment. Remember, you must press the shutter button for each shot.
	nEV5 where n = 0.3, 0.5, or 0.7	5 shots total are taken with the n EV increment. Note: there is no 5-shot option with the 2.0 or 3.0 EV interval. Remember, you must press the shutter button for each shot.
BRK WB	White Balance Bracket	Shifts the selected white balance's color temperature plus/minus 10 or 20 MK^{-1}. Negative MK^{-1} takes the image's color toward green/blue. Positive MK^{-1} takes the color toward yellow/red. MK^{-1} stands for Mired, which is a unit of color temperature.
Sub-Options	Lo	Shifts the color temperature by plus/minus 10 MK^{-1}.
	Hi	Shifts the color temperature by plus/minus 20 MK^{-1}.
BRK DRO	DRO Advance Bracket	DRO (Dynamic Range Optimization) sets the DR function to DRO Auto. The camera analyzes the contrast of light and shadow in the image, averages it, and then boosts the contrast where needed to result in a bright, smooth image. The camera shoots one image and generates three saved images, each at a different contrast level.
Sub-Options	Lo	Executes DRO Auto and creates 3 saved images using Lv 1, Lv 2, and Lv 3 options.
	Hi	Executes DRO Auto and creates 3 saved images using Lv 1, Lv 3, and Lv 5 options.
📡	Remote Cdr. (Commander)	When this option is selected, the camera expects the shutter button to be triggered using a Wireless Remote Control. Sony sells a remote control unit that works for both your Sony A77 camera and for attaching your camera to your TV. Camera autofocuses first when the following command is initiated: MENU>Still Picture Menu (3)>Priority setup>[AF]. This allows you to be away from the camera when initiating a shot.

Table 4-1: Drive Mode function options

The Drive Mode function is not available in Continuous Advance Priority AE, Sweep Panorama, 3D Sweep Panorama, or SCN Hand-held Twilight modes. Although you can change the Drive Mode while in Movie mode, the setting is not applied. You will see the changed Drive Mode value when you next switch the mode dial off of Movie and to another option where the Drive Mode value is valid.

In addition, some of the Drive Mode options have limited availability within modes. The Single Shooting, Self-timer, and Remote Cdr. options are the only Drive Mode options available in Auto, Auto+, and SCN modes (excluding Hand-held Twilight). The Continuous Shooting option is available in Auto and Auto+ but not in SCN. The remaining options—Continuous Bracket, Single Bracket, White Balance Bracket, and DRO Advance Bracket—are disabled in Auto, Auto+, and all SCN predefined modes. Another limitation is that Drive Mode is disabled when the DRO/Auto HDR function's [Auto HDR] is selected.

Flash Function

You can find the Flash function as follows:

Fn>Flash (left)>[Flash Off], [Autoflash], [Fill-flash], [Rear Sync.], [Wireless]

The Flash function allows you to specify how and when the flash will fire in order to give your subject the type of lighting you want. Table 4-2 lists each of the options along with a description and whether or not it is enabled. The Sony A77's flash is covered in detail in chapter 9. Keep in mind that only Flash Off, Autoflash, and Fill-flash are enabled when in Auto, Auto+, and selected SCN predefined modes. See table 4-2 for the specific SCN predefined modes.

Flash Option	Option Name	Description
⨂	Flash Off	Prevents the flash unit from firing. This option is disabled in P, A, S, M, and SCN's predefined Night Scene, Hand-held Twilight, and Night Portrait modes.
⚡ AUTO	Autoflash	The camera decides when the flash is needed. The flash unit automatically pops up and fires at low light levels. If the flash is up in Auto or Auto+ and you go to a brighter lighting condition, it does not fire unless the camera decides more light is needed. This option is enabled only in Auto, Auto+, and SCN's predefined Portrait, Macro, and Night Portrait modes.

Flash Option	Option Name	Description
⚡	Fill-flash	When this option is selected, the flash always fires, providing light to the subject. In Auto or Auto+, if the flash unit is down, it pops up immediately when you apply slight pressure on the shutter button. This option is available only in P, A, S, M, Auto, Auto+, and SCN's predefined Portrait, Sports Action, Macro, Landscape, and Sunset modes.
⚡ REAR	Rear Sync.	Use this option with a slow shutter speed. The flash goes off at the end of the exposure just before the second shutter curtain closes. If there is movement during the exposure, the resulting picture records the subject in its last position. If there is enough ambient light, the subject's movement during the exposure is captured as a blur. This option is only available in P, A, S, and M modes.
⚡ WL	Wireless	This option triggers an external Sony flash unit by popping up the built-in flash, which emits small bursts of light. The external flash applies light from another direction onto the subject. This allows you to create mood lighting—shadows and highlights with an ambiance that would not be possible with direct flash coming from the front of the camera. This option is only available in P, A, S, and M modes.

Table 4-2: Flash function options

Note: The SLOW SYNC. flash feature is executed using the AEL button (see figure C page xv) and is not part of the Fn button's Flash function. See chapter 9 to learn how this feature works.

Object Tracking Function

The Object Tracking function (table 4-3) allows the camera to track and maintain focus on a subject as it moves throughout the framed image.

To access:

Fn>Object Tracking (left)>[Off], [On]

Object Tracking Option	Description
▣⚡OFF	Disables Object Tracking functionality.
▣⚡ON	Enables Object Tracking functionality.

Table 4-3: Object Tracking function options

Once the Object Tracking function is set to [On], press the multi-selector button to activate. You will be presented with a request to select the object you wish to track (figure 4-2a). Frame the image with the subject you wish to track in the center of the screen. Press the multi-selector button again to select the object. Now you will have a white double box (a box within a box) framing the selected object and moving as the camera or the object moves (figure 4-2b). Press the shutter button halfway to focus. If focus is obtained, the double box will turn green.

Object Tracking is based on recognizing the selected object's colors and details. When you select the object, most likely it will be only a portion of the actual subject you want to track. Make sure the part you select is detailed and colorful enough to differentiate it from other objects within the scene. Otherwise, the

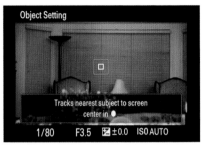

Figure 4-2a: Object Tracking function's object selection screen

Figure 4-2b: Object selected for tracking

camera may have difficulty tracking the desired subject. You are now ready to take a picture or initiate a movie. Object Tracking is retained when a picture is recorded. In the case of movies, the camera will revert back to the previous autofocus area.

All is not lost if the object you are tracking moves momentarily out of the frame. If the object moves back into the framed image quickly, the camera usually will track the object again. After about ten seconds, if the object is out of sight, the camera will stop trying to find the object and will revert back to the previous autofocus area.

The camera may have difficulty tracking if the subject:

• is not distinguishable from the rest of the framed image
• moves outside of the framed image
• moves too fast
• changes; for example, if a person turns around

Object Tracking is not available in Continuous Advance Priority AE, Sweep Panorama, 3D Sweep Panorama, or SCN Hand-held Twilight modes. This function is also disabled in manual focus mode.

Face Detection and Registration Function
Face Detection functionality is typically found in cameras with Live View sensors. Some cameras have elaborate face detection and registration commands while others, like the Sony A77, do not.

There are two parts to the Sony A77's Face Detection process. The first part turns on Face Detection to enable the camera to determine if a face is in the framed image. The second part registers specific faces for the purpose of prioritizing focus. Face Registration software determines whether any of the detected faces have been registered. If so, the camera will attempt to establish focus on each registered face in the order of its assigned priority. If you don't register the faces of your most important people and instead leave it to the camera's software to choose which face to focus on, you may end up with an unknown person as the focal point of your picture.

For example, you are taking a picture of your children at the zoo while other people are around. Of course you want the camera to focus on your children's faces, but there are lots of other faces to distract the camera. If your children's faces are registered and the camera can find them in the crowd, the camera will focus on them first—assuming that the other people don't have their faces registered in your camera too.

Of course, to be detected, the person must be facing the camera so that his or her facial features are clearly presented. The software bases its determination on detecting two eyes, a nose, and a mouth. Therefore, facial recognition will fail if the camera sees only the person's profile. Also, certain conditions, such as the face being too small in the frame or harsh shadows falling on the person's face, may interfere with face recognition.

The Face Registration process works from a library of portraits you compile. You can register up to eight faces and order them by priority, which the camera will use to determine which recognized face acquires focus first, second, and all the way up to eighth. This way, if you have a group picture, the camera will determine whether any of the registered faces are detected in the image and establish focus based on the priority saved in the face registration command. You can register multiple images of the same person to help ensure they are found in a group shot.

Important points:

- Up to eight faces can be detected within one framed image.
- Face Detection/Registration functionality is enabled for still pictures in all but Sweep Panorama, 3D Sweep Panorama, Continuous Advance Priority AE, and SCN's Hand-held Twilight modes.
- Face Detection is enabled when taking movies while the mode dial is set to an option other than Movie mode.
- Non-human faces cannot be detected.
- Obstructions such as sunglasses, hats, and poor lighting can prevent the successful registration and/or recognition of a face.
- Face Registration information is not deleted when executing the Initialize command.

Why Doesn't Face Detection Recognize My Cat?

Even with two eyes, a nose, and a mouth, your cat's facial proportions are uniquely feline and therefore not the same as a human face. Face detection and recognition software looks for facial structures and proportions characteristic of humans.

Activating Face Detection

It's easy to activate the Face Detection function by selecting the following:

Fn>Face Detection (left)>[Off], [On(Regist.Faces)], [On]

The Face Detection function has three options (table 4-4). Select the [On] or [On(Regist.Faces)] option and press the multi-selector button to activate.

Face Detection Option	Option Name	Description
[●] 👤OFF	Off	Deactivates Face Detection. Here the camera is oblivious to a face in the framed image unless you select it as an object for tracking. Face Detection is not available in Sweep Panorama, 3D Sweep Panorama, or Continuous Advance Priority AE modes.
[●] 👤	On (Regist. Faces)	Activates Face Detection and uses registered faces to establish priority for where to focus first, second, etc. Face Detection is automatically set to this value when Smile Shutter is on.
[●] 👤ON	On	Activates Face Detection but does not use registered faces to establish focus prioritization.

Table 4-4: Face Detection function options

Registering Faces

The Face Registration function is accessed through the MENU button.

MENU>Custom Menu (5)>Face Registration>[New Registration], [Order Exchanging], [Delete], [Delete All]

First, have your subject available along with sufficient lighting. Then execute the following steps:

1. Enter:

MENU>Custom Menu (5)>Face Registration>[New Registration]

2. Frame the face of the person you wish to register (figure 4-3a). Make sure the person is facing the camera so you can capture the entire face. A white box will display surrounding the face. Press the shutter button halfway; the box will turn green if focus is obtained. If not, the box will turn red, and you will need to make adjustments to obtain focus.

3. Press the shutter button to register the image (figure 4-3b).

Figure 4-3a: Face framed for registration **Figure 4-3b**: Face registered

The [New Registration] option is enabled only if there are still slots available to register a face. If all eight slots are filled, the option is disabled. The [Order Exchanging] and [Delete] options are enabled after at least one face is registered.

Assigning Priorities to Registered Faces

Each time you register a face, the image is stored in the next available slot. You can see the order when the [Order Exchanging] option is selected. The top left slot is assigned first priority, the slot to its immediate right is assigned second priority, and so on down to the bottom right slot ranked eighth priority. To change the order:

1. Enter:

 MENU>Custom Menu (5)>Face Registration>[Order Exchanging]

2. Highlight the face you wish to reorder and press the multi-selector button.
3. A double-arrow vertical bar will be displayed, indicating the location where the selected image currently resides. Use the multi-selector to toggle the position of the vertical bar to the selected face's new location (figure 4-4a).
4. Press the multi-selector button to accept the new location (figure 4-4b).

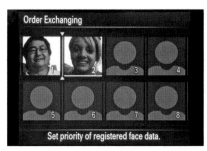

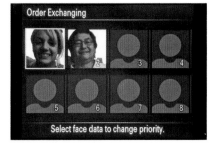

Figure 4-4a: Selected face's current location **Figure 4-4b**: Selected face's new location

Keeping Face Recognition Up to Date

Keep in mind that you can always change the registered images. This is especially important for your children as they grow. You can delete old images that no longer reflect how the person looks.

To delete a registered face, follow these steps:

1. Enter:

 MENU>Custom Menu (5)>Face Registration>[Delete]

2. Eight boxes are displayed on the screen. Each contains an image of a person you have registered or the box is empty. Toggle right or left to select the image you wish to delete and press the multi-selector button.
3. A confirmation menu displays. Select [Delete] to delete the selected registered image; or [Cancel] to exit the function.
4. Press the multi-selector button to process your selection.
5. Select the [Delete All] option if you wish to delete all of the registered faces at one time.

Using Face Detection and Registration

When Face Detection is [On] or [On(Regist.Faces)] and the camera detects a face, it surrounds the face with a colored box. This box changes color to indicate whether autofocus is possible and whether the face is registered. The following list shows the sequence of colored boxes:

- Camera detects a face – grey box encases the face
- Camera determines autofocus is possible on the face – box turns white
- Press the shutter button halfway
- Camera obtains focus on the face:
 - Face is unregistered – box turns green
 - Face is registered – box turns magenta

If the camera is unable to obtain focus, the box remains grey.

Multiple detected faces give you a combination of colored boxes based on whether focus can be obtained on the face and whether or not it is registered.

The Face Detection function is not available in Continuous Advance Priority AE, Sweep Panorama, or 3D Sweep Panorama modes.

Smile Shutter Function

How many times have you said, "Say cheese," and still found that the person was not smiling when the picture was taken? The Sony A77 can help prevent this from happening. Once focus is obtained, the Smile Shutter function instructs the

camera to automatically take a picture when it detects that the person is smiling. Furthermore, you can set the degree of smile sensitivity the camera should encounter to trigger the shutter. Table 4-5 contains the available options and values.

Smile Shutter Option	Option Name	Description
☺OFF	Off	Does not trigger shutter button when a detected face smiles.
☺ON	On	Triggers shutter button when a smile is detected on at least one face. The camera needs to detect only one smiling face to trigger, regardless of whether the person is registered or not. The size of the smile is subjective. The camera seems to trigger the shutter button when there is any change to a person's mouth-related facial expressions.
Sub-Options	**Option**	**Name/Description**
	☺ON	On: Slight Smile. Triggers shutter button when a slight smile is detected.
	☺ON	On: Normal Smile. Triggers shutter button when a normal smile is detected.
	☺ON	On: Big Smile. Triggers shutter button when a big, full smile is detected.

Table 4-5: Smile Shutter function options

Enter the following to access the Smile Shutter function:

Fn>Smile Shutter (left)>[Off], [On]

Once the [On] value is selected, a submenu presents three levels of smile sensitivity:

Fn>Smile Shutter (left)>On>[On:Slight Smile], [On:Normal Smile], [On:Big Smile]

Figure 4-5 shows the resulting display screen after [On:Normal Smile] option is selected. Note the vertical smile meter displayed on the left side of the screen with the arrow indicating the level of smile sensitivity.

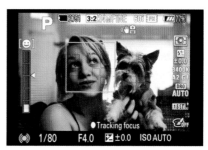

Figure 4-5: Smile Shutter display screen on left with Normal Smile selected

The next time the camera detects a face and obtains focus (the box around the face turns green), it will try to interpret the person's level of smile, which is displayed on the smile meter. If it is at or exceeds the selected sensitivity level,

the camera will automatically take the picture and will continue to take pictures until the person's smile no longer meets the selected level.

You can still manually take a picture even if the smile does not meet expectations. Maybe you have Smile Shutter turned on and your subject starts making funny non-smiley faces. Just press the shutter button as usual to take a picture. The camera will resume taking pictures automatically when it detects a smiling face that is at or exceeds your chosen smile sensitivity level.

How Does Smile Shutter Work with Multiple Faces?

Say you have multiple people in your picture, and not all of them are smiling. You have Smile Shutter turned on along with Face Detection. All it takes is one detected person smiling at or above the Smile Sensitivity level to trigger the shutter button.

Important points:

1. Smile Shutter works in P, A, S, M (conditional), Auto, Auto+, and all SCN predefined scene modes excluding Hand-held Twilight. If your lens has an AF/MF switch set to AF and the camera's mode dial is set to M, the AF setting overrides M mode and allows Smile Shutter to execute. Smile Shutter is disabled in manual focus mode.
2. Turning on Smile Shutter automatically turns on Face Detection.
3. The Smile Shutter value can be stored in a Memory recall group.
4. Smile Shutter does not always work as expected. What you might think constitutes a big smile might be more than what the camera's software needs to trigger a shot.
5. Only Drive Mode [Single Shooting] and [Remote Cdr.] options are available when Smile Shutter is turned on. If DRO/Auto HDR is set to HDR, Smile Shutter will take three shots and create an HDR image.
6. AF Illuminator does not fire when Smile Shutter is activated.

We ran many tests and found that even when the smile sensitivity level was set to [On:Big Smile], the camera's ability to distinguish between different degrees of a smile is not accurate. In addition, there were several times when the camera even took a picture of a frowning subject. We recommend you test this function before implementing it.

Mode Dial

The mode dial (figure 4-6) contains 12 options. Table 4-6 lists each one along with a brief description. The dial rotates 360 degrees in either direction. Turn the dial until the chosen mode is in line with the white line on the camera body next to the dial. You will hear and feel a click when the selected mode is in position.

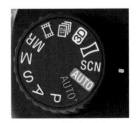

Figure 4-6: Mode dial set to SCN mode

The mode dial is the starting point for exerting control over your pictures and movies. It provides you with a mixture of automatic and semiautomatic settings, additional artistic features, and the ability to save a group of camera settings for easy recall.

Mode Dial Option	Option Name	Description
P	Program-Priority	The camera automatically sets the shutter speed and aperture value and allows you to manually change other camera settings.
A	Aperture-Priority	The camera automatically sets the shutter speed and allows you to shoot after you adjust the aperture value manually using the front or rear control dial.
S	Shutter-Priority	The camera automatically sets the aperture and allows you to set the shutter speed manually.
M	Manual	The camera allows you to set both the shutter speed and aperture value manually.
MR	Memory Recall	The camera allows you to apply a saved set of camera controls pre-registered in the Still Shooting Menu's Memory command.
⬚	Movie	The camera allows you to shoot movies and gives you the ability to adjust both shutter speed and aperture.
12	Continuous Priority AE	The camera shoots continuously with a wide-open aperture as long as the shutter button is held down and the memory card has room to store the images. The camera fires at 12 images/second until the buffer is filled. At that time, the buffer throughput constraints determine how fast the camera fires.
3D	3D Sweep Panorama	The camera builds a horizontal or vertical 3D composite panoramic image.
⬡	Sweep Panorama	The camera builds a horizontal or vertical composite panoramic image.
SCN	Scene	The camera allows you to select a specific predefined scene mode. The camera evaluates shooting conditions based on the selected mode and applies the appropriate settings.
AUTO	Auto	The camera evaluates the framed image and sets the controls according to its evaluation.
AUTO⁺	Auto+	The camera evaluates the framed image, determines a scene type, and applies camera settings appropriately. In addition, the camera can take multiple images and either retain them individually or combine them into a single composite image.

Table 4-6: Mode dial options

We cover Auto, Auto+ and SCN modes in this chapter. These three mode dial options automatically control the camera's ISO, white balance, and exposure compensation settings for each framed image.

The remaining mode dial options require you to take more control and set the camera's settings yourself. These semi-automatic and manual modes are covered in later chapters.

Auto Mode

Auto mode is activated when the mode dial is set to AUTO. When selected, the AUTO icon appears in the upper-left corner of the display screen.

Auto mode enables the camera to automatically determine the proper exposure, ISO setting, white balance, aperture, and focus for the framed image. Therefore, several camera functions are not available in the Auto mode.

- The ISO, WB, and Exposure Compensation buttons are not available and display error messages when pressed
- Exposure-related menu commands are not available
- The following Fn button functions are not available: SCN, Memory recall, AF area, ISO, Metering Mode, Flash Mode, White Balance, DRO/Auto HDR, Creative Style, and Picture Effect
- The following Fn button Drive Mode options are disabled: Bracketing, White Balance, and DRO
- The following Fn button Flash Mode options are disabled: Rear Sync. and WL (Wireless)

Why are Some Low-Light Pictures Out of Focus in Auto Mode?

You would think it couldn't happen, but yes, some low-light pictures could end up out of focus when using the flash in Auto mode. We noticed that in low light situations, the camera sets the exposure to the widest aperture. This means the picture has very shallow depth of field. Therefore, if your picture covers a large amount of depth, only a portion of it will be in focus. The rest of the image will be less in focus as the detail is farther outside the focus range.

How to fix it? Change the mode dial from Auto to A or M, use a smaller aperture (such as f/8 or f/11), and set the shutter speed to 1/60 of a second.

Auto+ Mode

Auto+ mode covers the same functionality as Auto mode and more. Auto+ enables the camera to interpret the type of scene in the framed image and then sets the camera's controls to optimize recording based on that scene. For example, say the

camera determines that the framed image has a subject very close to the lens. It selects the Macro scene type and sets the camera controls to the best values for a close-up picture.

Auto+ mode also selects the shooting function that it determines will give the best outcome. This might be Auto HDR, where multiple images are taken at slightly different exposures and then combined into one picture. Or, the camera might take multiple shots and then select the best from the lot to store on the memory card. This camera is very intelligent and flexible.

Auto+ Menu Commands

Auto+ mode has two specific menu commands that control its functionality: Auto+ Cont. Shooting and Auto+ Image Extract.

These commands are enabled only when the mode dial is set to Auto+. Navigate to the menu commands as follows:

> MENU>Custom Menu (1)>Auto+ Cont. Shooting>[Auto], [Off]

> MENU>Custom Menu (1)>Auto+ Image Extract.>[Auto], [Off]

The Auto+ Cont. Shooting command allows the camera to shoot one image or a set of images. With Auto+ Cont. Shooting = [Auto], the camera determines whether it should shoot multiple images to improve the odds of obtaining one excellent result. When the command is set to [Off], the camera takes only one image. Even when set to [On], the camera may decide one shot is all that is needed.

Auto+ Image Extract command controls whether you save all of the continuous images or allow the camera to select the best of the lot. Set this to [Auto], and the camera determines what it believes is best. Set this command to [Off], and all of the images are retained. But there are exceptions: several shooting functions can change the outcome. We will discuss them later in this chapter. For now, just be aware that when Auto+ Image Extract. = [Off], there will be situations when only one image is saved.

Once Auto+ mode determines the camera's settings, you will see the scene type's icon and an informational message with the shooting function and the number of shots the camera will take when Auto+ Cont. Shooting is set to [Auto].

Note that both menu commands are enabled regardless of how you set the other one. For example, you can have Auto+ Cont. Shooting set to [Auto] and Auto+ Image Extract. set to [Off], which will allow you to shoot and keep multiple shots. You can also have Auto+ Cont. Shooting set to [Off] and Auto+ Image Extract. set to [Auto], which will allow you to only take one shot at a time.

Auto+ Scenes

In Auto+ mode, the camera evaluates the image and assigns a scene type (table 4-7). This is significant because it goes beyond automatic exposure to match the subject with the best settings. When the scene type is determined, the camera displays its icon in the upper left corner of the display screen (figure 4-7).

Auto+ Scene Icon	Scene Name	Description
🌙	Night Scene	The camera determines that the image is a night scene with evening-type lighting available. The internal flash unit pops up automatically.
	Backlight Portrait	The camera detects a face with the light coming from behind. The internal flash unit pops up automatically to add light to the detected face.
	Backlight	The camera determines that the light is behind the focus area, causing a silhouette effect. The internal flash unit pops up automatically to add light to the subject.
	Spotlight	The camera determines the subject is illuminated by a spotlight and records the subject while leaving the background dim.
	Hand-held Twilight	The camera determines that it is hand-held in a low light situation. The stabilizer is activated, and the camera takes a series of shots and combines them into one image to reduce noise. The internal flash unit pops up automatically.
	Portrait	The camera detects a face and attempts to establish focus and exposure for the face.
	Macro	The camera determines that it is close to the subject. The aperture is narrowed to increase the depth of field.
	Low Brightness	The internal flash unit pops up automatically to add light to the subject.
	Landscape	The camera determines that the subject covers a broad range of distances and increases the depth of field.
	Twilight Night Scene	The camera determines that the subject is in a low light situation. The internal flash unit pops up automatically.
	Night Portrait	The camera detects a face, and the internal flash unit pops up automatically.
	Baby	The camera detects a baby's face by interpreting its facial features and proportions. Flash intensity is reduced.
AUTO⁺	General (Default)	When the camera cannot identify the scene, it chooses a group of generic settings based on lighting and focal point.

Table 4-7: AUTO+ available scenes, associated icons, and brief descriptions

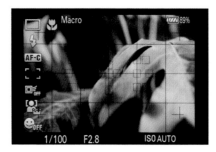

Figure 4-7: AUTO+ with Macro scene selected

Each Auto+ mode scene type has predefined camera settings to optimize the resulting picture per the software's interpretation. For example, the camera can detect when there is a human face in the image. When detected, the camera's software assigns the appropriate Portrait scene type depending on the ambient light intensity. The focus and exposure are set on the face. If Face Detection is set to [On(Regist.Faces)], the software also checks to see if the face is registered and then establishes focus based on the registered priority.

There are times when the camera's software is unable to determine a specific scene type. In this case, the AUTO+ icon displays on the screen and the camera chooses generic settings. You will get a good exposure, but the shutter speed, aperture, and ISO may not be optimal.

How Close Does the Subject Have to be for a Macro Picture?

The answer depends on the lens attached to the camera body.

For an 18-55 mm lens, the minimum is about 10 inches (about 25cm) with a maximum magnification of 0.25

For a 16-50 mm lens, the minimum is about about 12 inches (about 30cm) with a maximum magnification of 0.2

Other macro lenses:

30 mm: Minimum 4.8 inches (12cm), max. magnification = 1.0

60 mm: Minimum 4.8 inches (12cm), max. magnification = 1.0

100 mm: Minimum 14.4 inches (36 cm), max. magnification = 1.0

Some of the parameters used for classifying a picture are based on what is lacking. The failure to detect a face means the scene is not considered a Portrait. The failure to focus on a close subject (i.e., within about one foot) means the scene is not considered a Macro. Frequently, the camera may identify a distant shot as a scenic shot, but as we mentioned earlier, this is not always the case.

Scene identification as practiced by Auto+ mode is imperfect. It should be viewed as a convenience, and as you become more comfortable with using the camera, you can categorize the subject yourself and select the appropriate predefined scene mode using the SCN mode dial option.

Auto+ Shooting Functions

As part of Auto+ mode, the camera evaluates the image and may automatically assign one of the following shooting functions along with the number of shots the camera will take:

- Cont. Shooting
- Daylight Sync.
- Slow Sync.
- Slow Shutter
- Auto HDR
- Hand-held Twilight

After the shooting function is assigned and prior to taking the shot, the camera displays an informational message that includes the shooting function and the number of shots the camera will take. For example, if Cont. Shooting is selected, the following message will be displayed on the screen:

Cont. Shooting 3-shot Cont. Shooting

Although we have done a lot of shooting in Auto+ mode and have been happy with the results, we have rarely seen any shooting functions automatically selected. The few times when it happened, it was fleeting. Sometimes a normal hand tremor changed the situation enough for the selected shooting function to be unselected. As a result, we could not explore just what initiated these shooting functions. That said, when we actually took a picture that had an automatically engaged shooting function, the results were very good.

SCN Predefined Scene Modes

Auto and Auto+ modes are convenient ways for new camera users to take pictures. But occasionally they fall short of taking the pictures you want. Should this be the case, you can use SCN Mode to choose a specific predefined scene option from eight predefined scene modes.

When you select SCN Mode, the list of predefined scenes is displayed on the screen. Toggle the multi-selector or rotate the rear control dial to move through the list. Each predefined scene mode includes a brief description to help you decide which one best suits your image (figure 4-8). Press the multi-selector button to select a scene mode. The scene mode's icon displays in the upper left corner. The camera then applies its settings based on the selected scene mode and the characteristics of the image.

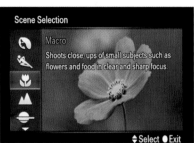

Figure 4-8: Description of Macro predefined scene mode

Table 4-8 lists each of the SCN predefined scene modes, their icons, and a brief description.

The SCN mode dial option allows you to select the image's scene type rather than have the camera interpret it for you. Although this is not always perfect, it helps improve the likelihood that the camera's settings will be in tune with the image and that you will record an excellent picture. Keep in mind that you cannot override exposure-related settings in predefined scene modes, though you can make some changes to Drive Mode, Face Detection, and Smile Shutter.

SCN Option	Option Name	Description
(icon)	Portrait	Use when you want to focus on people within the image. This mode enables the Face Detection/Registration function. The detected face(s) acquire focus while the background is blurred. To increase blur, use a telephoto lens to reduce the depth of field. We choose a telephoto lens with a focal length of 50 mm to 70 mm.
(icon)	Sports Action	Use when taking pictures of a moving subject. Object Tracking is enabled. The camera is set to a fast shutter speed and a higher ISO. Since most likely the subject is moving, press the shutter button halfway and hold to maintain focus. When ready, press the shutter button fully and hold. The camera shoots continuously when you hold the shutter button down.
(icon)	Macro	Use when the subject is close to the camera. The definition of "close" depends on the lens you use. For the DT18-55 mm zoom lens, it is about 10". For the DT16-50 mm zoom lens, it is about 3.3'. You can use a macro lens to shoot closer subjects. Any camera movement will affect a closeup picture, so use a tripod for the best results.
(icon)	Landscape	Use when photographing distant objects outdoors. The camera closes down the lens aperture to increase the depth of field.
(icon)	Sunset	Use when taking pictures of sunrises or sunsets. This mode enhances the image's red and orange tones.
(icon)	Night Scene	Use when taking pictures in a nighttime environment. The camera's shutter speed is reduced to capture more light on the sensor. Use a tripod for the best results
(icon)	Hand-held Twilight	Use this mode when shooting night scenes of a relatively stationary subject without a tripod. The camera utilizes internal image processing software, taking a number of shots and combining them into a single image to reduce image noise and blur (due to low light and camera shake). This option only produces JPEG files. If you have the Quality set to RAW or RAW & JPEG, the camera will change it to JPEG Fine. Results will be marred if the subject has too little contrast; if the subject moves during the capture sequence; or if the image has repeating patterns that create a moiré effect.
(icon)	Night Portrait	Use when shooting a portrait in a nighttime environment. Face detection/registration is enabled. The shutter speed is reduced to capture more light on the camera's sensor; therefore, use a tripod for the best results.

Table 4-8: SCN predefined scene modes

Recommendations

We recommend that you try all of the Sony A77's automatic modes. Although it's likely you will want to take control of the camera settings yourself, the quick and easy automatic modes do come in handy. These modes are excellent for capturing a picture on the spur of a moment when you don't have time to evaluate camera settings and lighting.

It's not always obvious how the camera's software determines its automatic settings. We recommend that instead of just accepting the results, you review your work and evaluate your saved files to determine whether the results satisfy your needs. Check out the nuances of camera command settings for specific predefined scene modes. You can always view an image's settings in the data display screen format described in chapter 3. Keep in mind that the camera's software is doing a best guess and implementing decisions based on what is considered a typical picture.

If you find the results are satisfactory, you may remain an avid user of the automatic modes. However, the camera has many more capabilities that we believe you will want to explore. Chapters 6 and 7 cover using the semi-automatic and manual modes respectively. These modes afford you more control over the camera's photographic outcomes. Granted, there is a learning curve, but everything you are learning now provides the groundwork for those two chapters.

Chapter 5: Customizing the Camera

Introduction

Navigating the menus and setting the commands on the Sony A77 can be frustrating. The number and diversity of commands and functions can make it difficult to find, select, and choose the settings you need. To remedy this, the camera has some customization opportunities.

You may find that you change a specific function frequently and you want easy access to it. You have that capability with this camera. Three of the camera buttons can be reassigned to execute different functions.

In addition, you may find you frequently utilize a complete set of camera settings. Instead of setting and resetting your camera's command values, you can store up to three customized set of command values for instant recall. This can give your camera a whole new personality; it can be like having four cameras instead of just one.

Using the camera's predefined color schemes for your pictures and movies can even eliminate the need to post-process your images. Lastly, you can take advantage of a couple of command settings to facilitate your camera utilization style.

Assigning Button Functionality

Although each of the camera's buttons is labeled and has a default value, three of them—AEL, ISO, and AF/MF (figure 5-1(a-b) can be reassigned to execute a different function. This has one obvious drawback: if you change the button's function, it no longer matches the button's label. This might cause some confusion later if you forget the button's special use or if you share your camera with someone who is unfamiliar with your customized settings. But the advantages can outweigh the potential confusion if you frequently activate or change a specific function.

Figure 5-1a: AEL and AF/MF programmable camera buttons

For example, the AEL (Automatic Exposure Lock) button, which locks the exposure, might be a button you rarely use. (Instead, you can press the shutter button halfway to lock in focus and exposure.) On the other hand, you might constantly change the camera's Metering Mode. You can reset the AEL button's function to the Metering Mode command and have its options at your fingertips.

Figure 5-1b: ISO programmable camera button

The AEL, AF/MF, and ISO buttons may be customized through the following three menu commands.

MENU>Custom Menu (3)>AEL button

MENU>Custom Menu (3)>ISO button

MENU>Custom Menu (3)>AF/MF button

The following is a list of the available values for each button.

Exposure Comp.	Flash Comp.	AEL Hold	Aperture Preview
Drive Mode	White Balance	AEL Toggle	Shot. Result Preview
Flash Mode	DRO	Spot AEL Hold	Smart Telecon.
AF Area	Auto HDR	Spot AEL Toggle	Focus Magnifier
Face Detection	Creative Style	AF/MF Control Hold	Memory
Smile Shutter	Picture Effect	AF/MF Control Toggle	Aperture Preview
ISO	Image Size	Object Tracking	
Metering Mode	Quality	AF Lock	

Reassigning any of these three buttons can give you easy access to your most frequently used commands, modes, and settings. When you press one of the customized buttons, the assigned option is initiated. As your needs change, you can always reset the button back to its default or to a different command, mode, or setting.

Note that the values of these three buttons revert to their defaults when you execute the Initialize command's [Reset Default] or [Custom reset] options but not when you execute Initialize [Rec mode reset].

Assigning Button Functionality Recommendation
We recommend that you use this capability only if you are going to consistently use a specific operation and need quick access. Otherwise, we recommend leaving the three buttons set to their delivered defaults.

Memory Command

The Memory command allows you to register a group of camera commands, functions, and settings, most of which are covered in detail later in the book. At this point, we cover what the Memory command does and how to utilize it as a customization shortcut. We recommend waiting to set up a memory group until

you have read the rest of the book and become more knowledgeable about the camera's settings. That way, you will be better equipped to construct an effective and useful combination of camera settings to be stored in a memory group.

The camera allows you to register up to three separate combinations of camera settings and then recall and apply them. You can select a saved memory group by using the mode dial's MR (Memory recall) option (figure 5-2). Any subsequent changes to the camera's settings remain outside the saved memory group and are not applied when the group is recalled.

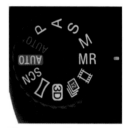

Figure 5-2: MR option on the mode dial

This allows you to have up to four sets of camera settings available at any time: three saved, customized memory groups (MR groups) plus the current camera settings outside of the groups. For example, if you have a favorite set of camera settings for taking landscape pictures, you can save them in one MR group and recall them whenever you wish to take a landscape picture. Maybe you also take a lot of outdoor portraits. Save your most used settings in another one of the MR groups. This way you can speed up your photographing process by moving the mode dial to MR and selecting the appropriate MR group.

Although not all of the camera's command values can be saved in MR groups, the values of the following frequently used items can be saved:

Mode Dial Option	ISO	Creative Style	Object Tracking
Exposure Mode	White Balance	Flash Mode	Picture Effect
Aperture	Exposure Compensation	Flash Compensation	Local AF Area's Position
Shutter Speed	Metering Mode	Face Detection	Still Shooting Menu Items
Drive Mode	DRO/Auto HDR	Smile Shutter	

As long as the MR mode dial option is selected, you can use any one of the three MR groups. You can temporarily override any of the saved settings by selecting a command or function and changing its value. This does not change the saved MR group's settings, but the new value stays in effect until you exit the MR mode dial option or select another MR group.

Note that the saved MR group settings are reinitialized to the camera defaults when Initialize command is set to [Reset Default] only. The MR group's content is retained when the Initialize command is set to [Rec mode reset] or [Custom reset].

Setting Memory Group Values

Execute the following steps to save a set of camera settings for later recall:

1. Move the mode dial to an option other than MR.
2. Set the camera options to the values you wish to save.
3. Select

 MENU>Still Shooting Menu (3)>Memory>[1], [2], [3]

 1, 2, and 3 each represent a specific MR group with a specific set of camera values (figure 5-3).
4. Toggle the multi-selector to select a specific MR group number.
5. Press the multi-selector button to save the camera settings in the selected MR group.

You cannot save exposure compensation adjustments or manual focus settings in an MR group.

Recalling Saved Memory Settings

To recall the saved settings:

1. Turn mode dial to MR.
2. Toggle the multi-selector to the left or right to select an MR group and its saved settings.
3. To view any of the settings, toggle the multi-selector up or down to move through the selected MR group's saved settings.
4. Press the multi-selector button to activate the selected MR group's settings.

Figure 5-3: MR 1 group selected with first page of values displayed

Keep in mind that when you use a memory group, the mode dial is set to MR. Look at the LCD screen to see the applied MR group's saved mode and recalled settings.

To change the selected MR group, either exit and reenter the MR mode dial option or press the Fn button and highlight Memory recall in the top left corner. Then repeat the above steps 2 through 4.

Overriding Recalled Memory Settings

Just because you save a set of commands and apply them doesn't mean you can't change them on the fly for a specific image. Once a memory group is applied, you can change a setting's value simply by using any non-mode dial button. For

example, if you wish to override an MR group's White Balance (WB) value, press the Fn button, select WB, and choose another value. Remember this overridden value is not saved in the MR group; it only changes the setting's value for the current usage. Once you exit, the MR group will have its original WB value when you recall it.

This expands the benefits of MR groups even more. Instead of having a memory group handle only a specific type of image, you can set up an MR group to handle a specific image genre. In other words, an MR group can recall a group of settings for portraits with the WB function set for indoor lighting. When you recall the group, you can either leave the setting at indoor lighting or override it to another setting such as outdoor shade using the Fn button. The overrides are applied only as long as you remain in the MR group and do not override them again. If you recall a different MR group or change the mode dial from MR, the override will be lost, and the original MR group will show the WB function set for indoor lighting the next time it is recalled.

Memory Mode Recommendation

This timesaving feature can be very useful if you take pictures with a specific group of camera settings over and over again. Sony has made this a very easy feature to save, view, and repetitively use without slowing you down. The only concern you might have is remembering what MR group is for what type of pictures or movies. In this case, we recommend you keep some simple notes outlining each MR group's purpose for easy reference. This will also be valuable should you have to execute the Initialize command's [Reset Default] option where the MR groups' settings are reset to the camera's defaults.

Utilizing Predefined Color Schemes

Instead of conducting post-processing later on your computer, the Sony A77 gives you the option of applying a look and feel at the time you take the picture or movie. This can be done using either the Creative Style or Picture Effect functions available through the Fn button (figure 5-4).

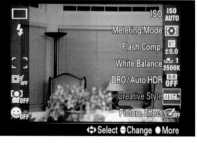

Figure 5-4: Creative Style and Picture Effect icons, lower right

Creative Style Function

When you press the Fn button, the Creative Style function is in the right column one up from the bottom. This function is available for all mode dial options except for the automatic modes (Auto, Auto+, and SCN). Automatic modes force Creative

Style to its default value, Standard. When you recall an MR group, the applied Creative Style is the one saved at the time the MR group was created.

The Creative Style function has 13 options to choose from. Each option applies a different mood or style to your resulting image. Table 5-1 lists the available Creative Style options and descriptions.

Creative Style	Description
Standard	Default – captures image with natural coloration.
Vivid	Accentuates colors, making them stand out more.
Neutral	Tones down colors, making them more subdued.
Clear	Captures images in clear tones with fluid colors in highlighted areas. Good choice for radiant light.
Deep	Enables intense coloration to stand out while maintaining color differentiation.
Light	Enables light color tones to brighten and increases contrast for better viewing.
Portrait	Softens skin tones for a more pleasing effect.
Landscape	Heightens saturation, contrast, and sharpness to produce more vivid and crisp results.
Sunset	Accentuates existing colors and adds warm sunset/sunrise tones.
Night Scene	Accentuates contrast to capture an image closer to the actual scene.
Autumn Leaves	Accentuates existing colors and adds warm red, orange, and yellow tones.
Black & White	Transforms the image into black-and-white with gradations of gray.
Sepia	Transforms the image into old-fashioned sepia coloration.

Table 5-1: Creative Style options

The camera allows you to go a step further and fine-tune the selected Creative Style's contrast, saturation, and sharpness (figure 5-5) for all styles except [Black & White] and [Sepia], where only contrast and sharpness can be adjusted.

Each fine adjustment has a range from +3 to –3 that changes in increments of 1, meaning you can increase or decrease the option by a factor of 1, 2, or 3. Your fine-tuning adjustments are retained until you change them or execute the Initialize command to reset the camera settings to their defaults.

The effects of your selected color scheme and fine adjustments are best evaluated on the LCD display screen. Table 5-2 describes each of the available adjustments and its effect on the image. The camera allows you to preview a Creative Style prior to its selection. Although each style's name gives you an idea of how

the image will be affected, the only way to be sure is to actually preview it on the display screen. For example, applying [Vivid] Creative Style to a multi-colored floral image will have a much different effect than applying it to an image with one or two colors. In the latter case, you may find a different Creative Style to be more appealing.

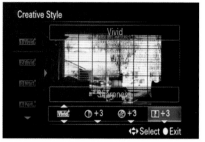

Figure 5-5: Creative Style's fine adjustment options

Fine Adjustment Option	Description
Contrast	Controls the intensity of highlights and shadows. A +3 value increases highlight and shadow intensity, reduces white and black color variations, and gives the image a bolder, stronger look. A -3 value reduces highlight and shadow intensity, increases white and black color variations, and gives the image a smoother overall look.
Saturation	Controls the richness of the colors. A +3 value makes the colors bolder and accentuates them, giving the image more color contrast. A -3 value mutes and softens the colors, giving the image a more homogenous look.
Sharpness	Controls the identified detail edges. A +3 value heightens the edges, creating a bolder, more pronounced image. A -3 value softens the edges, creating a more blended look.

Table 5-2: Creative Style's fine adjustment options

Important points:
- You can set a Creative Style when Quality is set to RAW, but since the Creative Style is only saved with JPEG files, you will not see its effects on saved RAW files outside the camera. In this case, the images will appear as though no Creative Style had been applied.
- Creative Styles are available for MP4 and AVCHD movie files.
- Creative Style is set to [Standard] with no adjustments when the mode dial is set to AUTO, AUTO+, or SCN, or when the Picture Effect function is selected.
- Saturation adjustment is not available for the [Black & White] and [Sepia] options
- The selected Creative Style and its adjustments can be stored in an MR group.
- The selected Creative Style and its adjustments are retained even if the camera is turned off and back on.
- Creative Style adjustments are reset to zero via the Initialize command's [Reset Default] and [Rec mode reset] options. The Initialize [Custom reset] option does not reset the Creative Style values.
- Use the exposure button to adjust exposure while using a Creative Style.

Selecting a Creative Style is easy. Just execute the following steps:

1. Press the Fn button.

2. Select the Creative Style icon from the lower right column of functions. The Creative Styles screen displays (figure 5-6). The last six selected Creative Styles display in the vertical column on the left side of the screen, with the latest selected option listed first. The full list of options is available in the far left menu option on the horizontal bar at the bottom of the display screen.

3. Toggle the multi-selector to the right to enter into the Creative Style horizontal menu. You will be positioned on the Creative Style menu option (far left). Scroll through the options toggling the multi-selector up and down.

4. To adjust the style's contrast, saturation, and sharpness, toggle the multi-selector to the right.

5. Scroll through the selected adjustment options using the multi-selector to toggle up and down to change an adjustment value (figure 5-7).

6. Press the multi-selector button to apply the style and its adjustments and exit back to Live View.

The Creative Style icon is displayed on the image preview (figure 5-8) indicating the selected Creative Style and its adjustment settings. You will see the same icon displayed the next time you press the Fn button (figure 5-9).

Figure 5-6: Creative Style menu

Figure 5-7: Creative Style icon with changed adjustment settings

Figure 5-8: Live View with applied Creative Style icon with its fine adjustments

Figure 5-9: Creative Style icon with its fine adjustments displayed via the Fn button

Picture Effect Function

The Picture Effect function gives you the opportunity to quickly apply a predefined effect filter while recording movies and picture files rather than as a post-processing activity. There are 12 Picture Effect options (table 5-3), several with suboptions to apply tinting or identify a focus area.

At first, Picture Effect might seem like a duplication of Creative Style, but this is not the case. There are some similarities between Picture Effect and Creative Style. Both are accessed through the Fn button, with Picture Effect listed last in the right column. Both function values can be stored in an MR group, but both functions cannot be operational at the same time. Picture Effect automatically turns off when Creative Style is set to a value other than Standard. Creative Style switches to [Standard] when selecting a Picture Effect option. In other words, each function defaults to a non-competing value when you set the other to a non-standard option.

Aside from the facts that the Picture Effect function's color repertoire is different and you can pinpoint a focus area, you cannot use Picture Effect options when Quality is set to capture RAW files. In addition, while Creative Style and Picture Effect are not available in automatic modes (Auto, Auto+, and SCN), Picture Effect is also not available in Sweep Panorama, 3D Sweep Panorama, or Continuous Advance Priority AE.

Picture Effect options do not have the fine adjustment capability that Creative Style options have. Instead, some Picture Effect options allow you to further identify how the effect should be applied. For example, the Toy Camera option has the suboptions [Normal], [Cool], [Warm], [Green], and [Magenta], giving you the opportunity to apply a color tint to the Toy Camera effect.

Important points:
- Picture Effects can be applied only when Quality is set to JPEG files.
- Picture Effect is set to [Off] when the mode dial is set to AUTO, AUTO+, SCN, Sweep Panorama, 3D Sweep Panorama, and Continuous Advance Priority AE, and when a Creative Style option other than [Standard] is selected.
- Picture Effect options along with their suboptions can be stored in an MR group.
- The selected Picture Effect and its suboptions are retained even if the camera is turned off and back on.
- Picture Effect is set to [Off] via Initialize>[Reset Default] and [Rec mode reset]. Option Initialize>[Custom reset] does not reset Picture Effect value.
- While using a Picture Effect, adjust the exposure (shutter speed and aperture) with the exposure button.
- You can further adjust a Picture Effect image using Sony-supplied Image Data Converter software.

5

Picture Effect	Icon	Description	Options
Off	OFF	Turns off Picture Effect.	
Toy Camera	Toy Norm	Creates an image as if it were taken with a toy camera. Colors and shadowing are more pronounced with less smoothness and gradation.	Set the color tone: [Normal], [Cool], [Warm], [Green], [Magenta]
Pop Color	Pop	Emphasizes color tones and makes them more vivid.	
Posterization	Pos / Pos	Emphasizes primary colors—or, in the case of a black-and-white image, makes the two colors more pronounced. Creates a more contrasting, abstract look.	Select primary colors or black-and-white: [Color], [B&W]
Retro Photo	Rtro	Creates the image in an old-fashioned photo style using sepia and faded contrasts.	
Soft High-Key	SftH key	Creates a softer and more ethereal image.	
Partial Color	Part R / Part G / Part B / Part Y	Creates an image that retains one color and turns the rest of it black-and-white.	Select retained color: [Red], [Green], [Blue], [Yellow
High Contrast Mono.	HC BW	Creates a high contrast black-and-white image.	
Soft Focus	Soft Mid	Creates a soft lighting effect.	Set effect intensity: [Mid], [High], [Low]
HDR Painting	Pntg Mid	Takes three images and merges them to create a high-dynamic range (HDR) image. The image's colors and detail are heightened.	Set effect intensity: [Mid], [High], [Low]
Rich-tone Mono.	Rich BW	Takes three images and merges them to create a high-dynamic range (HDR) image in black-and-white.	
Miniature	Mini AUTO	Creates an image with the main subject in focus and the background out of focus. Often used for miniature model images where the model is in focus and the background is not.	Set focus area: [Auto], [Top], [Middle (Horizontal)], [Bottom], [Right], [Middle (Vertical)], [Left]

Table 5-3: Picture Effect options

Selecting a Picture Effect is easy. Just execute the following steps:

1. Press the Fn button.
2. Select the Picture Effect icon, which is the last option in the right function column.
3. Scroll through the options using the multi-selector to toggle up and down.
4. For options with right and left arrows on the icon, toggle the multi-selector right or left to move through Picture Effect's suboptions (figure 5-10).
5. Press the multi-selector button to apply the Picture Effect and the selected suboptions.

An icon is displayed on the image preview (figure 5-11) indicating the selected Picture Effect and suboption. You will see the same icon displayed the next time you press the Fn button.

Figure 5-10: Picture Effect function's Soft Focus and suboption

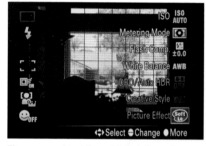

Figure 5-11: Live View with Soft Focus Picture Effect icon with Low suboption

Creative Styles and Picture Effect Recommendation

Creative Style and Picture Effect provide interesting color effects with some limitations. Although you can modify a Creative Style's color contrast, saturation, and sharpness, the allowable range may not be everything you want. Creative Style allows you to capture the image in both RAW and JPEG formats while still giving you the option of processing your pictures outside the camera. Picture Effect allows you to apply expressive filters to your pictures, but only to JPEG files.

We recommend that you play with both functions and see if any of the special styles and effects gives you results you like. If so, use them. One note of caution: many Creative Style options are subtle. Unlike Picture Effect, which has an [Off] option, the closest Creative Style option to [Off] is [Standard]. That said, the [Standard] option has contrast, saturation, and sharpness adjustments available. If your intention is to have no Creative Style affecting your images, make sure these adjustments are set to zero.

Customizing Camera Commands

Display Menu

When you first turn on the camera and press the MENU button, the resulting display screen has the camera's menu positioned at the beginning.

MENU>Still Shooting Menu (1)>Image Size

This might work out fine when you need to change a variety of commands scattered throughout the menu structure. But you might find it much more convenient to have the display menu positioned at the last selected command instead. This is very convenient when you are making adjustments to a specific command between shots, since you can eliminate having to toggle through the menu to the command you want. Once you set the Menu start command for the last command viewed, you can instantly make the change you want the next time you press the MENU button.

MENU>Setup Menu (1)>Menu start>[Top], [Previous]

The [Top] option positions the menu at the first command in the menu structure. The [Previous] option positions the menu at the last command viewed.

Delete Confirmation Step

Not all captured pictures and movies are keepers. There are several delete methods to choose from, one of which is to delete a single file using the Delete button. This delete method has a default confirmation step with two options: [Delete] and [Cancel]. The default is to have the [Cancel] option enabled, but you can enable the [Delete] option instead. Leaving the default set to [Cancel] requires you to toggle up, position the cursor on [Delete], and press the multi-selector button to finalize the delete process.

MENU>Setup Menu (2)>Delete confirm>["Delete" first], ["Cancel" first]

Changing the command to ["Delete" first] eliminates the need to reposition the cursor from [Cancel] to [Delete]. This might not seem like much of a timesaver, but if you frequently delete files from your camera using the Delete button, it will definitely save you time.

One thing to keep in mind: once you delete a file from the memory card, it is gone forever. For some people, keeping the [Cancel] option enabled is a worthwhile safeguard, even though it requires one extra step to delete a file.

Mode Dial Guide

If you are a novice to the Sony camera line, you might want to set the Mode Dial Guide command to [On]:

MENU>Setup Menu (3)>Mode Dial Guide>[On], [Off]

When the guide is activated, an informational screen tells you about the selected shooting mode each time you turn the mode dial (figure 5-12). This is great while you are learning the camera, but it won't take long before you know more about the selected mode than the informational screen gives you. We turned this feature off very quickly.

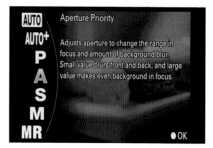

Figure 5-12: Mode Dial Guide

Recommendations

Whether you use any of these customizations comes down to your own personal preference. The few times we re-initialized the camera, we quickly changed the Menu start and the Delete confirm commands to the [Previous] and ["Delete" first] options respectively, and left the Mode Dial Guide command set to [Off].

If you frequently shoot the same type of pictures or movies with few setting changes, consider saving the camera settings in a Memory recall (MR) group. This is an excellent way to record quickly without taking time out to adjust your camera settings. For example, a day at the park would most likely mean sunlight, high shutter speeds, low ISO, and possibly AF Tracking. It could also mean that most of your pictures would include smiling people whose faces have already been registered in the camera. But then, you might also want to take close-up pictures of the flowerbeds scattered around the park. Consider setting up MR groups for both scenarios so you can easily switch back and forth throughout the day.

If you are going to keep MR groups for any length of time, we recommend that you carry a written record with a short description of each group. There have been times when we have forgotten what a saved MR group is for. Better to have a safety net to refresh your memory rather than miss an opportunity because you temporarily forgot something. Also, write down your settings so that you can rebuild an MR group should you need to re-initialize your camera.

Whether you eliminate the extra Delete process step or not is completely your own decision. We only recommend that you consider it and base your decision on how certain you are that the selected image is one you really want to delete. This shortcut does not do the actual deleting. It only positions the action on the Delete option instead of making you take an extra step to confirm your decision. We do most of our deleting outside the camera, so this shortcut rarely matters to us. But if you frequently delete your images within the camera and you aptly select images to be deleted, you may want to set this shortcut to ["Delete" first] to save yourself an extra step.

If you wish to add some ambiance to your pictures and movies, investigate the available options in the Creative Style and Picture Effect functions. We have enjoyed using both functions and have been surprised by how easy it is to capture an artistic image with little effort. We have even taken the results and done additional image processing on our computer using third-party software.

As mentioned earlier, the settings for Creative style and Picture Effect options are retained and automatically applied to your movies and pictures in most of the camera's modes. Therefore, when you don't want to apply any specific styles or effects, make sure that Creative Style is set to [Standard] with all of its adjustments at zero and that Picture Effect is set to [Off].

In regard to setting the AEL, ISO, and AF/MF buttons to other functions, this again depends on how you use the camera. If you use this shortcut, be careful not to be confused by the camera's labels for each button. You can always set a button to a new function for a specific photo shoot and then change it back afterwards. If you find you want to permanently set one of the buttons to another function and you tend to be forgetful, consider using some tape to relabel the button.

We recommend not changing any button functions until you are very familiar with the types of pictures and movies you will be taking. However, due to the difficulty of pressing the Preview button, we quickly reset the AF/MF button to execute the depth of field Preview function.

5

Chapter 6: Taking Control of the Camera

Introduction

This chapter is about taking more control of your camera's operation. Auto, Auto+, and predefined scene modes automatically set the camera's focus, shutter speed, and aperture. While this yields a sharp and properly exposed image, it prevents you from adjusting the camera settings and improving the image at a higher level.

You can gain this enhanced capability by using the P, A, S, and M modes, which stand for Program AE, Aperture-Priority AE, Shutter-Priority AE, and Manual Exposure. By setting the mode dial to these values, you can override the camera's automatic recommendations and apply a bit more or a bit less exposure. Moreover, you can have greater control of functions. For example, you can set the ISO when you use Multi Frame Noise Reduction. You can also gain more control of your autofocus lens, controlling where it will focus within the viewfinder.

Remember, automatic focusing is established by 19 focusing sensors aimed at different points on the display screen. These focusing points are marked by tiny black-framed squares, and any one of them can serve as the target area to be focused on.

Sometimes the focusing sensors can be a detriment; for example, if you take a portrait of a dog, you may find the point of focus is on the dog's nose, blurring the eyes. To remedy this, you can disable most of the focus points and use only the one aimed at the eyes.

Also, you may wish to control the depth of field or shutter speed. Certain types of photography require the aperture to be set at a constant value or the shutter speed to be set for exposures longer than 30 seconds. These settings are unavailable to you in Auto or Auto+. Furthermore, the Sony A77 has some unique algorithms for improving image quality by taking several pictures in rapid sequence and then combining them. You can utilize these commands at will if you use P, A, S, or M modes.

In this chapter, we first cover some of the general controls that become available when you quit using the automatic modes. Then we discuss P, A, and S modes, saving M mode for chapter 7.

Exposure Compensation

Fine Tuning Automatic Exposure

You can alter your image's exposure once you enter P, A, or S mode. If you feel the scene needs a little more or less light, you can adjust the exposure by pressing the Exposure Compensation button marked with a plus/minus on top of the camera (figure 6-1).

Figure 6-1: Arrow points to Exposure Compensation button with +/- symbol

The Exposure Compensation scale (figure 6-2a) is displayed on the screen as a horizontal scale in units of 0.3 EV (Exposure Value). To use it, either toggle the multi-selector or turn the rear control dial to the right for more exposure (figure 6-2b) or to the left for less exposure. In figure 6b, 1 EV more exposure is being applied.

The extent of compensation is shown graphically. You will see numbers from -5 to +5 on the scale with two tick marks between each number. Each number represents one f-stop, and each tick mark represents 0.3 f-stop increments. As you turn the rear control dial, an orange arrow moves along the top of the scale indicating the amount of EV or f-stop change. The shutter speed and/or aperture settings change as you move the arrow left or right on the scale. The arrow starts blinking if you try to compensate the exposure past the scale's range. As you move away from the camera's recommended exposure, the screen either brightens or darkens.

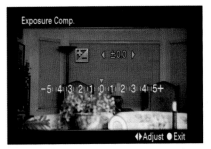

Figure 6-2a: Exposure Compensation scale at the camera's recommended exposure

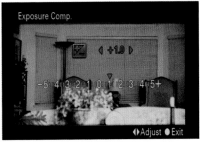

Figure 6-2b: Exposure Compensation scale set to increase exposure

What are EV Values?

Even though the Sony A77 has an accurate exposure system, you may wish to either add to or subtract from the recommended exposure. This capability is always available to you via the Exposure Compensation scale. In this context, Exposure Value (EV) describes the difference between the recommended and the set exposure. The camera's scale starts at 0, where no compensation is applied. By rotating the rear control dial, it is possible to provide up to five f-stops overexposure or five f-stops underexposure. Since there are two bars between each increment, you can set the exposure values by increments of 0.3 f-stops.

The amount the arrow moves with each turn of the rear control dial or toggle of the multi-selector is controlled by Exposure step command:

MENU>Exposure step>Still Shooting Menu (3)>[0.5 EV], [0.3 EV]

Normally, we leave Exposure step at its default value of 0.3 EV. Depending on whether you are in Aperture-Priority or Shutter-Priority, you are changing, respectively, the shutter speed or the aperture opening as you move left or right on the Exposure Compensation scale. The beauty of the camera's electronic display is that it shows you, in real time, the effects of overriding the camera's recommendations. Once you have set the exposure, a slight press of the shutter returns you to live preview.

Use this tool when you suspect that the camera's exposure recommendation is incorrect. You might feel that darkening or brightening the image provides a better mood for the scene. Or, it may be that the lighting situation is so extreme that you have to decide which areas—the bright highlights or the dark shadows—have to be sacrificed in order to capture the image.

Tip: Histogram and Exposure Compensation

6

We like to view the histogram when using the Exposure Compensation scale. Watching how the curve changes position and shape helps us judge whether we are in danger of overexposing the highlights or underexposing the shadows. Unfortunately, when the camera is set to P, A, or S mode and you press the Exposure Compensation button, the Live View changes and you lose your histogram display.

To see your histogram while performing Exposure Compensation, go to the menu and specify that the front or rear control dial is to be used for Exposure Compensation. If you do this, you can apply Exposure Compensation by simply turning the selected dial. Plus, you can retain the appearance of a live histogram to help you judge your exposure. The command is:

MENU>Custom Menu (4)>Dial exp. comp.>[Off], [Front dial], [Rear dial]

Normally, this command is set to [Off]. Select either Front dial or Rear dial to see the histogram while viewing the Exposure Compensation scale.

Focus Mode: Identifying Where to Focus

The Sony A77 uses phase detection sensors to determine focus, with each sensor aimed at a small, select region of the scene. These areas are referred to as AF (autofocus) areas. Their placement within the scene is marked by small, black-bordered squares (figure 6-3). By dispersing the AF areas, a larger percentage of the scene is available for focusing. The appearance of these AF areas varies. Later, in chapter 7 we will describe how you can activate or deactivate AF areas. If the borders become a darker, thicker black it indicates that you have activated these areas to be focused (figure 6-3) while the fainter black border squares have been deactivated (figure 6-3). If none of the squares have a heavy black border, then the camera is in a default mode were all the focus areas are potentially active. This is the most commonly used focusing area. When the camera identifies focus, the squares overlying the focus region have green borders (figure 6-4).

The focusing points are concentrated in the central regions of the scene, so a single subject might cover multiple AF areas. When this occurs, there is a bias to focus on the areas closest to the camera. This is reasonable, since we often take pictures of the objects closest to us. However, this is not always the desired objective. For instance, a portrait photographer likes to focus on the eyes rather than the nose. So, for a face-on photograph, you can limit the AF area to one point and use that point to aim at the subject's eyes.

The AF area function command that determines the target area where the camera establishes focus is:

Fn button>AF area (left)>[Wide], [Zone], [Spot], [Local]

Table 6-1 defines the focus areas.

When the camera has identified a focus area, it signals this by changing the area's translucent borders from black to green (figure 6-4).

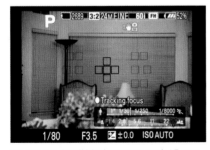

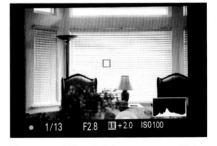

Figure 6-3: Small black squares mark AF area focus points. The thicker black borders are selected.

Figure 6-4: AF border's becomes green if it is identified as being in focus.

AF Area Option	Option Name	Description
⌐ ⌐ ∟ ⌐	Wide	The camera determines which of 19 AF areas should be used to determine focus. AF areas used to establish focus develop green borders. If Face Detection is turned on, focusing on a face can only occur if the face is positioned over an AF area.
⌐⌐⌐ ⌐⌐⌐	Zone	This option allows you to tell the camera which of three zones (left, center, right) to use to establish focus. Toggle the multi-selector button to select one of the zones. As you toggle through them, the highlighted zone's AF focus area squares show thicker borders (figure 6-4). They appear dark and distinguished from inactive AF areas. Press the multi-selector button to select a zone. The selected zone's AF area focus squares remain bold. The camera determines which of the AF areas within the specified zone are to be used to establish focus. This allows you to bring a portion of the image into focus while the rest is out of focus.
(spot AF area icon)	Spot	The camera uses only the center AF area to obtain focus. All of the other points are inactive. The center AF area's borders appear thicker and darker than the other 18 AF areas.
(local AF area icon)	Local	This option allows you to tell the camera which of the 19 AF areas to use to obtain focus. Toggle the multi-selector button to one of the 19 AF areas and press the shutter button halfway to obtain focus. The selected AF focus area has a darker, wider border than the other 18 AF areas. Press the multi-selector button to reset to the center AF area. If you select the center AF area, this is no different than using the Spot option. Like the Zone option, the Local option allows you to bring part of your image into focus while the rest is out of focus. Unlike the Zone option, the Local option allows you to pinpoint the area of focus to a much smaller part of the image.

Table 6-1: AF area function's options

Choosing an AF Area Function

Normally, we set AF to the default, [Wide], since it is reliable and rapidly acquires focus without the need to aim the camera precisely. We turn off Object Tracking so that we can transition to spot focusing by pressing the multi-selector button. This is advantageous when we're using a telephoto lens with a shallow depth of field.

For example, when photographing animals from a distance, we like the eyes of the animal to be recorded sharply with a reflective glint. Spot focusing enables us to accomplish this. By selecting [Spot] and aiming the center focus point at the eyes, we can lock focus there. If we used wide focusing on a small bird, focus would invariably be on the body part closest to us: usually, the breast or back.

While [Wide] gives you the widest possible field to establish focus, it doesn't necessarily give you the best picture. You may want only your subject in focus and the rest of the image somewhat blurred and de-emphasized. If this is the case, activate just a single focus point by selecting either [Spot] (the center focus point) or [Local] (selecting a focus point that lies off center on the screen) .

Ultimately, the key to reliable AF focusing is a well-illuminated subject with fine details. If this is not the case, you will need to use manual focusing.

ISO

To get a feel for ISO, many film photographers once used the following rule: for a subject in open sunlight, set a shutter speed that is the reciprocal of the ISO (1/ISO) and set the lens's aperture to f/16. Old-time photographers will recognize this as the "Sunny f/16" rule.

The Sony A77's nominal sensitivity is ISO 100, so on a sunny day, without clouds, you will get a properly exposed image by setting the shutter speed to 1/100 of a second and the lens's aperture to f/16. For many photographers, increasing the camera's ISO eight times to an ISO of 800 will generate an image of acceptable quality—at this ISO, the shutter speed is reduced to 1/800 while retaining a lens aperture of f/16. This setting makes the camera more suitable for action photography, as the fast shutter speed will freeze the subject's motion. In this way, ISO adjustment makes your camera a more versatile recording tool.

When in Auto, Auto+, or SCN mode, the camera uses an Auto ISO setting where it varies its rating for subject and lighting. Eventually, you will find this limiting because you will want to set the camera for maximum picture quality, even if it means using a tripod. An experienced photographer usually prefers to set the ISO manually, and to do so, it's necessary to set the mode dial to P, A, S, or M. We will discuss more about this later; right now, we will show you how to change ISO settings.

There are two ways to control ISO. The one that provides the most information but is slower to implement is to press the Fn button on the back of the camera.

Fn button>ISO (right)>[ISO n], [AUTO], [n]

Note: [n] above represents the ISO number ranging from 50 to 16000.

Table 6-2 lists the ISO function's available options.

ISO Function Option	Option Name	Description
ISO *n*	Multi Frame Noise Reduction	*n* = the selected ISO number Multiple shots are taken and combined to reduce noise caused by poor lighting. This option only works with JPEG files. Toggle to the right to move into the list of suboptions. When one is selected, the multi-ISO icon with the selected ISO shows in the lower right of the display screen.
AUTO	Auto ISO	The camera determines the appropriate ISO value based on available light, detail contrast, aperture, and shutter speed within the specified range. Toggle to the right to specify the minimum and maximum ISO range. The Auto ISO icon show in the lower right of the display screen.
n	ISO	*n* = the selected ISO number The single ISO icon with the selected ISO shows in the lower right of the display screen

Table 6-2: ISO function options

A faster way to activate the ISO function is to press the ISO button on the top of the camera (figure 6-1). This immediately drops you into the ISO function so you can begin selecting the option you want. You can either toggle the multi-selector or rotate the front or rear control dial to select your ISO value. The front dial changes settings rapidly by one f-stop increments, while the rear dial does so at 1/3 f-stops. So if you need to rapidly change from ISO 50 to 6400, use the front control dial.

Setting your own ISO requires that you keep an eye on shutter speed. If your shutter speed is too slow, the camera may move during exposure and blur the image. These movements are due to hand tremors and can be avoided by using a tripod or reduced by bracing oneself against a solid support.

A handy rule of thumb when shooting 35 mm film is to use a shutter speed that is the reciprocal of the focal length of the lens in mm. So, if you set the lens to 100 mm, then you should set a minimum exposure of 1/100 second. For digital photography, this guideline may be too conservative; some readers will point out that because of the sensor crop, the shutter speed should be 1/150 second. Other readers who are knowledgable about the Sony's SteadyShot feature will point out that this stabilization device allows you to shoot at 1/50 or 1/25 second. SteadyShot works on the sensor, counterbalancing camera movement to ensure a sharp image is captured. Normally, it is active and has to be turned off as a menu command.

Obviously, there are many variables that affect how slow a shutter speed you can use before blurring the image. We simply use the 1/focal length rule and are thankful that we have the SteadyShot feature to provide a safety factor when taking

photographs. Remember, the way the camera is held determines how steady it is. Using the viewfinder and bracing the camera against your face provides more stability than holding the camera at arm's length and composing with the rear LCD monitor. When possible, we brace the camera against a solid support, such as a nearby tree or pole. However, nothing beats a tripod, and arguably the finest details can only be obtained by using this accessory with a remote release.

Letting the Camera Set the ISO

In addition to selecting a specific ISO value from the displayed ISO numbers, there are two more ways to set ISO: Auto ISO and Multi Frame Noise Reduction.

Auto ISO, as the name implies, adjusts the camera sensitivity automatically. Essentially, when ambient light levels are low, the camera raises its ISO so you can use a faster shutter speed. This increases your chances of getting a sharp photograph while handholding the camera. The Auto ISO's range can be set so that it does not raise the ISO to the point where noise degrades the image.

ISO and Noise: Image Degradation

The most obvious defect introduced by raising the ISO is what is referred to as "noise"—the granular appearance of color blotches in regions that should have smooth tones.

The Sony A77 is not immune to these defects, and it exhibits greater noise at ISO 1600 or higher. However, this should not prevent you from shooting at high ISOs. Depending on how you use the resulting pictures, the noise effects may be inconsequential.

If your goal is to make images strictly for web use, you might be pleasantly surprised to find that the quality of your Sony A77 at ISO 3200 is acceptable. We have used an upper limit of ISO 3200 and have been pleased with the results. For critical work, we make sure we shoot in RAW and use third-party software (e.g., Noise Ninja) to help reduce noise effects.

You can stipulate the minimum and maximum ISO that the camera can automatically apply. This way, the camera will stay within the range you set. To set the Auto ISO's minimum and maximum, press the Fn button and select ISO. You can also press the ISO button instead. In both cases, toggle down to Auto ISO.

Fn button>ISO (right)>Auto ISO

When you reach Auto ISO, use a right toggle to access the submenu for setting the ISO's lower and upper limits. You will be positioned at the minimum limit option. Toggle up or down to select a minimum ISO value. Toggle right again to position

on the maximum option. Again, toggle up or down to select the upper limit of the ISO range. Press the multi-selector button to accept your entries.

A legitimate question is, how high should the limit be set? Unfortunately, there is no definitive answer. The upper limit can only be established through personal use and preference. We recommend 1600 as a starting point, with the assumption that most people will start finding unacceptable noise above that level when making 8 x 10 or larger prints. However, if you are using the images to send as email attachments or are printing them in small sizes such as 4 x 6, you may be very pleased by the camera's performance at 3200 or even higher.

You can set the camera's ISO to incredibly high values. However, we find that values exceeding 6400 result in very noisy images. The lowest value you can set is 50. We don't usually use this except for special situations, for example, if we want a very slow shutter speed on a bright day. On a bright day, it is difficult to open the shutter long enough to blur the moving of water in a stream, so we use ISO 50 for this type of shot. Otherwise, we generally leave the lower ISO value at 100.

You cannot use Auto ISO in M mode. It is only available in P, A, and S modes. Auto ISO is the default mode in Auto, Auto+ and SCN modes.

Multi Frame Noise Reduction

One method Sony uses to handle noise is to fire multiple shots and average the images to reduce noise. This feature is available in SCN Hand-held Twilight mode. Unfortunately, when you use this mode, you cannot set the ISO, nor can you use Exposure Compensation. In essence, you have to trust the camera to make the settings for you.

However, the ISO function has the Multi Frame Noise Reduction option, which implements a similar noise reduction process while allowing you to set a specific ISO. When this option is activated, the camera takes a series of shots and merges them to form a single image with reduced noise. We tend to use this feature at ISOs of 3200 or 6400; setting higher ISOs generates levels of noise that this command cannot remove.

Fn button>ISO (right)>[Multi Frame Noise Reduction]

As before, you can save a step by pressing the ISO button and then toggling up and down to find Multi Frame Noise Reduction. Once you are there, toggle right and then set the ISO by toggling up and down. Press the multi-selector button to accept your choice. You can now fire the camera.

WB (White Balance)

The Sony A77 has to be calibrated to record colors accurately. In effect, the camera must be told what type of light is illuminating the subject. This task used to be performed manually; however, the method was inconvenient and would result in an image with horrible colors if the wrong light source were selected. This was especially true with DSLRs relying on optical viewfinders.

To get around this problem, camera designers developed AWB (Automatic White Balance), which enables the camera to calibrate itself to the light source. In essence, AWB takes a statistical sampling of the image and makes a "best guess estimate" on the identity of the light. For the most part, it does a good job, and many users always use AWB. But, like all statistical sampling techniques, it can be fooled. This is most evident when working with indoor lighting. Fortunately, the Sony A77 has tools to compensate for this.

To better control the appearance of your photograph, we recommend that you become accustomed to setting your own white balance (WB). Your results will be more consistent and more reproducible if you get into this habit. To do so, use the following command:

Fn button>WB (right)>See table 6-3 for the list of values

You can also access the WB function by pressing the WB button on top of the camera (figure 6-1).

6

WB Function Option	Option Name	Description
AWB	AWB	White balance is set automatically by the camera.
☀	Daylight	White balance is set for the subject being in direct sunlight.
🏠	Shade	White balance is set for the subject sitting in the shade and not illuminated by direct sunlight.
☁	Cloudy	White balance is set for subject on a cloudy, overcast day where the sun is hidden by the cloud cover.
💡	Incandescent	White balance is set for the subject illuminated by indoor lights (assumes the light is tungsten filament).
⚡-1	Fluor.: Warm White	White balance is set for the subject illuminated by "Warm" fluorescent lights (3000 K).
⚡0	Fluor.: Cool White	White balance is set for the subject illuminated by "Cool" fluorescent lights (4100 K).
⚡+1	Fluor.: Day White	White balance is set for the subject illuminated by "Day White" fluorescent light (5000 K).

WB Function Option	Option Name	Description
🎇+2	Fluor.: Daylight	White balance is set for the subject illuminated by "Daylight" fluorescent light (6500 K).
WB ⚡	Flash	White balance is set for using an electronic flash unit. Some yellow tints are added to enrich and warm up the picture.
Ⓚ⊘	C.Temp./ Filter	This option allows you to set the white balance based on a specific color temperature value represented in K units (kelvin). Your light bulbs should have a kelvin rating on the packaging. You can set the white balance to that specific value with the following steps: 1. Toggle the multi-selector to the right to enter the list of color temperature values. Scroll up or down through the list using the toggle button. 2. Right toggle again to enter the color temperature selection grid. You can toggle in all directions to move the color temperature value. 3. Press the multi-selector button to select a final value.
📷	Custom 1	Use this option to store a custom white balance setting.
📷	Custom 2	Use this option to store a custom white balance setting.
📷	Custom 3	Use this option to store a custom white balance setting.
📷 SET	Custom Setup	Use this option to set up a custom white balance to be stored in one of the three custom settings.

Table 6-3: WB icons and light sources

When you press the WB button, you can immediately select most of the options by toggling up or down with the multi-selector. This allows you to highlight AWB or one of the light source icons (figure 6-5). Once a value is highlighted, press the multi-selector button to select it.

The icons in table 6-3 graphically represent light sources, making them easy to remember. However, they only

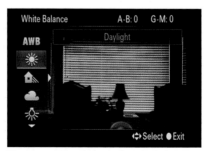

Figure 6-5: White balance for a daylight setting

serve as a rough guide to the illuminant's color. For example, the Incandescent option assumes an idealized bulb emitting a specific color. In fact, indoor bulbs can emit widely varying color content; and, depending on the operating voltage, the light can range from ruddy red to brilliant white. For those who need rigor in setting these values, use the Color Temp./Filter option.

Inaccurate preset WB occurs frequently with fluorescent lights. These bulbs vary so widely in their color output that the WB settings provided by Sony may not work. If the results are unsatisfactory, use Custom WB instead.

There are other choices in WB that require a bit more effort. When you select [C. Temp./Filter] you will have additional options to select. One of them is the letter K, which stands for the color temperature scale. Chemists and physicists know this as the abbreviation for kelvin, a quantitative way of specifying color temperature. Rather than discuss the scientific and physical basis of the scale, it is sufficient to say that you can dial in the correct value to give you accurate color balance. This is especially handy if you're using photographic lights with output specified in degrees kelvin.

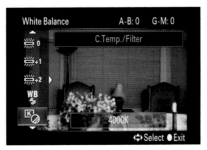 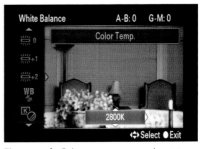

Figure 6-6a: Selecting Color Temp./Filter for k to a numerical value

Figure 6-6b: Color temperature scale set to 2800 K

Follow these steps to use the color temperature scale:

1. Press the WB button on top of the camera. Highlight the [Color Temp./Filter] option (figure 6-6a). Right toggle to enter the color temperature scale. Note that the camera is set to 4000 K and the resultant image is too orange.

2. Select the color temperature by toggling up or down. You can also turn the rear or front control dial to raise and lower the temperature setting. The range is 2500 K to 9900 K.

3. When the number reaches the value you want, in this case 2800 K, press the multi-selector button (figure 6-6b). Note that the color value appears more natural.

To use the above option, you need to know the color temperature of the light source. An expensive color temperature meter is the most accurate way to determine this value. Also, check to see if the manufacturer provides a k value. For example, the tungsten illuminator on our microscope is rated at 3200 K, a value provided by the lamp manufacturer, so we dial that number into the camera's white balance scale.

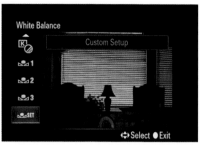

Figure 6-7a: White balance set for Custom WB

Figure 6-7b: Gray circle indicating where to place a white piece of paper in the frame

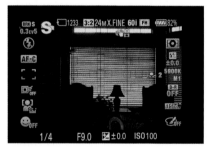

Figure 6-7c: Calibrated value stored in Custom WB #2 and applied to image. Note change in white balance.

Unfortunately, many light sources are not rated. Worse, sometimes bulbs that are rated fail to maintain their ratings over the life of the bulb. Tungsten filament bulbs emit a cooler color as they age. Also, their color temperature depends on their operating current, and they emit a warmer color with a drop in voltage.

In the case of fluorescent bulbs, there is a wide variation among manufacturers; therefore the color temperature values in table 6-3 are only approximations. For these situations, we rely on our favorite method of setting color temperature, Custom white balance. We set the white balance manually by calibrating it to the light source (white paper) and store it in the camera's memory. To do this, all you need is a blank white sheet of paper and follow these steps:

1. Press the WB button on the top of the camera.
2. Highlight the icon labeled SET (Custom Setup) (figure 6-7a).
3. The screen changes. A circle with a fine line border appears in the screen (figure 6-7b).
4. Aim the camera at the white sheet of paper; making sure the paper fills the targeting circle.
5. You will see the prompt, "Use spot focus area data. Press shutter to load."
6. Press shutter.

7. A new screen appears, prompting you to "Select a register." You will have three registers to store your color temperature. Select one and press the multi-selector button. In this case, Register #2 was selected.
8. The value will be stored in the register.
9. You can now use the camera.
10. The Custom white balance can be recalled if you select the Custom 1, 2, or 3: the number being the one you selected when storing the WB value it. Note that Register 2 (figure 6-7c) is being used in this Live View. The Custom WB #2 has a color temperature of 5900 K.

You can store WB custom settings in one of three registers and use them as preset WBs. We find this procedure to be very reliable, and it is our preferred method of manually adjusting the camera to the light source. When working with a microscope, we remove the specimen from the field of view and calibrate the WB setting against a clear region. The camera is then calibrated to the light with the benefit that any color cast introduced by the lens is also removed. We find it to be a more accurate adjustment; colored specimens are rendered better than when the camera was calibrated with the C. temp. setting.

Here is another suggestion to use when customizing your white balance: instead of using a white sheet of paper, substitute an 18% gray card. This, as the name implies, only reflects a percentage of light and provides a handy reference for neutral color under varying light conditions.

Using a gray card has a dual purpose. First, you can use it for Custom WB, substituting it for a white piece of paper. Second, you can position an 18% gray card within your picture, in an unobtrusive location that can be cropped out of the final image. You can then use this point for the Specify Gray Point command when processing your picture with Image Data Converter. Although you can use a white sheet of paper, the danger is that one of the color channels may be clipped, biasing your WB to the properly exposed color channels. By using the 18% gray card, you can be assured that all of the color channels will be properly exposed.

Fine-tuning WB: Fine Adjustment

Sometimes, no matter what you do, the procedures described above may generate an unacceptable coloration in your image. When using fluorescent or LED lights sources that emit a discontinuous spectrum of light, you may find the images have color casts that cannot be removed by selecting a preset WB value. In the next chapter, we will describe how Sony deals with this type of discoloration within the camera. Now, we will describe how these color casts can be adjusted in your computer.

At the onset, we will state that our preference is to use post-processing software for correcting color casts. Sony's Image Data Converter software and third-party

software such as Photoshop or Aperture provide powerful tools for "touching up" RAW images.

Earlier, we recommended that you save your images as both RAW and JPEG files. Each file format has its advantages. A major benefit of saving in RAW format is the ease of correcting white balance errors outside the camera.

If you're using Image Data Converter, figure 6-8 shows a slider and a color temperature scale in a side screen for fine-tuning white balance. The slider allows you to rapidly evaluate different color temperature settings. Additionally, there is a button marked Preset which displays a variety of light sources, enabling you to find your illumination type.

Figure 6-8: Image Data Converter controls for adjusting a RAW file's color temperature

In the previous section, we mentioned including an 18% gray card within a picture. This technique can be used with the Specify Gray Point command to provide a neutral reference for adjusting WB (figure 6-8). In addition, Image Data Converter has another slider called Color correction (figure 6-8) were you can adjust the tint from green to magenta. Together with its Color temperature slider, you should be able to obtain an image with a neutral-looking white balance.

Summary of WB

The majority of our photographs are taken with AWB. The camera does a satisfactory job of recording pleasing colors from subjects illuminated with various lighting sources. However, we have noticed that indoor lightning with incandescent lamps can throw off AWB. Under these conditions, our images have an orange-red hue. To obtain more neutral colors, we use the WB setting for incandescent lighting (accessed via the WB button on top of the camera). For very difficult conditions where there are several light sources—e.g., a mix of incandescent and fluorescent bulbs—we calibrate WB against a white sheet of paper (Custom white balance option).

Again, we recommend saving files in RAW format. Virtually all programs that read RAW files have a straightforward command for readjusting white balance when it is set incorrectly in the camera.

Customizing Automatic Focusing

Automatic Focusing: Speeding up Focusing

The Sony A77 conserves battery power by not starting autofocus until you press the shutter button halfway. In addition, to guarantee a sharply focused image, the camera does not fire until focus has been established. Although this is a good thing, it also slows down your ability to capture your subjects quickly. To speed up firing the camera, you can select an option to start focusing by simply viewing through the electronic viewfinder. Use the following command:

MENU>Custom Menu (1)>Eye-Start AF>[On], [Off]

Another strategy for speeding up your photography is to disable the camera's ability to block activating the shutter until focus is achieved. This speeds up initiating exposure at the risk of obtaining an unfocused image. Use this command:

MENU>Still Shooting Menu (3)>Priority setup>[AF], [Release]

The [AF] value requires that the image be in focus for the shutter button to be activated except in manual focus mode, where this has no effect. The [Release] value does not require the image to be in focus. Interestingly, this value allows out-of-focus shots even in Auto and Auto+ modes.

Automatic Focus in Dim Light

The camera needs light to operate its autofocus. In dim surroundings, the camera may not be able to focus. It solves this problem by projecting a red beam called the AF Illuminator light to illuminate the subject. Normally, this provides enough light to achieve automatic focus. Although a red light is less obvious than a brilliant white beam, it can be annoying to audiences and performers—for example, if you are shooting a stage production in a dimly lit theater. To avoid this distraction, Sony provides the command below:

MENU>Still Shooting Menu (2)>AF Illuminator>[Auto], [Off]

The [Auto] value enables the camera to turn the AF Illuminator light on in low-light situations, whereas the [Off] value means the light does not turn on.

Controlling Autofocus Speed

The camera has an AF drive speed command for you to set an autofocusing speed.

MENU>Custom Menu (4)>AF drive speed>[Fast], [Slow]

Reports on online forums say that if the AF drive speed is not set to [Slow], some third-party lenses are in danger of having their focusing gears stripped. We are not willing to personally risk one of our lenses to test this out; therefore, we can only pass on this advice as a precautionary note.

Manual Focus: Overriding Automatic Focusing

Our discussion about using manual focus spans this chapter and the next. In this chapter, we discuss overriding automatic focus and fine-tuning focus manually. In chapter 7, we describe using manual focus as the sole means of focusing.

First, a cautionary note. Some Minolta and Sony lenses can damage the focusing motor if the lens focusing ring is forced. So, when you turn the ring, stop if you feel resistance. To experience what you should feel when turning the focusing ring, first see if your lens has an AF/MF switch. If so, turn it to MF. If your lens lacks this switch, turn the focus mode dial to MF. Once the camera is in MF mode, turn the lens ring. This is the level of drag you should experience. Anything more, and you risk damaging the focusing motor. Sony has three different autofocus motors for their cameras, and failing to properly switch to MF can damage them. A good safety rule is to know the feel of manually focusing the lens and stop turning it if there is any resistance.

The focus mode dial (figure A page xiv) is inconveniently placed if you need to change focus rapidly from AF to MF. Frequently, especially with long telephoto

lenses, you will find that the lens is not focused precisely on the subject and you need to fine tune the focus. One way is to use just one AF sensor with a [Spot] AF area. By using a single sensor and aiming it at the point you wish to focus on, you can focus precisely on one part of the subject.

An easier way to fine tune AF is to engage manual focus by pressing the AF/MF button on the back of the camera. You can fine tune focus and take the shot while pressing this button. A useful adjunct to this command is to make the AF/MF button an on/off switch—i.e., when you press it once, the lens is in manual focus; when you press it a second time, it returns to autofocus. This is accomplished by reassigning the function of the AF/MF button. Use the following command:

MENU>Custom Menu (3)>AF/MF button>[AF/MF Control Toggle]

One command that we don't care for is direct manual focus (DMF), which is obtained with the following:

MENU>Still Shooting Menu (3)>AF-A setup >[DMF]

6

When DMF is used with Sony lenses that are driven by the camera body's motor, it allows you to switch automatically from automatic to manual focus. Basically, what happens is that the camera will autofocus when DMF is set. When the camera finds focus, the lens is disengaged from the motor and you can turn the focusing ring to adjust focus further. This sounds handy, except that it doesn't work with Sony lenses containing the SAM (Smooth Auto Focus) focusing motor. A more complete description of SAM can be found in Chapter 9. As a result, we avoid this command, preferring to use the AF/MF button on the back of the camera.

DRO/Auto HDR Function

When photographing, you sometimes encounter a scene with overly bright regions that show no detail. Or, you might encounter another subject with deep shadows that appear as a featureless black mass. Finally, between these two extremes are regions with mid-tones that lack contrast. To an extent, these deficiencies can be remedied by downloading the image to a computer and post-processing the image with programs like Photoshop. But Sony has designed the A77 so that you can correct these deficiencies in the camera with two processes: Dynamic Range Optimization (DRO) and Auto High Dynamic Range (Auto HDR). When you select either one of these two operations, the camera will process the image automatically and then save it to your memory card.

Choose DRO when one exposure can record all of the intensity values for the scene. When this is impossible and extreme light levels overwhelm the sensor, use Auto HDR. Auto HDR employs three exposures taken in rapid succession: one for recording highlights, one for recording mid-tones, and one for recording shadows. By combining these three images, it is possible to create a composite where shadows can be lightened, highlights darkened, and mid-tones maintained.

The DRO and Auto HDR functions are found through the Fn button, where you can turn either function off or select one of them.

Fn button>DRO/Auto HDR (right)>[D-R Off], [DRO], [HDR]

Set the function to [D-R Off] to prevent either of the processes from executing.

DRO Function

The [DRO] function has a list of submenu options (table 6-4).

Fn button>DRO/Auto HDR (right)>[DRO]>[DRO AUTO], [Lvl1], [Lvl2], [Lvl3], [Lvl4], [Lvl5]

DRO Function Option	Option Name	Description
D-R OFF	D-R Off	Disables DRO/Auto HDR function.
DRO	D-Range Optimizer	Brings out detail in shadows by lightening and bright, washed-out areas by darkening so that fine details in both areas are more easily discerned.
Sub-Options	**DRO AUTO**	Executes DRO automatically when the image has deep shadows and bright highlights. The camera chooses what level to adjust the blacks and whites.
	DRO Lvl 1	Level 1 – The least amount of change to blacks and whites in the image.
	DRO Lvl 2	Level 2 – The second least amount of change to blacks and whites in the image.
	DRO Lvl 3	Level 3 – The middle amount of change to blacks and whites in the image.
	DRO Lvl 4	Level 4 – The second most amount of change to blacks and whites in the image.
	DRO Lvl 5	Level 5 – The most amount of change to blacks and whites in the image.

Table 6-4: DRO options of the DRO/Auto HDR function

The DRO Level command determines the extent to which shadows are lightened in an image: the maximum effect occurs at Lvl 5, while the minimum effect occurs at Lvl 1. It is difficult to estimate what level you need for a given scene. We recommend trying multiple levels until you get to know how each should look. With practice, you should be able to implement this function to your liking. There is a DRO Auto option where the camera makes the decision, but this does not guarantee recording an image you will like.

As you might remember from chapter 4, the Drive Mode function has the option [BRK DRO]. When this is set, the DRO/Auto HDR function's value automatically changes to DRO Auto, and the function is locked to prevent you from changing the Lv value. Once you change the Drive Mode's setting from [BRK DRO] to another value, the DRO/Auto HDR function reverts back to its previous value.

The DRO function is available in P, A, S, M, Continuous Advance Priority AE, and Movie modes. You can add a Creative Style to affect the results, although Picture Effects are not enabled with the DRO function. Be prepared for some processing wait time if you shoot a long video or hold down the shutter button for many shots in Continuous Advance Priority AE mode.

Auto HDR Function

Traditionally, HDR photography involves downloading pictures taken at different exposures and combining them on a computer to form a composite image. Usually an operation called tone mapping is performed to create an image that displays details in the brightest and darkest areas of the scene. Frequently, the resulting image displays oversaturated colors and a surrealistic appearance, which many find attractive. For example, when you merge three different exposures with third-party software like Photomatix, the final composite image will have dramatically different colors from the original scene.

When you use Sony's Auto HDR function, you might be surprised to find that the final image does not have the supersaturated colors seen when the same images are processed with Photomatix. Indeed, the color balance and saturation of Auto HDR are similar to a DRO image. It appears that Sony engineers have adjusted Auto HDR output so that the resulting image retains the color balance and tonality associated with a typical photograph.

Even though Sony A77 HDR and DRO images resemble each other, there is in fact a difference. If you look in the deep shadows, the DRO image reveals noise while the Auto HDR image does not. This reflects HDR using a longer exposure for capturing shadow detail. In contrast, by using a single exposure, DRO has to increase the brightness in the shadow areas by image processing, thereby making the noise more evident.

The following command (table 6-5) enables the HDR process:

Fn button>DRO/Auto HDR (right)>[HDR]>[HDR AUTO], [1.0EV], [2.0EV], [3.0EV], [4.0EV], [5.0EV], [6.0EV]

Once HDR is selected, you have the choice of letting the camera determine the best EV by setting [HDR AUTO]. Alternatively, you can take control and select a specific EV value ranging from 1.0 to 6.0. The selected value becomes the range over which the three shots are distributed. Use a low EV value when the scene has a moderate range of light intensities; use a high EV value when the range of intensities is more extreme.

HDR Function Option	Option Name	Description
HDR	Auto HDR: Exposure Diff.	The camera shoots three images and combines them to bring out detail, especially in the shadows and bright, washed-out areas. The process closely retains the subject's coloring.
Sub-Options	**HDR AUTO**	The camera determines the best EV value to use to bracket the three shots.
	1.0EV	The camera brackets the three shots within 1.0EV.
	2.0EV	The camera brackets the three shots within 2.0EV.
	3.0EV	The camera brackets the three shots within 3.0EV.
	4.0EV	The camera brackets the three shots within 4.0EV.
	5.0EV	The camera brackets the three shots within 5.0EV.
	6.0EV	The camera brackets the three shots within 6.0EV.

Table 6-5: HDR option of the DRO/Auto HDR function

The HDR function is available in P, A, S, and M modes only and is enabled for JPEG files only (Quality = [Extra fine], [Fine], or [Standard]). As with DRO, Picture Effect is not enabled, but you can add a Creative Style to affect your results.

Using DRO and Auto HDR

We encourage you to try these imaging techniques and see if they help your photography. They can be a benefit. But as you gain more experience, you may decide to forego these processes.

We rarely use DRO for still photography. We prefer to post-process RAW images on our computer, where we can try various DRO levels to obtain the effect we want. Sony's PMB software allows you to approximate the DRO effect by working

with RAW images. Although the effect is not identical, we prefer having greater control over the process rather than relying on an automated camera rendering.

Where we have found DRO to be a powerful benefit is in recording video. Your ability to post-process these files may be limited, and DRO provides a simple means of taming extremes in contrast to make a pleasing video.

In regard to Auto HDR: like DRO, it can improve an image, but also like DRO, it is difficult to anticipate the image's appearance. We prefer shooting in RAW, which Auto HDR cannot do, and post-processing on the computer, which allows us to experiment with different interpretations of the composite image. To generate the image files for this task, we describe how to acquire various exposures with auto bracketing in chapter 7.

Three Semi-automatic Modes: Shutter-Priority (S), Aperture-Priority (A), and Program (P)

Using the S, A, and P modes gives you greater control over the camera. You select these modes by rotating the mode dial (figure 6-9). Unlike the Auto and Auto+ modes and the SCN predefined scene modes, here you can select the shutter speed, aperture, WB, and ISO. This gives you greater artistic control in creating the image; however, there is the increased risk of selecting a setting that detracts from image quality.

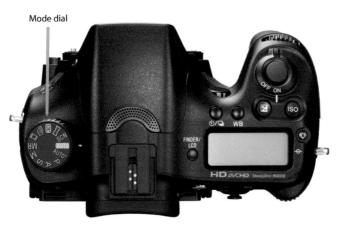

Figure 6-9: The mode dial is the largest knob on top of the camera

Shutter-Priority (S) Mode

Turn the mode dial to S to select Shutter-Priority mode. In this mode, you choose the camera's shutter speed while the camera selects the aperture for proper exposure. This is advantageous for action shots. A fast shutter speed can keep you from blurring the image while your subject is moving. Conversely, if you wish to show moving subjects as an extreme blur, you can use this mode with a slow shutter speed.

When this mode is selected, the letter S appears in the upper left corner of the display screen with the shutter speed number and aperture values glowing white on the lower border. If you rotate either the front or rear control dial, the numbers for the shutter speed change. As the white numbers are changed, they become orange colored. As you change the shutter speed, there is a commensurate change of aperture value ensuring that you maintain a constant exposure. If you reach the limits of the lens aperture control—i.e., if you exceed the maximum or minimum aperture—the aperture values will not change and will instead start flashing.

The orange number 2 at the bottom left of figure 6-10 refers to the camera being set for a 2 seconds exposure. Pressing the shutter button halfway reveals the aperture number in white (figure 6-10). If Exposure Compensation is used, the image on the display screen can be either too bright or too dark. If the histogram is visible, it too will indicate over- or underexposure by shifting to the right or to the left.

To correct this, press the Exposure Compensation button. You will see a new screen showing an Exposure Compensation scale (figure 6-11). Rotate the rear or front control dial to the left or right to see the effects of changing exposure on the image. The display screen darkens or brightens: the shutter speed is maintained while the aperture closes or opens. The scale and numerical values provide a record of how far you have changed the exposure. Press the shutter button halfway to return to Live View.

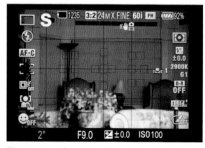 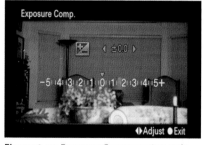

Figure 6-10: S mode with aperture set for f/0.9—note it is displayed in white

Figure 6-11: Exposure Compensation scale

Awareness of shutter speed is important for two reasons. The most obvious is in action photography when you wish to freeze motion. A shutter speed of 1/500 of a second or faster is desirable when freezing a running athlete. Conversely, a slow shutter speed of 1/60 of a second may blur the athlete's entire body, giving the impression that he is speeding along the track.

With experience, you can combine these two effects so that a running athlete's face and body are recorded sharply while his feet and arms are blurred. This provides an intermediate effect, allowing the viewer to recognize the athlete while maintaining the impression of rapid motion. A favorite technique in scenic photography is to use a long shutter speed to blur moving water, hiding the individual splashes and drops (figures 6-12(a-b).

The second reason for keeping an eye on shutter speed is that the camera can move during slow shutter speeds, especially if it is being handheld. Hand tremors blur the fine details of the image. As a rough approximation, when the shutter speed is slower than 1/focal length of a lens in mm, the subject's fine detail can be blurred by camera movement. When you are at slow shutter speeds, consider the following three options: opening the aperture, raising the ISO, or mounting the camera on a tripod. The SteadyShot feature provides you with a bit more safety: users claim they can hold 2-3 EV lower shutter speeds when this is on. But without a tripod, there is no guarantee of obtaining a tack-sharp image at slow shutter speeds.

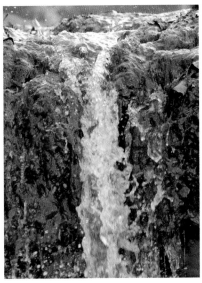 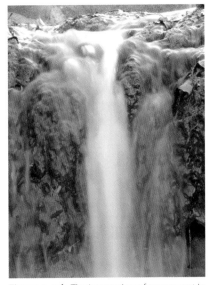

Figure 6-12a: A small stream recorded with a shutter speed of 1/320 second

Figure 6-12b: The impression of movement is enhanced when using a longer shutter speed (4 seconds)

Aperture-Priority (A) Mode

Aperture-Priority (A) mode is the converse of S mode. Here, you select the aperture and the camera selects the shutter speed. This gives you control of depth of field, which is critical for close-up photography where depth of field is shallow. If the lens aperture is open, the shallow depth of field blurs parts of the image. This effect can be advantageous in portraiture where you focus on the model's face, opening the aperture to blur the background and foreground. In this manner, the viewer's attention is focused on the face.

In A mode, as soon as you press the shutter button, you see both the aperture values and the shutter speed (figure 6-13). When you turn either the rear or front control dial, the aperture numbers turn orange while the shutter speed numbers remain white. Exposure Compensation works as described for S mode, except you change the shutter speed rather than the aperture when over- or underexposing.

Figure 6-13: A mode with aperture at f/4 and shutter speed 1/3 of a second displayed in white

Press the Preview button to see the effects of closing down the aperture and ascertain whether you have sufficient depth of field. This button stops down the lens to the recommended exposure so you can see its effects.

Program (P) Mode

Program (P) mode is similar to Auto mode in that it sets both shutter speed and aperture, but with an important difference: you are in complete control of both. You have to make the decision whether the shutter speed should be fast or slow, or whether the aperture should be opened or closed. When the camera first selects an aperture/shutter speed you will see a P in the upper left corner of the screen (figure 6-14). If either the aperture or shutter speed is inappropriate, you can change these values with the Program Shift function. Simply rotate the front or rear control dial, and these values change in synch so that you maintain a constant exposure. An asterisk will appear next to the P as a reminder that you have implemented the Program Shift function.

Figure 6-14: When you select P mode, shutter speed and aperture are displayed on the screen

To use Program mode turn the mode dial to P and press the shutter button halfway. The aperture and shutter speed values appear in white. Turning the rear control dial to the left or right changes both the shutter speed and aperture. Your exposure does not vary.

Exposure Compensation is also available in the P mode via the Exposure Compensation button.

Recommendations

Once you move the mode dial to P, A, or S, you start taking greater control of your camera. Many controls unavailable to you in the Sony A77's automatic modes are now accessible, and you can develop your own working style.

The first thing is to be aware of how the controls work. For example, the focusing area can be changed, and being able to do so rapidly can make your camera more responsive. We usually use the [Wide] option because it does not require precise aiming and can quickly focus on the subject. The danger is that out of 19 autofocus areas, the camera may select one that is not optimal. Because of this, we tend to use a smaller lens opening to increase the depth of field.

When working with a lens with a shallow depth of field, we take advantage of [Spot] and [Local] and use a [Single] focusing area. This slows us down, but it is necessary when photographing small birds with a long telephoto. When the bird is perched, we aim the selected [Spot] on the bird's eye and use it for focus. With a long telephoto and an open aperture, the bird's eye and head are in focus: the shallow depth of field causes some blurring of the breast feathers or beak.

To rapidly switch between [Wide] and [Spot,] we disable the Object Tracking function. This activates the multi-selector button so that pressing it during live preview sets the AF area to [Spot]. Keeping the button depressed initiates and locks focus. We take the picture by maintaining pressure on the multi-selector button while pressing the shutter button.

Even with accurate control of the autofocus area, we find it necessary to rapidly switch from AF to MF for critical work with long telephotos. The AF/MF button is conveniently placed at the rear of the camera body, and pressing it disengages the motor drive from the focusing ring. This is especially critical if you are using an older Minolta or Konica Minolta lens that is driven by the focusing motor in the camera's body. Pressing the AF/MF button frees the lens's focusing ring so it can be rotated without damaging the internal motor.

When working with long lenses, we find it desirable to go into the menu and reassign the AF/MF button's function from [AF/MF Control Hold] (the default) to

[AF/MF Control Toggle]. The former requires that you continually press the AF/MF button to focus manually, while the latter requires only one press. In order to return to AF, you press the AF/MF button a second time.

We use AWB. However, we often find using predefined WB selections to be useful. For example, when photographing a red sunset, AWB seems to tone down the colors, and we feel we obtain better coloration by using the preset Daylight WB. If you shoot RAW, you can alter white balance during post-processing, and we frequently take advantage of this convenience. For example, in Image Data Converter, the Specify Gray Point function enables you to select a region of neutral color in your image and use it to establish WB. This is a very nifty capability; sadly, it is not usable with JPEG files. Because of this, when we shoot JPEGs only, we take extra care in choosing WB. If the color balance is incorrect and the preset values do not work, we use Custom white balance.

In regard to ISO, we like to set our own speed. For our highest quality work on a tripod or in the laboratory, we use ISO 100. For rapidly moving subjects in daylight, we use ISO 400-800. For dim light work, we go to 1600 and occasionally 3200. For low light work, we prefer ISO 400 with a tripod. For occasions when a tripod is unavailable, we use Multi Frame Noise Reduction.

In terms of regulating contrast with unusual lighting conditions, we do not use DRO. In part, the problem is the difficulty of envisioning the results prior to taking the exposure. We are more comfortable taking a picture with this command [Off] and then post-processing our RAW files instead. Many image processing software packages allow you to control the brightness of highlight and shadow areas independently. Image Data Converter has a DRO command, and we find that working with it is more convenient than trying to work with the Sony camera commands.

In regard to Auto HDR, we do use this function to tame extremes in lighting levels. However, when we want to generate surrealistic HDR colors, we use Bracket Continuous. We save differently exposed images and download them to a computer for post-processing with the Photomatix program. We enjoy the effects that can be achieved with that software.

In terms of our shooting style, we tend to use Aperture-Priority (A) mode when we are concerned about depth of field and Shutter-Priority (P) mode when we are concerned about shutter speed. This usually translates into using Aperture-Priority for stationary subjects and Shutter-Priority for moving subjects. Program-Priority is our point-and-shoot mode. Although we could use the more automated Auto or Auto+ modes, we like to save our files as RAW and therefore prefer the camera's Priority modes.

Chapter 7: Manual Operation of the Camera

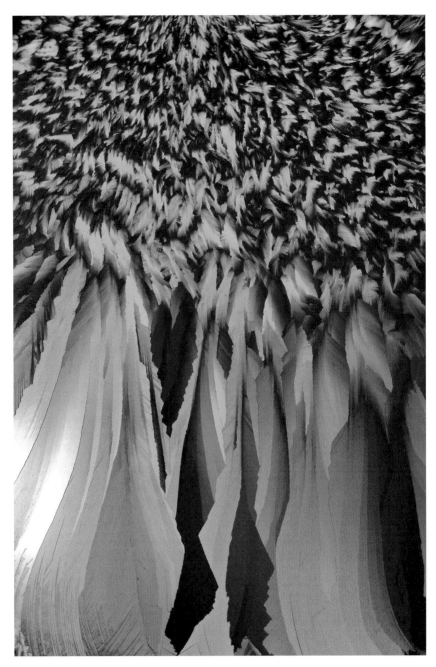

7

Introduction

Chapter 6 dealt with partially automated/partially manual settings, where the camera is setting its own aperture, shutter speed, or focus. This chapter is about taking complete control of the camera and fine-tuning its settings.

There are conditions where you want the exposure and focus to be fixed to a constant value. For example, suppose you want to take a panoramic shot the old-fashioned way without using the A77's Sweep Panorama feature (see chapter 8). To do this, you mount the camera on a tripod, set the exposure to manual, and take a series of overlapping pictures by panning with the tripod head. Focus is also fixed and will not change as you perform the pan. After you take all the pictures, you merge them on your computer to create your panoramic image.

The advantage of doing a panoramic this way, which is more inconvenient than Sony's automated Sweep Panorama mode, is the increase in resolution. By working with the full area of the sensor, you can collect a series of images that have a vertical height of 4000 pixels rather than the 2000 pixels generated with Sweep Panorama. A knowledgeable shooter can go further and create an even larger panorama by doing multiple sweeps.

Knowing how to set the camera to manual exposure and manual focus enables you to pursue strategies like this for improving your images.

In addition, we cover some advanced features that can be used in P, A, or S modes to extend your control over the camera. For example, you can instruct the camera to change a command value incrementally for each picture in a series. This creates a set of images (or "bracket") in which each is slightly different so you can select and use the best. For example, you can set a command to take a series of pictures where the exposure varies between each shot. Simplistically, this provides a shotgun approach for finding the proper exposure. For the expert, it may be the basis for generating an image under difficult lighting conditions, or for creating a surrealistic color rendition by using HDR in post-processing.

Manual Exposure Mode Controls

Turning the mode dial to M sets the camera to Manual Exposure (M) mode and displays M in your electronic viewfinder or LCD display (figure 7-1a). The aperture and shutter speed values are displayed at the bottom of the screen as white numbers. You can change them by rotating either the front or rear control dial: once you start rotating the dial, the numbers controlled by it turn orange and change in value (figure 7-1a). If you do not move the control dial for 10 seconds or more, the orange color will change to white. As you proceed to set the aperture or shutter speed, you will see a set of numbers change. These numbers are next to the letters M.M. (Metered Manual) on the bottom, center of the LCD screen. The numbers

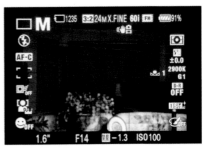

Figure 7-1a: M is displayed when in M mode and f-stop is being altered

Figure 7-1b: Varying from recommended exposure

indicate the EV, and that you are departing from the recommended exposure. In the case of figure 7-1b, the camera is set to −1.3 EV; a lower exposure than what the camera recommends.

In M mode, the brightness of the Sony display screen is an indicator for the appearance of the recorded image. If the camera's sensor is receiving too little light to record an image, you will see a black screen. If the sensor is receiving too much light, you will see a brilliant white screen. Use the front and rear control dials to adjust the aperture and shutter speed until the image appears acceptable on the display screen.

The camera's display screen provides EV data indicating whether you are following the camera's recommended exposure (0 EV) or the degree you are departing from that recommendation. It will show a 1/3 EV difference for up to +/− 2 EV. The EV scale provides a quantitative value so you can apply a known offset to the recommended exposure. As the camera departs from 0 EV, you will see a scale indicator. The changing set of numbers indicates how far you are moving from the camera's recommendation. For example, when recording a snow scene, you may feel that the recommended exposure results in an image where the snow appears dingy or gray. To restore the brilliant white appearance of the snow, you can apply +1 EV additional exposure. The beauty of having a Live View camera is that you can ascertain the efficacy of changing the exposure from the camera's recommendation.

A convenient feature of M mode is that you can see a live histogram while changing exposure values. This provides an additional data point to help you avoid overexposing highlights or underexposing shadows.

Extremely Long Exposure "B" Shutter Speed

M mode allows you to set exposures of up to two minutes. Turn the rear control dial to the left until the shutter speed numbers switch from numerical values to the letter B (Bulb). This occurs when you go beyond a 30-second exposure. At this setting, the shutter opens upon depressing the shutter button and remains open as long as it is depressed. Releasing the shutter button terminates the exposure. The B shutter speed is unavailable in any of the semi-automatic (P, A, or S) modes. The longest shutter speed you can set in those modes is 30 seconds. When using long exposures, be sure the camera is mounted on a tripod. Use a cable release to ensure that pressing and releasing the shutter button does not jar the camera.

How Shutter Speed Numbers Work

Normally, the Sony A77 shutter speed is measured in fractions of a second. So when you see the number 1/4, it actually means ¼ second. Once you reach a shutter speed longer than 1/3 second, the display switches from fractions to decimals. So the next longest shutter speed is 0.4. From 1 second on, the "symbol follows the shutter speed number; so 1" indicates one second and 30" represents 30 seconds.

Noise Reduction with Long Exposure

Images with long exposures may suffer from noise. This image defect is corrected by a procedure known as Dark Frame Subtraction, which is controlled by the Long Exposure NR command as follows:

MENU>Still Shooting Menu (2)>Long Exposure NR>[On], [Off]

When the command is turned [On] and exposure is set to 1 second or longer, the following steps occur:

1. When the shutter button is pressed, the camera records the image including the noise generated by the sensor.
2. The camera takes another exposure but does not record an image. This is the so-called "dark frame" which creates a reference map for the noise pattern.
3. The camera subtracts the dark frame image from the first image to reduce the noise.

The Long Exposure NR command at least doubles the time it takes to record an image. For example, if you take a photograph with a 10-second exposure, the camera will automatically take a subsequent exposure of equal time to create the dark frame. Then the camera processes the subtraction to remove the noise from the first image. For exposures that run over several seconds, this can create a tedious wait, so some people turn this command off.

Most of our exposures are less than 1 second in duration, so for us this function is rarely useful. However, in the few pictures we have taken with long exposures, we have been pleased with the results of the Long Exposure NR command, and therefore we leave it on.

B stands for Bulb

"Bulb" is a historical reference to a time when cameras had pneumatically driven shutters. To open the shutter, the photographer squeezed an air bulb, and to close the shutter, the photographer released the bulb. In modern cameras, the analogous operation is to press the shutter button to open the shutter and maintain pressure on the button to keep the shutter open. Releasing the shutter button closes the shutter.

If you intend to use long exposures, we recommend that you get a remote camera release. Sony's cable release has a lock to keep the shutter open, which makes using long shutter speeds more convenient.

Noise Reduction at High ISO

We previously mentioned that using higher ISOs results in increased noise and that we tend to photograph at ISOs lower than 1600. If you are forced to work at higher ISOs, you might try the in-camera noise reduction option. You can set noise reduction to High, Normal, or Low. While this option does work, it sacrifices definition to provide you with a smoother image. It also works only on JPEG files, not on RAW files. Be aware that this command can take some time to execute, so for a moment your camera may not be ready for the next shot. You can use the following menu command to adjust the level of Noise reduction:

MENU>Still Shooting Menu (2)>High ISO NR>[High], [Normal], [Low]

We set the High ISO NR command to [Low]. If noise is a problem, we take the picture as a RAW file and remove the noise later using third-party software. We use Noise Ninja, which seems to reduce noise with less loss of detail than Sony's High ISO NR option.

Metering Modes

When controlling your exposure is critical, it is important to know where and how your camera's light meter measures intensity. There are three methods used by Sony's built-in meter: [Multi segment], [Center weighted], and [Spot] (table 7-1).

The default and most commonly used method is [Multi segment], where light over the entire area of the display is used to calculate the exposure. This is more than a simple average—it is a complex algorithm that ensures a good exposure for a wide variety of subjects. Historically, various digital camera manufacturers developed these algorithms. While the early designs were unreliable, current versions are so reliable that this measurement practically turns your camera into a point-and-shoot. The results are quite good, and you can refine them by studying the live histogram to adjust the exposure slightly. Again, the advantage of having a Live View camera is the ability to ascertain if you need to modify the exposure before you take the photograph.

Metering Mode Option	Option Name	Description
◉	Multi segment	The camera divides the framed image into multiple areas, measures the lighting in each, and determines an overall exposure.
◉	Center weighted	The camera biases its exposure on the central area and provides less emphasis on the periphery.
▪	Spot	The camera only uses the center of the framed image to determine exposure. A faint circle displays on the screen indicating the area the camera will use.

Table 7-1: Metering Mode command icons

The second method is [Center weighted], which uses an easily understood algorithm for evaluating exposure. It is based on the assumption that the most important part of the picture is in the center; therefore, the meter biases the exposure so that the center of the display screen is well exposed. The peripheral areas are measured as well and contribute to the overall exposure, but they are given less priority. Historically, this has been a popular way to measure light in an SLR camera. While this older technology has the virtue of simplicity, it is not as reliable as [Multi segment] area metering, and it results in a higher percentage of unacceptable exposures.

The third and most direct way to meter is [Spot]. It is a natural for M mode. When it is selected, you see a small circle in the center of the screen that marks the area being measured for light. By placing this circle over an area, you get a measure of the intensity from that restricted area; and, by aiming your camera so that this circle covers the region you wish to expose, you can easily set your exposure. It

requires finesse and thought to interpret the reading, but it is a natural to combine this with manual exposure. For example, suppose you are shooting a stage play where the actor is lit with a spotlight and the remainder of the stage is black. You can find the exposure for the actor by using [Spot] to measure the light reflected off his face. The actor's face and body will be exposed properly, and the dark background will not influence the exposure measurement.

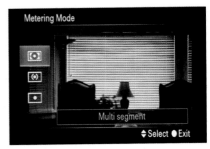

Figure 7-2: Metering Mode's three options with [Multi segment] selected

The metering method is selected with the following command (figure 7-2):

Fn button>Metering Mode (right)>[Multi segment], [Center weighted], [Spot]

Manual Focusing: Overriding Automatic Focusing

In chapter 6, we described how to focus a lens by turning the focusing mode dial to MF. We also described how to use the AF/MF button for quickly resetting focus by switching temporarily to MF. These are important skills, but now we will introduce how to improve focus accuracy even more.

If you have very fine details in your image, you may need to magnify the Live View image to achieve a more accurate focus. This is done by pressing the Smart teleconverter/Focus Magnifier button (figure 7-3, orange arrow). This button's dual name can be confusing because it serves two different functions. Superficially, the functions look identical in that they raise the magnification of the image on the LCD screen or viewfinder. Practically, they are quite different. The Smart teleconverter function works only when Quality is set to a JPEG option. When executed, the magnified image can be captured. It is an example of digital magnification and its effect can be obtained in post-processing the image on the computer. In contrast, Focus Magnifier function solely works as a means of increasing the magnification of an image on the LCD screen and viewfinder and does not allow you to save the magnified image. It will work in either RAW or JPEG formats.

This button's functionality is controlled by the following command:

MENU>Custom Menu (3)>Smart Telecon. Button>[Smart Telecon.], [Focus Magnifier]

When set to [Smart Telecon.], pressing the button once provides a 1.4X increase in magnification; press it again to get a 2X increase in magnification. This enlarges fine details on the subject's surface, making it easier to focus precisely.

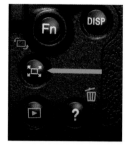

Remember, the Smart teleconverter command only works when you use JPEG and not when you use RAW. Its real role, as mentioned earlier, is as a digital zoom that crops the captured image down to what you see in the display screen. If you attempt to use this feature while shooting RAW & JPEG or just RAW, you will be interrupted by an error message requesting that you set the camera to JPEG. Typically, this occurs just as you

Figure 7-3 Smart teleconverter/ Focus Magnifier button on the back of the camera (Photograph courtesy of Sony)

are about to take a prize-winning picture, and the delay imposed by this message forces you to miss the shot.

Since the Smart teleconverter/Focus Magnifier button performs a function that can be done at home on the computer, we don't care to use it. To avoid losing shots, we reassign this button's function to [Focus Magnifier]. When the button serves only as Focus Magnifier, it works with both RAW and JPEG formats.

The major disadvantage of increasing magnification is losing the overall view of your subject. Admittedly, you return to full view when you press the shutter button, but the delay can be disconcerting. Because of this, we take advantage of the Peaking function. This is a colorization strategy that highlights the borders of in-focus areas with a fringe of color. You can determine how large and what color these fringes should be. They are not recorded with your picture or video, and they only appear when you resort to manual focus.

MENU>Custom Menu (2)>Peaking Level>[High], [Mid], [Low], [Off]

MENU>Custom Menu (2)>Peaking Color>[Red], [Yellow], [White]

We use Peaking at its [Mid] setting with the yellow color when taking pictures through a microscope or telescope. When we take pictures outside, we switch to red, which stands out much better in sunlight. For evening pictures, we usually switch to white.

Peaking is inactive while the camera is in AF. It only appears when you use MF by either turning the focus mode dial to MF or pressing the AF/MF button.

Fine Adjustment Screen for Color

In chapter 6, we described how to use standard settings for white balance and how to calibrate your camera to a light source using a white sheet of paper. For most of us, this is sufficient. However, the Sony A77 provides even greater control by allowing you to visually fine-tune your color settings. Once you select a WB setting, you can add tinting to record the perfect image.

Undesirable colors can be the result of unusual lighting conditions, such as when several different light sources illuminate the subject. For example, an interior scene might be lit by daylight streaming through the window, an incandescent light on the table, and fluorescent lights on the ceiling. These extreme conditions can be corrected by adding a tint to the image. The slight additions of hue will be recorded in both JPEG and RAW files. Sony calls this Fine Adjustment for Color. It is a continuation of using a WB preset.

When you are in a WB preset—for example, with daylight highlighted—toggle the multi-selector to the right (figure 7-4a). This brings up the color fine-adjustment screen, which is seen as a multi-hued square. Initially there is an orange dot in the center of the square. Toggle the multi-selector vertically to control the magenta/green tint (figure 7-4b) or toggle horizontally to control the amber/blue tint. Apply these controls until you neutralize any color cast on the viewing screen. The degree of tinting is shown by the displacement of an orange square within a large multicolored square. Press the multi-selector button to exit the WB adjustment. In the case of figure 7-4b we actually imparted a magenta/amber tint to the screen to show the tints being applied.

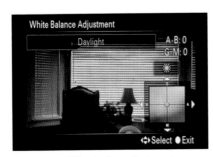

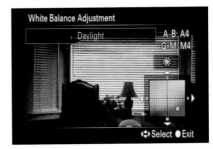

Figure 7-4a: WB color fine adjustment screen

Figure 7-4b: WB color fine adjustment modified to apply magenta/amber to the image

Lens Compensation

To obtain the ultimate picture quality, the A77 has software that corrects imperfections introduced by the lens. These imperfections include vignetting (peripheral shading), distortion (geometric distortion), and chromatic aberration (color fringing). Vignetting indicates uneven illumination, with the periphery of the image darker than the center. Distortion indicates that straight lines bow in (pincushion distortion) or bow out (barrel distortion). Finally, chromatic aberration indicates that the subject's borders have red or blue fringes due to the lens's inability to bring all wavelengths of light to the same focus.

Correcting these problems with software requires an in-camera database to catalog the lens defects and a processing algorithm to correct the image. Sony periodically provides updates to the camera firmware, expanding the database as new lenses are introduced to its line-up. Remember, this correction is a software alteration of the image and is providing a modified image file. For the scientist who requires the recording of an unaltered image, these corrections should be turned off, leaving the recorded image showing all of the lens defects.

The chromatic aberration and shading correction default setting is [Auto]; so, if the attached lens is in the database, these optical faults will be corrected in JPEG files. RAW files are not corrected, and they will show the image defects. Curiously, at the time of writing, the distortion default setting is [Off]. If you desire it to be active, you must turn it to [Auto].

Below are the three lens compensation commands. Once you select one of them, press the multi-selector button to enter the command and then toggle up to select [Auto] or down to select [Off].

MENU>Custom Menu (5)>Lens Comp.:Shading>[Auto], [Off]

MENU>Custom Menu (5)>Lens Comp.:Distortion>[Auto], [Off]

MENU>Custom Menu (5)>Lens Comp.:Chromatic Aberration>[Auto], [Off]

Fine Tuning Autofocus

The phase detection sensor used for focusing is noted for its speed. However, it is also known that, for some lenses, the sensor may incorrectly identify the focus point and set it behind (back focus) or in front (front focus) of the desired point. Sony provides the following command for the experienced user to tweak the focus point:

MENU>Setup Menu (2)>AF Micro Adj.>[AF Adjustment Setting], [amount], [Clear]

If you suspect that your lens is front or back focusing, you should use the command. Keep in mind that this adjustment, if done improperly, can result in your images being further out of focus.

We recommend the following procedure to test a lens for focus accuracy: first, mount the lens on the camera and aim it at a newspaper lying flat on the floor. Use a tripod and adjust the camera so it is aimed down at approximately 45 degrees. What you want to see in the viewfinder is the lines of newspaper print running parallel to the viewfinder's horizontal axis. The camera's digital level gauge and grid lines can help ensure that when looking through the camera's viewfinder, the lines of the newspaper text should run parallel with the horizontal frame of the viewfinder.

Next, focus on a single line of text by setting the camera to [Spot] AF area. Aim the central AF area on the selected text. In figure 7-5a, it is the line with the bold lettering, "incident brightfield . . ." Using the maximum aperture, take a picture and note in playback mode whether this line is sharp or blurred. You will have to magnify the image in playback, but if it was centrally placed it will stay in the center of the LCD screen.

is brought to bear on the sam
the object of study need not r
incident light reflected from

The Leitz Ultropak is a fine s
illumination is entirely separ
form the image itself — a situ
opaque objects which I study
than when incident illuminat
"incident brightfield illumin
function — their illumination
forming rays, particularly in

Notice that in the case of inc
condenser. Inevitably then,

Figure 7-5a: Camera aimed at newspaper to test lens focus accuracy. The bold font in the center is in focus; the text toward the top is out of focus.

is brought to bear on the sam
the object of study need not r
incident light reflected from

The Leitz Ultropak is a fine s
illumination is entirely separ
form the image itself — a situ
opaque objects which I study
than when incident illuminat
"incident brightfield illumin
function — their illumination
forming rays, particularly in

Notice that in the case of inc
condenser. Inevitably then,

Figure 7-5b: Lens focus AF Micro Adj. changed so the bold type in the center and the text toward the bottom are now out of focus

If this line is out of focus, as in figure 7-5b, you have a problem: here, it is back focusing. To correct, go into the AF Micro Adj. command, select [AF Adjustment Setting] and adjust by selecting +5 or −5. You can then go back and repeat the shot to see whether you corrected the error.

Sony cameras can remember up to 30 lenses. Apparently the lens focal length and aperture are the identifying tags; so, if you have two lenses with the same focal length and aperture, they cannot be distinguished.

Bracketing and Dynamic Range

The Sony A77 has a special feature for dealing with unusual lighting conditions. If it is difficult to judge exposure, white balance, or contrast, the camera can record several images, each differing slightly. By using this shotgun approach, it helps you find the best setting. Three of these functions are available when you press the Drive Mode button or the Fn button. They are White Balance (WB) Bracket, DRO Bracket, and bracket exposure.

WB bracket works with both RAW and JPEG files. You will get three RAW and three JPEG files where the JPEG files will show the effects of different WB values on a single exposure.

DRO Bracket works most efficiently with JPEGs. Firing an exposure records three JPEG images, each reflecting a different level of DRO. If you try to use DRO Bracket with RAW or RAW & JPEG, the three RAW images will look identical when loaded into your computer.

Bracket exposure works with both JPEG and RAW files and involves taking three shots each with a different exposures resulting in three JPEG and three RAW files. The RAW and JPEG files will differ, reflecting the changing exposure.

White Balance Bracket

In WB Bracket, the camera takes one exposure and generates three images from it via internal processing that show slight variations in white balance. You can find this option by pressing the Drive Mode button or by selecting the Drive Mode function through the Fn button. Then use the multi-selector to navigate to WB Bracket. You can select [Lo] or [Hi] level of color shift; [Hi] provides a greater color shift than [Lo].

Fn button>Drive Mode (left)>WB Bracket>[Lo], [Hi]

DRO Bracket

We described DRO in chapter 6. DRO Bracket is found when you press the Drive Mode button or select Drive Mode function through the Fn button.

Fn button>Drive Mode (left)>DRO Bracket>[Lo], [Hi]

When you select DRO Bracket, you have a choice of [Lo] or [Hi]. Your selection depends on how wide a range you want to cover with the bracket. [Lo] provides three images with a DRO effect of LV1, LV2, and LV3. [Hi] covers a greater range, providing three images with a DRO effect of LV1, LV3, and LV5.

Like WB Bracket, DRO Bracket uses one exposure to generate three renderings of the subject. Remember, these differences are generally seen in the JPEG files and not in the RAW files. The camera only fires one shot and generates the three different images through internal processing. One oddity about using RAW files with DRO Bracket is that you will see its effects during playback on the LCD screen or if you use Sony's Image Converter software. But if you use third-party software, such as Apple's Aperture, you will not see any difference in the three recorded RAW files.

Bracket Shooting Cont. and Single Bracket

Bracket shooting differs from both WB and DRO brackets: your camera actually exposes the sensor multiple times and records multiple shots. Although the saved shots can be used to fine tune exposure, we prefer using them for HDR (High Dynamic Range) photography. To do this, we download the three exposures to our computer and use HDR software to combine them into a composite image. With tone mapping software, we can alter color and contrast to produce surrealistic images. This differs from Sony's Auto HDR function, which renders a more realistic image without extreme coloration.

The bracket shooting technique overcomes the sensor's limitations through image processing. For example, a single exposure concentrates on the mid-tones in a scene; therefore, a bright sky may be overexposed and deep shadows may be underexposed (figure 7-6a). When you bracket exposures, you can use the first shot to record the camera's optimum exposure; the second shot to record details in the highlights (figure 7-6b); and the third shot to record details in the shadows (Figure 7-6c). The final composite HDR image shows detail in both the highlights and shadows (figure 7-6d).

Individually, figures 7-6(a-c) would be unsatisfactory; but, with the right tone mapping software, you can merge them into a single image that displays details in the highlights, the mid-tones, and the shadows (figure 7-6d).

To accomplish this requires collecting a set of varying exposures. Scroll down through the Drive Mode options. Figure 7-7 shows the BRK S and BRK C options on

Figure 7-6a: Camera's recommended exposure

Figure 7-6b: Underexposed by 2 f-stops

Figure 7-6c: Overexposed by 2 f-stops

Figure 7-6d: Combined image using HDR software

the same screen. The BRK S option will collect five shots separated by 0.3 EV when it becomes enabled. The figure also shows BRK C selected with a preset value of three shots separated by 3.0 EVs. To change its value, toggle the multi-selector right or left. To select a new value, press the multi-selector button.

In summary, by pressing the Drive Mode button or the Fn button to access the Drive Mode function, you will find the following commands:

Fn button>Drive Mode (left)>BRK S>[select series] with the series: [0.3EV3], [0.5EV3], [0.7EV3], [2.0EV3], [3.0EV3], [0.3EV5], [0.5EV5], [0.7EV5]

Fn button>Drive Mode (left)>BRK C>[select series] with the series: [0.3EV3], [0.5EV3], [0.7EV3], [2.0EV3], [3.0EV3], [0.3EV5], [0.5EV5], [0.7EV5]

To select the series, you will be prompted to specify the number of shots you wish to take and the difference in EV for each shot. For example, you can choose to take five shots and have them vary by 0.3, 0.5, or 0.7 EV. Or, you can choose to have the shots vary further by 2.0 or 3.0 EVs; however, doing so, limits you to three shots.

Another difference between BRK S and BRK C is that BRK S requires you press the shutter button for each exposure. BRK C takes all the shots automatically when you press the shutter button. We see little need for BRK S and find it inconvenient. It is simpler to use BRK C and collect all our images with a single press of the shutter button.

Figure 7-7: BRK S and BRK C (highlighted) options and assigned values

If you intend to load a series of images into an HDR program, you should be aware of the order in which they are recorded. For example, the Photomatix program prefers receiving the images in this order: underexposed, mid-exposure, overexposed. The file numbers assigned to each image are used to establish order, with lower numbers indicating less exposure. So you want your bracket series numbered to indicate this. If you do so, loading your files onto the program will be an easy process since it will automatically take the data and process it correctly. If you set the Bracket order to [o⇨-⇨+] the computer will not be able to process the images automatically. You will have to manually renumber the file names so that they follow a progression of underexposed to overexposed photographs.

MENU>Custom Menu (4)> Bracket order>[0⇨-⇨+], [-⇨0⇨+]

The option [o⇨-⇨+] starts the exposure sequence at the exposure recommended by the camera meter and then proceeds to underexpose and overexpose the scene. (Photomatix has trouble accepting this sequence, and you will have to reorder it.) The second option, [-⇨o⇨+], starts the exposure on the underexposure side, proceeds to the recommended exposure, and then goes to the overexposure. This is the correct order for Photomatix.

Recommendations

Manual operation of the camera is for the perfectionist who wants to obtain the best possible exposure and focus. Though it can be done by handholding the camera, the better strategy is to mount the camera on a tripod.

You might think that tripods are only for static landscapes, but this is not so. If you are a nature photographer working with extreme telephotos or macros, you will find the tripod a useful tool. Its stability helps you judge focus critically and frame your pictures precisely. You can obtain high quality images with lower ISOs and longer shutter speeds, and also work with f-stops where your lens exhibits the best sharpness.

For our work with telephotos and close-up lenses, we find ourselves using f/8 or f/11 and relying on MF. We may use AF at first, but with some subjects—especially animals in the field—we have to override AF and use MF. To ensure the most accurate focus, we reassign the Smart Teleconverter button's function to [Focus Magnifier].

We also find the Peaking function to be invaluable. It also assures us that our subject is in focus, thus we acquire a higher percentage of sharp photographs. This reduces the need to delete out-of-focus images and do reshoots. Set the Peaking Level to the [Mid] option first. From there, you can determine whether you prefer more or less color fringe. When choosing a color, consider one that will show up the best with the type of pictures you take.

When shooting outdoor scenes, we turn off AWB and set WB to one of the preset values. When working indoors with incandescent lighting, we use Custom WB. We do not do fine adjustments of color on the camera; for that, we prefer working with the saved file on our computer.

We do not use WB Bracket or DRO Bracket, since the Sony A77's live preview allows us to get good results with the camera controls.

When photographing for HDR, we use bracket shooting over Auto HDR. We load the images into third-party software, such as Photomatix. Once the photographs are merged we use the software for tone rendering. If you decide to do this, we have the following recommendations.

First, mount the camera on a tripod. Any shift in the camera position will blur the resulting pictures when they are merged. Use the camera in A mode to force it to maintain a constant aperture, and then you can vary the exposure by changing the shutter speed. Maintaining a constant depth of field is essential for merging the images; otherwise, you will lose definition in areas that become blurred as the depth of field becomes changes. Lastly, use a cable release in order to prevent any movement prior to or during exposure.

7

If you do not have a tripod, it is possible to capture HDR by bracing yourself against an immobile object, using a fast ISO to keep the shutter speed high, and using a wide-angle zoom setting. If you do this, it will increase the chance that you will capture a high-quality set of images that can be merged.

Do not forget to select BRK C. You want to capture the shots as quickly as possible with the camera aimed at the same point during the sequence. If you use BRK S, you will have to press the shutter for each shot you take, allowing sufficient time for a mobile subject to move, and thus resulting in images that will be significantly out of alignment.

Chapter 8: Additional Features

Introduction

The Sony A77 has many exciting features that give you the opportunity to capture unique pictures. Normally, these techniques require downloading the images to a computer and then doing image processing, but you can carry out many of these processing techniques automatically within the Sony A77. We have discussed some of these techniques in earlier chapters, such as ISO's Multi Frame Noise Reduction and Auto HDR functions.

In this chapter, we cover three remaining modes on the mode dial: Sweep Panorama, 3D Sweep Panorama, and Continuous Advance Priority AE. Each of these modes offers you an opportunity to capture a special image that would have been difficult and time-consuming with more conventional photographic methods.

We also cover another wonderful Sony A77 feature: retrieving GPS information. The A77 can be set up to capture GPS information and store it with still pictures recorded at the site. The camera's software goes further by also correcting date and time information that may have changed due to entering a different time zone. So, when you return from trips where you see a new location every day, you don't have to try to reconstruct which picture came from where. The saved GPS information does that for you when you view your images through Sony's PMB software.

Panoramic Modes

The Sony A77 uses two modes to build a wide view of a scene: Sweep Panorama (figure 8-1) and 3D Sweep Panorama. Just as the names indicate, both of these modes create panoramic pictures—one as regular 2D images and the other as 3D images that can be played back on compatible 3D HDTVs. In both cases, the recorded images are created in JPEG format; in addition, the 3D image has an additional MPO file used with the JPEG file to create the 3D effect on your HDTV.

Figure 8-1: Mode dial set to Sweep Panorama

In both modes, a panoramic picture is created by slowly and smoothly sweeping (or panning) a large area horizontally or vertically. The camera rapidly takes a series of shots as you sweep. Once this is completed, the camera stitches them together to form a panoramic image. But there are some conditions. The camera needs to be moved at a fairly constant rate—neither too fast nor too slow. You must also sweep on a level horizontal or vertical plane. This is an excellent opportunity to utilize the Level data display

option discussed in chapter 3. Any substantial variation in the speed or level, and the camera will stop shooting and display an error message.

During the sweep, the shutter speed, ISO, and aperture is set on the basis of the available lighting. The camera will not use a shutter speed longer than 1/60 of a second. The camera applies the exposure setting at the beginning of the sweep and does not change it during the recording, so in extreme lighting conditions, the panorama may have areas that are under- or overexposed.

The camera does an excellent job of recording the individual shots and stitching them together. The software is very tolerant of small variations in the sweep rate and the level. Actually, you can get some very interesting results when you break the rules. For example, you can try changing the zoom setting while you are panning, which creates an interesting staircase-type pattern. You may also notice that if you take a panorama with moving objects, such as cars speeding along a road, you can capture the moving objects several times so they appear cloned in the final picture. It's certainly worth experimenting with this mode.

The camera automatically saves the file as a JPEG with the quality set to JPEG [Fine]. If you previously had the quality set to another value, like [RAW], the camera will record the panorama in JPEG and when you exit Panorama modes it will revert back to the file quality previously set.

The camera also automatically determines the ISO, WB, focus, and exposure when framing the initial starting point. You do have the option of making adjustments, although ISO can only be adjusted through the Fn button and not through the ISO button on the top of the camera. You can assign the image's metering mode and apply a Creative Style.

In either Panorama mode, you cannot use the flash, self-timer drive mode, any multiple exposure shooting mode, Picture Effect, Object Tracking, Face Detection, Smile Shutter, or DRO functionality.

You can magnify the images before recording the picture, but you can only enlarge recorded Sweep Panorama and 3D Sweep Panorama pictures to 16:9.

The camera's menu has two commands for each type of panorama, which are enabled once the mode dial is set to the specific panorama mode. These commands control the panorama's size and the direction in which you are required to sweep the camera.

Sweep Panorama Mode Commands

Switch the mode dial to Sweep Panorama, and the following commands are enabled (figure 8-2):

MENU>Still Shooting Menu (1)>
Panorama: Size>[Standard], [Wide]

MENU>Still Shooting Menu (1)>
Panorama: Direction>[Right], [Left],
[Up], [Down]

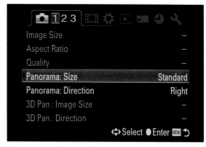

Sweep Panorama has two sizes: [Standard] and [Wide]. The picture's pixel count depends on the selected size and direction (table 8-1). With [Wide], you

Figure 8-2: Sweep Panorama commands

can pan further and get much wider coverage in the resulting picture. You can sweep the camera in four directions: [Right], [Left], [Up], and [Down].

One thing to note: the [Standard] and [Wide] options produce pictures at the same height. Although the [Wide] version might appear shorter, it isn't. Instead, the whole picture is displayed smaller so you can see more of it in the display screen.

Sweep Panorama Size		
Panorama Direction	**Standard** **Equivalent Pixels**	**Wide** **Equivalent Pixels**
[Right] / [Left]	8192 x 1856	12416 x 1856
[Up] / [Down]	3872 x 2160	5536 x 2160

Table 8-1: Sweep Panorama size

8

Figures 8-3(a-d) show Sweep Panorama results for several different combinations of size and direction.

Figure 8-3a: Size/Direction = Standard/Right

Figure 8-3b: Size/Direction = Wide/Right

Figure 8-3c: Size/Direction = Standard/Up

Figure 8-3d: Size/Direction = Wide/Up

3D Sweep Panorama Mode Commands

Switch the mode dial to 3D Sweep Panorama, and the following commands are enabled (figure 8-4):

MENU>Still Shooting Menu (1)>3D Pan.: Image Size>[16:9], [Standard], [Wide]

MENU>Still Shooting Menu (1)>3D Pan.: Direction>[Right], [Left], [Up], [Down]

3D Sweep Panorama has three sizes: [16:9], [Standard], and [Wide] (figure 8-5(a-c)). As with Sweep Panorama, [Wide] allows you to pan further and gives the resulting picture much wider coverage, but again it appears shorter than the [Standard] 3D image when playing back on the LCD screen. Selecting [16:9] results in a 3D picture with the least amount of panoramic width coverage. It has the same ratio as a movie but creates a 3D still image. All of the panoramas in each of the three sizes have two files stored on the memory card: JPEG and MPO.

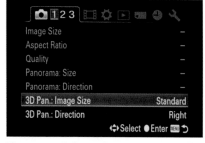

Figure 8-4: 3D Sweep Panorama commands

3D mode has only two directions to choose from: [Right] or [Left]. This may seem limiting, but it actually isn't. Read the box on "Recording a Vertical 3D Panorama" to learn how to get around this.

As with Sweep Panorama, 3D Sweep Panorama images have pixel counts that depend on the selected size and direction (table 8-2).

3D Sweep Panorama Size (Equivalent Pixels)			
Direction	16:9	Standard	Wide
[Right] / [Left]	1920 x 1080	4912 x 1080	7152 x 1080

Table 8-2: 3D Sweep Panorama size

Figures 8-5(a-c) show several combinations of 3D Sweep Panorama size and direction results.

Figure 8-5a: Size/Direction = 16:9/Right

Figure 8-5b: Size/Direction = Standard/Right

Figure 8-5c: Size/Direction = Wide/Right

Recording a Vertical 3D Panorama

Just because you have set the camera to sweep right (or left) doesn't mean you can't sweep up (or down) instead. The camera expects you to sweep at a constant speed, keep the camera relatively level, and move the camera in the direction of the arrow displayed in the viewfinder. As long as you do that (and the camera can obtain focus), you will get a panoramic image.

Let's say you want a 3D panorama of a tall tree. You can select any of the three sizes. Set the direction to [Right] and hold the camera at 90 degrees with the arrow pointing upward. Position the camera framing the bottom of the tree. Press the shutter button and shoot the panorama like you would normally, moving the camera in the direction of the arrow. The camera will handle the change in orientation just fine.

Shooting a Panoramic Picture

After you select a panorama type, set its size, and choose the direction to sweep, the camera will display a Live View screen with three things:

- An arrow corresponding with the selected direction.
- A message telling you to sweep according to the arrow.
- A two-tone screen where one side has dull gray over the Live View and the other side appears unaffected (figure 8-6). The line where the two sides meet is the point where the panorama will start. Place this line at the point where you want to start recording the image.

Frame the image so the point where you wish to start the sweep is positioned just inside the non-grayed side of the display screen. Note that the grayed side depends on which direction you select. If you select [Right], the grayed side is on the left of the display screen. If you select [Up], the grayed side is on the bottom of the screen.

Figure 8-6: Sweep Panorama starting point

Make any adjustments you might need to the image's WB, ISO, and exposure. Add a Creative Style if you like. Once you complete your adjustments, press the shutter button halfway again to make sure your focus is still intact.

You have one more step to complete before you can take your panoramic shot. Getting a realistic shot depends on a smooth, level, and constant sweep. It also depends on creating a very tight radius when you do the sweep. So, as you pan the camera, hold it as close to the center of the sweep as possible. The best way to accomplish this is either to hold the camera up to your eye and use the view-finder as your sweeping guide, or mount your camera on a tripod with a vertical or horizontal swivel and sweep the camera using it. These two methods keep the panning in a tight, short radius. Holding the camera away from your body and using the LCD screen as your sweeping guide makes the radius larger and can create some distortion.

Now you are ready to record. Holding your camera steady, press the shutter button down and start panning. Notice that the arrow moves across the screen along a simulated bar as you pan. The bar represents the full amount of time you need to hold the shutter button down and pan the camera. Continue to pan the camera until the arrow has traveled the full distance. If you take your finger off the shutter button prematurely, the process will stop and you will receive an error message. We have found it best to continue to pan until the camera actually stops shooting. That way we know we have not prematurely ended the process.

Panorama Results

Each panorama has an element of mystery as to what exactly you will capture. This is what can make the feature so exciting and inviting to use. Yes, you can end up with a flawless panoramic where everything is a true representation of the scene. Most of these are pictures of stationary landscapes. But even with these ordinary scenes, you can still end up with new and exciting results.

Keep in mind that although using a tripod with a pan head should result in the best quality image, credible and sometimes creative images can be obtained when sweeping by handholding the camera.

Try moving the camera slightly up or down within the narrow range of allow-able vertical movement. The resulting image may have a slightly wavy effect, or it may be narrower in height (or width, depending on the sweep direction) due to the camera's need to create a rectangular image and trim extremes that are out of bounds.

Try taking panoramic pictures of moving subjects. Depending on the subject's speed, panning in the direction the subject is moving may shorten or truncate it, while panning in the opposite direction may lengthen or elongate it. Even taking panoramic pictures of stationary objects can give you some interesting results. When panning, the camera takes images which overlap. Most of the time, the camera's stitching software eliminates the overlapping areas and creates a smooth panned image. However, the resulting panoramic picture may sometimes have the same object appearing multiple times.

Viewing 3D Without a 3D TV

Just because you don't have a 3D-compatible TV doesn't mean you can't view your images in 3D. You can produce anaglyph images with third-party software.

Anaglyph images have been around for a long time. They are created where two images are taken of a subject, one angled slightly off from the other with one having a red color layer and the other with a cyan color layer. These layers are superimposed, creating a composite image. When viewed with 3D glasses (cyan filter over one lens and red filter over the other), the two images' offset creates a combined image, which appears three-dimensional. This works best if the main subject is in the center and therefore appears to be in the foreground, while the remainder of the image appears to be in the background.

We work with the Anaglyph Workshop software package for Mac OS X. (They also have a version for Windows XP, Vista, or higher.) For more information, visit http://www.tabberer.com/sandyknoll/more/3dmaker/anaglyph-software.html

Panning Problems

Taking panoramics can require some trial and error before you are successful. If the camera detects inconsistent panning—i.e., too fast, too slow, or not level—or if the shutter button is released too soon, it will stop recording and display an error message (table 8-3). Although there might be some frustration, we are sure you will ultimately enjoy the results.

Panorama Mode Error Messages	Cause
Could not shoot panorama. Move straight in the direction of the arrow.	• Didn't pan all the way. • Didn't keep the camera level horizontally or vertically. • Panned in the wrong direction.
Could not shoot panorama. Move camera slowly.	Panned too quickly.
Could not shoot panorama. Move camera quickly.	Panned too slowly.

Table 8-3: Panorama mode error messages

8

It can be difficult to pan at a consistent speed each time you record. Most likely you will notice some results with a black section at the end of the picture (figure 8-7). This means you panned too quickly, and the remaining portion of the allotted size did not have anything recorded to fill that space. Try retaking the picture while panning a bit slower.

Continuous Advance Priority AE Mode

We have one more option to discuss on the mode dial: Continuous Advance Priority AE mode (figure 8-8). The name is quite a mouthful, but fortunately the mode is quite simple. It automatically sets the camera's exposure and takes up to 12 shots per second as you continue to hold down the shutter button.

Figure 8-7: Panorama results with unrecorded space blacked out

Why would you use Continuous Advance Priority AE? Let's say you want to take a picture of your best friend crossing the finish line at a 5K run. What are the odds that your finger will press the shutter button at just the right moment to capture this accomplishment? Most likely, not good.

Set the camera to Continuous Advance Priority AE, make sure the focus mode is set to C for Continuous AF, and press the shutter button just as your friend is about to cross the finish line. Somewhere in the 12 images/second, there should be a picture of your friend actually crossing the line.

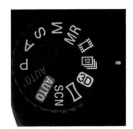

Figure 8-8: Mode dial positioned on Continuous Advance Priority AE mode

This applies to any scenario where you are trying to capture an event that happens in a split second. You can also use the Drive Mode Continuous Hi option and shoot 8 pictures/second, but that might not be fast enough to capture the event. Continuous Advance Priority AE mode gives you a better chance of capturing the moment by giving you 50 percent more shots per second. This ensures a greater chance of capturing a rapidly changing event. However, it is not a technique that is conducive for panning. You have barely more than a second of shooting time

so you can't follow a football runner rushing the length of the football field for a touchdown. Rather, it is a technique for capturing those brief moments of activity, such as when a basketball center leaps up and slam dunks the ball through the hoop.

Continuous Advance Priority AE Mode: Throughput

In a perfect world, where the camera's memory buffer could move unlimited number of images per second to the memory card, this mode's only limitation would be the available space on the card. The problem is that memory cards cannot accept the data quickly enough; plus, the A77's buffer is limited.

To capture rapid sequences, the A77 has a quick memory cache that accepts the images and then transfers them to the slower memory card. Unfortunately, the A77's buffer cannot hold more than 17 images before it is filled, and its acceptance of new pictures is limited by the memory card. Therefore, when you first hold down the shutter button in Continuous Advance Priority AE mode, the camera initially shoots at 12 images/second, but in a little over one second the buffer becomes a bottleneck. The shooting rate slows down considerably as the camera works to clear the buffer so another image can be taken.

So, how many images will be recorded before you hit the bottleneck? That depends on their size and quality. If you select [RAW], you will be taking and storing large files. If you select [RAW & JPEG], not only will you be storing large RAW files but also a set of JPEG files. All of this information needs to move from the sensors to the buffer to the memory card. In our experience, we get 12 images/second for the first second regardless of the image's image size, aspect ratio, and quality. Then the rate drops to one image every couple of seconds ranging from the thirteenth image when recording large files to the seventeenth image when recording the smallest JPEG files.

Continuous Advance Priority AE Mode: Focusing

Continuous Advance Priority AE mode allows you to be either in autofocus or manual focus mode. In autofocus mode, the camera shoots with the aperture wide open and does its best to keep up with focusing each shot—although it can have misses, especially if the subject is moving rapidly forward or backward. You will still see the subject on the display screen; but, instead of displaying each framed image prior to it being recorded, the camera will display each image after it is recorded, just like it does with the Drive Mode Continuous Hi option. This has not been a problem for us, since between the camera's rapid firing and the subject moving we simply have not noticed whether we are seeing the image in Live View or after it is recorded. Also, because shooting continuously only lasts about 1½ seconds, we do not do much panning to follow the subject.

You can also switch to manual focus and then close down the aperture, which you cannot do in autofocus mode. By closing down the aperture to increase the depth of field and by using a high ISO to sustain a fast shutter speed, you can capture a sharp image of a rapidly occurring event. Here, you can employ pre-focusing on an area where you expect the action to occur. To do this, you have to understand game strategy. For example, you are shooting a baseball game and the runner is tempted to steal second base. If you think this may occur, you would pre-focus on second base and start firing just before the runner enters the frame. With continuous firing, you will have a sequence of shots recording his slide onto the base.

Continuous Advance Priority AE Mode: Feature Capabilities

Obviously several camera features do not work in this mode: any features that involve multiple shots such as bracketing, noise reduction, and HDR are inoperable. In addition, any feature that requires the camera to conduct an action prior to recording an image is not functional, such as Smile Shutter (figure 8-9). The following is a list of camera features not available in Continuous Advance Priority AE mode:

- Flash
- Object Tracking
- Face Detection
- Smile Shutter
- Picture Effect
- Auto HDR
- ISO Multi Frame Noise Reduction
- Drive Mode:
 - Continuous Shooting, Self-Timer, Continuous Bracket, Single Bracket, White Balance Bracket, DRO Advance Bracket, Remote Cdr.
- Long Exposure NR command
- Movies

So, what can you use? The Drive Mode defaults to [Continuous Shooting: Hi]. You can apply a Creative style to your image; you can use the DRO function within DRO/Auto HDR; and you can set ISO, WB, and Exposure Compensation. As mentioned earlier, you can also select the shutter speed and aperture if you put the camera in manual focus mode.

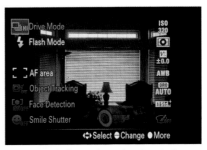

Figure 8-9: Fn button's results when in Continuous Advance Priority AE mode

GPS Feature

Have you ever been on a trip where keeping track of each picture's location became a major project unto itself? Who needs that extra task? Wouldn't it be easier to have your camera keep track of where each picture was taken, along with the date and time? It would be so convenient to automatically have this data available when sorting through hundreds of pictures later.

Here the Sony A77 comes to your aid. This camera is capable of retrieving the GPS setting of your location and storing that information with your pictures. You will see the image's longitude and latitude coordinates in the lower left corner of the display screen. The GPS information is also automatically downloaded with your saved images to your computer when you use the Sony-supplied PMB software. Then it is a simple step to view the saved GPS information while organizing your images. In addition, you can call up PMB's Map View function and pinpoint each image's location on a Google map.

GPS Command

The camera's GPS feature is controlled by a command with three subcommands (figure 8-10). These three subcommands enable the GPS feature, correct the camera's date and time information, and speed up the retrieval of GPS information. The main GPS command is:

MENU>Custom Menu (1)>GPS Settings>[GPS On/Off], [GPS Auto Time Cor.], [Use GPS Assist Data]

The GPS status is represented by different icons which are displayed on the LCD display screen only and not the viewfinder. To see the GPS icons, ensure you have at least one of the following DISP Button (Monitor) options checked: [Graphic Display], [Display All Info.], or [For viewfinder]:

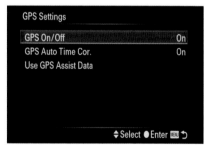

Figure 8-10: GPS menu

MENU>Custom Menu (2)>DISP Button(Monitor)>[Graphic Display], [Display All Info.] or [For viewfinder]

Initiate GPS

The GPS feature is controlled by the [GPS On/Off] option.

MENU>Setup Menu (1)>GPS Settings>GPS On/Off>[On], [Off]

Simply put, when set to [On], the GPS becomes active and searches for satellite signals while the camera is on. When set to [Off], GPS is off and no GPS icon displays, regardless of the other two GPS settings.

As soon as the GPS On/Off option is set to [On], the camera displays the GPS connecting icon in the upper right of the LCD screen just below Movie Record Setting information (figure 8-11). A repeating series of zero, one, two, and

Figure 8-11: GPS satellite searching icon with one dot showing

three dots cycling underneath the icon indicates that the camera is trying to establish connection with GPS satellites.

 ⇨ ⇨

The camera will continue searching for satellites until you either turn the camera off or change the GPS On/Off command to [Off]. The camera's GPS is not as sensitive as a dedicated handheld GPS, and you may have trouble obtaining a signal when you are indoors or next to an obstruction that blocks its access to the satellite's signal, such as a tall building. We found that the camera's GPS had trouble locating satellites when we were in a pine forest. You can also have problems obtaining a satellite signal if you are near radio or electric towers, since their signals can disrupt the camera's reception. If you cannot connect, move to an unobstructed location and try again.

Turning on the GPS system and waiting for the satellite signal does not prevent you from recording pictures or movies; you just won't have the GPS information attached to your recorded images until the camera can retrieve it. Once the camera has retrieved the

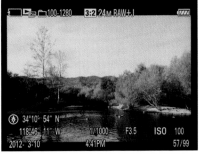

Figure 8-12: GPS location information displayed in lower left corner

information, you can see the recorded GPS location when playing back your images (figure 8-12). If you don't see it immediately, cycle through the three display formats using the DISP button. Remember from chapter 3, there are three different data display formats for reviewing your still pictures. The GPS information is included in the "With recording data" display format on both the viewfinder and LCD screen.

Personal GPS Observations

We turned on the GPS feature indoors and waited about 10 minutes to see if the camera would give us an error. It didn't. Instead, we noticed that the cycling from zero to three dots varied wildly—going from zero to two dots and back multiple times and then returning to the sequence of zero to three dots.

Eventually, we moved to an outside area known to have clear access to the satellite signal. The camera still could not obtain the signal, but after we turned the camera off and back on, it obtained the signal immediately.

We also noticed that when we moved back inside, the camera retained the GPS coordinates and recorded pictures with them. The retention lasted for several minutes, so all of the images previously recorded with no GPS data could now be recorded with near-accurate data.

Once current GPS location information is obtained, the initial GPS icon is replaced with one of the following three icons:

The bars represent the number of satellites found. Obviously, three vertical bars is the most desirable number and leads to the most accurate GPS data, while one bar is the least desirable number and leads to more general GPS data.

If you see the following GPS error icon, turn the camera off and then back on. If the problem persists, contact Sony Technical Support for help.

GPS Date and Time Correction

When you enable the GPS feature, the second suboption, [GPS Auto Time Cor.], becomes enabled. This option allows the camera to utilize the GPS system's date and time and adjust the camera's clock information to local time.

MENU>Setup Menu (1)>GPS Settings>GPS Auto Time Cor.>[On], [Off]

This option can be invaluable when your travels span multiple time zones. Setting the GPS Auto Time Cor. option to [On] automatically ensures that the camera's clock is set to your current location's date and time. Although the Sony manual says it will correct the date and time when you turn off the camera, we found that the clock is updated only when we turn on the GPS function and the location information is retrieved. A not-so-obvious benefit of this option is that if you forget to reset the camera's clock when you get back home, having the GPS Auto Time Cor. option turned on will do it for you.

Speeding up GPS Retrieval

The last GPS setting option, [Use GPS Assist Data], will save you time. You could end up waiting 5–10 minutes for your camera to obtain a GPS satellite connection. Most likely you won't be happy waiting this long before you can take any pictures with GPS information. Frequently, these delays are caused by an inability to find the satellites; so, if the GPS can be told where to look for the satellites, it cuts down on your waiting time. Sony has done just that by enabling the creation and use of a file that helps your camera find the satellites easily.

Use the following command:

MENU>Setup Menu (1)>GPS Settings>Use GPS Assist Data>[OK]

This command retrieves 30 days' worth of GPS satellite location information and saves it in a GPS Assist Data file, which is stored on your camera's memory card (figure 8-13). Keep in mind that if you try to retrieve GPS information outside this 30-day period, the camera will locate the satellites directly from their radio signals. This will take more time and from this, the camera will build a new GPS Assist Data file if Use GPS Assist Data is set to [OK]. Also keep in

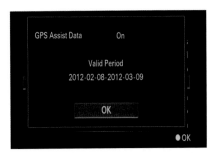

Figure 8-13: GPS Assist Data 30-day period

mind that the file is stored on your memory card, so when you change memory cards, the camera will have to rebuild the file. In addition, if you reformat a memory card, the GPS Assist Data file will be erased and the camera will need to rebuild it.

Another way to retrieve the GPS Assist Data file is to have the Sony-supplied PMB software connect to the Internet and build the file for you. Then, while your camera's memory card is connected to your computer, the PMB software will download the file to the card. Put the memory card back in the camera, and you are ready to go.

To do this, execute the following steps:

1. Start up your Windows computer.
2. Make sure you are connected to the Internet.
3. Connect your camera's memory card to the computer. Use a card reader or connect your camera with the memory card directly to the computer using a USB cable.
4. Start up the PMB application.
5. Select GPS from the menu on the left side of the screen.
6. Select the [GPS Support Tool] option.
7. Update the GPS Assist Data file. You will receive a message box informing you that the GPS Assist Data file has been stored on the memory card.
8. The memory card with the GPS Assist Data is ready to be used and you can disconnect the camera.

PMB software is not available on Mac computers. In that case, you can either build the GPS Assist File through your camera or utilize third-party software available through the Internet.

Viewing GPS Data

As mentioned earlier, GPS longitude and latitude information is displayed when you play back your images on the LCD screen or the viewfinder. You can also use PMB software to view GPS location information when reviewing an image's file properties. Note that files with associated GPS information display with a green icon in the lower right corner of the thumbnail images (figure 8-14).

The real benefit is being able to see approximately where the image was taken on Google Maps. This is accomplished by starting the PMB software and displaying thumbnail files with GPS information. To view the GPS location, highlight the image and click the Map View icon in the lower left corner of the screen. A Map View window opens up in which Google Maps shows the corresponding GPS longitude and latitude coordinates pinpointed with a flag (figure 8-15). You can zoom right down to street level to see the location. It's important to remember that the camera's saved GPS coordinates are approximate. When we took a picture in our backyard, we found the resulting GPS coordinates to be off by 50 yards.

Figure 8-14: Imported images with GPS green icon

Figure 8-15: PMB Map View results

As mentioned before, Mac computer owners need to find another means of utilizing the GPS data. Adobe Photoshop Lightroom 4 can process your Sony A77 images and display their location on a world map using the stored GPS data. Since software is always evolving, check the Internet for other Mac user opportunities.

Recommendations

We strongly recommend that you turn on the GPS function when traveling. If you are like us, on any trip that involves frequently changing locations, it doesn't take long to lose track of which church, park, lake, or mountain we captured in our favorite picture. Having the GPS turned on solves most of the ensuing debates.

You can save time by ensuring that the GPS Data Assist data file is updated at least monthly. It can be very frustrating to wait 5–10 minutes on site for the camera to pull down the GPS information, during which time the shot you wanted to take could have wandered away.

PMB software can be used to build the GPS Data Assist file, but it only works on Windows computers. Mac users can have the camera retrieve the file or employ third-party software available on the Internet. Although we are not advocating the use of third-party software for this purpose, it is something to look into. We prefer having the camera build the file. Although we have to wait a few minutes (sometimes longer), this option fits in well with the way we use the camera and manage our computers and our files.

We love panoramic shots. They are fun to shoot, and the results are impressive. We have experimented with many different shots, varied the level and/or panning speed, and taken shots of moving and stationary subjects, all giving us a variety of results. We have also played around by applying a Creative Style to add some punch to the results. We are sure you too will want to play with this feature.

We did not buy a 3D-capable television to see our 3D panoramas. Instead, we ordered inexpensive glasses with red and cyan filters and generated anaglyphs from saved Sony A77 .MPO files. Then we viewed our saved 3D pictures on our computer screen. It was definitely impressive to see how the pictures popped with the glasses. We recommend that you experiment and see if taking 3D pictures is something you enjoy. It isn't for everyone, but you won't know unless you try.

If you need to capture a specific event that will occur literally within a split second, consider using Continuous Advance Priority AE mode. Of course, keep in mind that the camera's throughput for saving the images to your memory card is limited. Your timing will have to be exact to capture the event.

Chapter 9: Using Accessories

Introduction

The Sony A77 is a versatile tool that can be expanded by using accessory lenses and adapters. With the right accessories you can take on any photographic assignment. If you own accessory lenses for an older Minolta Maxxum or Konica Minolta film or digital camera, they are most likely usable on your A77.

Supplementary lenses can give you a new perspective on recording scenes. You can use a super wide-angle lens to encompass a greater area in an interior shot, or employ a telephoto lens for a close-up portrait of a wary animal. You can play with perspective to generate a picture that emphasizes the expanse of a scene, or use an extreme telephoto to flatten a scene so that objects appear to be juxtaposed. All of these tricks become possible once you mount different lenses on the camera body.

Besides lenses, there are other accessories of interest, such as tripods for holding the camera. By holding the camera steady, a tripod ensures that you obtain the maximum performance from your optics. Its ability to accurately aim and move the camera can help you generate panoramic shots at a higher resolution than that available in Sweep Panorama mode.

Choosing a Kit Lens

When you buy a Sony A77, you need to decide whether to buy just the body or add a kit lens. The Sony A77 is sold with a choice of two zoom lenses: one with a focal length ranging from 16-50 mm (figure 9-1) and one with a focal length ranging from 18-135 mm.

Both are capable of handling most photographic assignments. Which one should you chose? Consider the following:

- **Price.** The 16-50 mm currently sells for about $699.99 while the 18-135 mm is $499.99.
- **Optical Characteristic.** The 16-50 mm has more features than the 18-135 mm. The former has a fixed aperture of f/2.8 that does not vary as you change the focal length. The latter's aperture varies with its focal lengths. If you work with studio flashes that require a set aperture, you will have to compensate for the 18-135's changing apertures as you zoom in or out. The 16-50 mm lens with its fixed aperture does not require this sort of compensation.
- **Dim light capability.** The 16-50 mm is better suited for work in dim light. When it is used at 50 mm, you have a maximum aperture of f/2.8. In contrast, the 18-135 mm at 135 mm has a maximum aperture of only f/5.6.
- **Weight.** The 16-50 mm is a much heavier lens at about 20 ounces, as compared to the 18-135 mm at 7 ounces.

9

- **Quiet operation.** The focus motor of the 16-50 mm is much quieter than that of the 18-135 mm. Consequently, it is less disruptive when recording audio in Movie mode.
- **Coverage.** The 16-50 mm provides a wider angle of view than the 18-135 mm. However, the 18-135 provides an increase in its telephoto over the 16-50 mm.

So, which lens should you get? We have used the 16-50 mm and find it a great lens for scenes with dim lighting and studio flash work. It provides excellent resolution, and its only disadvantage is its weight. However, if your budget is limited, the less expensive 18-135 mm is a good choice, and its lighter weight is a benefit for outdoor work. Although it is not optically equal to the 16-50 mm, you will be pleased by its performance.

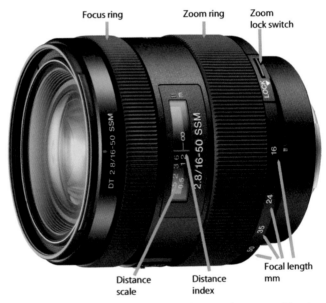

Figure 9-1: Parts of the Sony 16-50 mm f/2.8 kit lens (Photograph courtesy of Sony)

Manufacturer	Focal Length	Aperture	Type
Sony	100 mm	f/2.8	Fixed
Sony	11-18 mm DT	f/4.5-5.6	Wide-angle zoom
Sony	135 mm	f/2.8	Telephoto zoom
Zeiss	16-35 mm	f/2.8	Normal zoom
Sony	16-50 mm DT	f/2.8	Normal zoom
Sony	16-50 mm DT	f/2.8	Normal zoom
Zeiss	16-80 mm DT	f/3.5-4.5	Normal zoom
Sony	16 mm	f/2.8	Wide-angle fixed
Sony	18-200 mm	f/3.5-6.3	Normal zoom
Sony	18-250 mm	f/3.5-6.3	Normal zoom
Sony	18-55 mm DT	f/3.5-5.6	Normal zoom
Sony	18-70 mm DT	f/3.5-5.6	Normal zoom
Sony	20 mm	f/2.8	Wide-angle fixed
Zeiss	24-70 mm	f/2.8	Normal zoom
Sony	24 mm	f/2.0	Wide-angle fixed
Sony	28-75 mm	f/2.8	Normal zoom
Sony	300 mm	f/2.8	Telephoto fixed
Sony	30 mm DT	f/2.8	Macro fixed
Sony	35 mm	f/1.4	Normal fixed
Sony	35 mm DT	f/1.8	Normal fixed
Sony	50 mm	f/1.4	Moderate telephoto fixed
Sony	50 mm	f/2.8	Macro fixed
Sony	50 mm DT	f/1.8	Moderate telephoto fixed
Sony	55-200 mm DT	f/4.5-5.6	Telephoto zoom
Sony	70-200 mm	f/2.8	Telephoto zoom
Sony	70-300 mm	f/4.5-5.6	Telephoto zoom
Sony	70-400 mm	f/4.5-5.6	Telephoto zoom
Sony	75-300 mm	f/4.5-5.6	Telephoto zoom
Sony	85 mm	f/2.8	Telephoto fixed
Sony	85 mm	f/1.4	Telephoto fixed
Sony	500 mm	f/4.0	Telephoto fixed

Table 9-1: List of Sony-compatible A-mount lenses

9

Sony A-Mount Lenses

The Sony A77 uses an A-mount—a design that traces its roots back to the Minolta AF (Autofocus) lens. This means that all of the older Minolta and Konica Minolta AF lenses can be used on the A77. Although they are no longer made, these lenses are sometimes available for purchase through online auction houses or in camera stores at discounted prices. For example, we have acquired an older Minolta 100-300 mm APO lens of outstanding optical quality for a very reasonable price. Its low cost is balanced against its slower and noisier focusing system, making it great for still pictures but limiting its usability for taking movies.

Like all companies, Minolta and Sony use a series of letters to describe their lenses. Here is a list of some of their terms.

- **G:** Premium optics and superior mechanical design. Other than indicating that this is an excellent lens, mechanically and optically, there is no definition of the term "G."
- **D:** Distance Encoder. This allows the camera to use AID flash control.
- **DT:** Digital Technology. These lenses can only be used on cameras with APS-C sized sensors. They vignette when used with full-frame camera sensors.
- **HS:** High Speed. HS is found on lenses that rely on a motor in the camera body. The gears for moving the lens are optimized for speed.
- **SSM:** Super Sonic Wave Motor. This motor resides in the lens body and provides fast and quiet operation. The lack of noise is important when taking movies since any motor noise disrupts audio recording.
- **SAM:** Smooth Autofocus Motor. This motor resides in the lens body. It tends to be noisier than lenses with SSM and is associated with lower-priced lenses.

Manual Focusing A-Mount Lenses

The focusing motor for the lens may be located in either the lens or the camera body. In the latter case, you will see what appears to be a recessed screw head on the back of the lens. This engages a screw blade that protrudes from the camera's lens mount (figure 9-2). When the lens is mounted, the screw blade engages the slot so as to supply the force for moving the lens-focusing ring. The focusing motor is, in this case, located in the camera body.

If you wish to use manual focus (MF), you will need to disengage this focusing motor so you can freely rotate the focusing ring without damaging the lens. Otherwise the focusing motor's mechanism could be stripped by trying to manually rotate the lens focusing ring. Set the focus mode dial on the lower front of the camera to MF or press the AF/MF button on the back of the camera.

The golden rule in operating Sony lenses is: become familiar with the effort it should take to turn the focusing ring. If you encounter high resistance, make sure the camera is set to MF to avoid damaging the focusing motor.

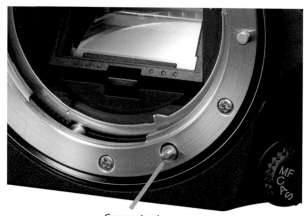

Connector to
camera's internal focus motor

Figure 9-2. Connector for lens focusing motor protruding from mount (photography courtesy of Sony)

Used Lenses

A glance at an online auction site or a visit to a camera store reveals an abundance of used lenses. While they may be optically excellent, these lenses are on sale because they are discontinued models. Older lens may lack some of the latest features, such as a distance encoder or built-in focusing motor, but this does not affect their ability to project a sharp image onto the sensor. For you, they can be bargains, providing excellent optical tools for your Sony A77 at a very reasonable price.

Minolta, Konica Minolta, Sigma, Tamron, and Tokina have made autofocus lenses that work on the A77. Before buying a lens, we strongly urge you to learn about it by looking for online reviews. This is critical because you can find out if a lens has trouble interfacing with your camera. For example, the gearing of one manufacturer's lenses may not withstand the torque of the Sony autofocus motor in the camera body. A helpful website for lens reviews is: www. dyxum.com

Older manual focus Minolta lenses will not work properly on the Sony A-mount. You can buy adapters to physically attach such lenses, but we found them disappointing. Most would not allow the lens to focus to infinity. When we did find one that allowed an older Minolta lens to focus to infinity, it did so with the aid of an interior lens that degraded the overall performance.

Figure 9-3: Fotodiox adapter to attach Nikon lens to Sony A mount

Nonetheless, such adapters can be useful provided that you remove the interior lens. For example, Fotodiox makes an adapter for attaching a Nikon manual focus lens to the Sony A-mount (figure 9-3). It has a lens that degrades performance; however, it can be unscrewed easily. Once the lens is removed, the Fotodiox serves as a short extension tube that limits you to close-up work. However, there is now no degradation of the image. We use this adapter for macro photography when attaching a bellows or using Nikon's macro lens. Considering that Nikon has an extensive line of special macro lenses, this has increased the utility of the A77 without the need to buy a Sony macro lens.

When you use a macro lens, you will be focusing manually. The A77's Peaking function, described in chapter 7, can aid you in finding focus. Here the electronic viewfinder presents an obvious advantage. The viewfinder and rear LCD's automatic gain feature keeps the display screens bright when you are working with a long bellows and small aperture macro lenses (although there is an increase in noise). In contrast, for DSLRs with optical viewfinders, the view gets progressively dimmer, which enhances display screen imperfections and ultimately makes it impossible to find focus.

Buying New Third-party Lenses

As mentioned earlier, several companies make lenses compatible with the Sony A77 that can become valuable additions to your system. These lenses are frequently less expensive, but more importantly, they cover focal lengths that are absent in the Sony lens line. Buying these lenses new from an authorized dealer ensures that you have a warranty.

One must be cautious in using third-party lenses. For example, they will not be in the Sony database so the camera cannot correct for their optical imperfections. On occasion certain lenses have proven to be problematic. If a problem occurs, and you bought the lens new from an authorized retailer, the manufacturer will upgrade the lens or fix the problem. However, if you buy the lens used or from an unauthorized reseller, you may have to have the lens repaired at your own expense.

One lens you may wish to consider for close-up work is the Tamron 90 mm. It has an enviable optical reputation and can be viewed as a safe buy for providing excellent optical performance.

Microscopes

For over 50 years, SLRs have been used on microscopes to take high magnification pictures of single-celled plants and animals as well as slides of human tissue. In the past, Nikon and Olympus sold elaborate accessories for mounting film cameras

onto microscopes. However, these cameras were ill-equipped for the task. Their optical viewfinders had to be modified to obtain clear views for focusing. The standard viewing screen obscured fine details of the specimen, and additional magnification was needed to obtain accurate focus. In addition, the movement of the instant return mirror and the mechanical shutter vibrated the camera body at the moment of exposure, blurring the picture.

With improvements in camera design, these weaknesses have been remedied in the Sony A77. Live View electronic finders now allow accurate focusing, and electronic first curtain shutters with locked, stationary mirrors reduce vibration.

The Sony A77 takes all of these advances and combines them into a single camera that can be a working tool for a microscopist. Its live preview solves the problem of accurate focusing, giving you a bright image that can be magnified. The Peaking function works well, and it can be used to see an overall view of the specimen while still providing an accurate means of focusing. Because it previews the image, errors in color balance can be corrected. When working with older microscopes or current microscopes from a variety of manufacturers, you might find that their optics introduce a color cast. Thanks to Custom WB, unwanted tints can be removed so you can record an image with colors that are accurately represented.

Perhaps the A77's most important feature for the microscopist is the absence of vibration during image capture. A fixed mirror eliminates mirror slap, and the electronic first curtain shutter is vibration free. Thus, the camera is always ready to take a picture at any shutter speed. With older mechanical shutter cameras, you had to resort to long exposures of one second or more to minimize the effects of shutter movement.

The way in which you mount the camera on the microscope depends on whether you have access to a research microscope in a laboratory or a microscope at home. Research microscopes are expensive and consequently not commonly available to the hobbyist. Attaching the camera can be expensive as well. A company that makes adapters to fit research microscopes is Martin Microscope Company (www.martinmicroscope.com/MMSLR.htm). This company has an adapter for about $500 that can make it a simple manner to mount the Sony A77 onto your microscope.

If you are interested in obtaining a home microscope, you can find affordable used microscopes at online auction houses; however, we recommend finding a seller with a brick-and-mortar store. The cost may not be as low as an online auction house, but you have a better guarantee that the microscope has been checked and adjusted for proper operation. We have purchased used microscopes from Bunton Instrument Company (www.buntgrp.com/used_microscopes.htm), Nightingale (www.microscopesfromnightingale.com), and G. W. Brown Company (www.gwbrowncompany.com).

Used microscopes should be purchased with trinocular heads. The majority of hobbyist microscopes have narrower photographic ports than those found on modern research microscopes. Most hobbyist microscopes have a tube with a 25 mm outside diameter. The simplest camera adapter is a tube with a clamp on one end that fits outside the microscope tube. The other end is a male screw threaded to take a variety of bayonet mounts. This is usually a T-mount, and you can easily buy such a mount for the Sony A77.

Light and the Microscope

The key to getting good photographs with a microscope is using the correct lighting. At very low powers, say from 10X to 100X, you can generate credible images with little effort. But once you start working at higher powers, your images can appear fuzzy and ill-defined. One cause of this is improper illumination. You need to learn how to manipulate the microscope light source to ensure that your lens is working under optimum conditions.

To learn to use a microscope at high powers, an excellent reference can be found here: www.olympusmicro.com/primer/basicsandbeyond.pdf. The section describing Kohler illumination is particularly important, as it is necessary for getting the best out of a microscope.

Follow these steps when using the Sony A77 on a microscope:

1. Adjust the microscope with the slide to get a sharp image through the eyepiece.
2. Adjust the microscope's light source intensity so the view through the eyepieces is comfortable. If the light is controlled with a voltmeter, run it at the voltage recommended by the manufacturer. If it is too bright, reduce the light intensity with neutral density filters.
3. Set the camera's focus mode dial to MF.
4. Set the camera's ISO to 100.
5. Turn the camera's mode dial to A or S mode.
6. Use the following commands:

 MENU>Custom Menu (1)>Release w/o Lens>[Enable] to allow the camera to fire without its camera lens. When you first use the camera, you will find this command is [Disable].

 MENU>Custom Menu (1)>Front Curtain Shutter (5)>[On] to prevent vibrations from the first curtain shutter. When you first use the camera, you will find this command is set to [On]

7. Set the camera's WB to Incandescent Lights, or set the color temperature scale to 3200 kelvin. If this does not work, use Custom WB.

8. Focus the image using the microscope control while viewing it on the LCD screen. We recommend using the Peaking function.

9. Fire the camera with a remote release or set the camera's self-timer to a two-second delay. This keeps any vibrations caused by manually pressing the shutter button from disturbing the picture.

Cable Release

Sony sells a cable release, the RML1AM Remote Commander Shutter Release Cable, for $69.95. While this may seem expensive, a remote shutter release can be an essential accessory to avoid vibration when you are taking pictures on a tripod-mounted camera. Not only is it convenient, but it is also mandatory for telescope and microscope work. If you use the B setting on Manual Exposure for shutter speeds longer than 60 seconds, this accessory provides a convenient lock mechanism to hold the shutter open for these longer exposures.

Another, less expensive option is the Sony RMT-DSLR1 IR Remote Commander Shutter Release Cable. Although it sells for only $29.95, we do not use this accessory. It requires that the IR beam be intercepted by the camera's sensor, which is positioned on the front grip. Since we are usually behind the camera, this accessory is not helpful. However, if you tether the camera to an HD television in order to project movies, this remote can be handy. It provides the ability to control HDTV playback in addition to remotely shooting your camera.

If you forget to pack your remote release, remember that you can eliminate vibration by using the self-timer command and setting it for two seconds. Its only disadvantage is that the two-second delay may cause you to miss the shot.

Tripod

You may already own a tripod, but if not, this section is for you. This accessory is often overlooked when you first start taking pictures and movies.

A steady support for picture taking is essential for long exposures, extreme telephoto work, and obtaining maximally sharp images with the camera. Nonetheless, many photographers object to using a tripod, arguing that it is bulky, reduces mobility, and hinders spontaneous photography. These arguments are all true, but it is also true that consistently using a tripod will improve the quality of your work. In fact, its inconvenience may be its strongest benefit because it forces you to work at a more deliberate pace—carefully framing the subject, evaluating depth of field, and ensuring that the horizon is not canted. This deliberate pace trains you to visualize the image before snapping the shutter.

Professional tripods are usually sold in two parts: the legs and the head. The legs provide the support, but they do not have a mechanism for aiming the

camera. The head is attached to the legs and is the actual aiming mechanism. Although one can buy a tripod with legs and head, many, if not most serious photographers buy the two components separately. In this way, one can have a custom unit that suits one's personal photographic style.

A good tripod can easily cost $300, with more expensive units running over $1,000. Although initially expensive, a good tripod will outlast a typical camera and lens. One of our tripods is over 30 years old and still functional. Your collection of tripods will grow along with your expertise in photography. We have a heavy studio tripod for home use; while its weight prevents us from taking it into the field, we appreciate its stability when working with critical subjects. For fieldwork, we use more expensive tripods made with carbon fiber. They weigh only a few pounds, and their light weight lets us take them wherever we go. This is not a good time to skimp on the cost of equipment. Inexpensive tripods are not only flimsy, but are also slow to set up and sometimes unable to hold their settings. Once you mount and position the camera, an inexpensive tripod may drift slowly out of position or even topple over with your camera attached.

Plan to spend a minimum of around $400 for the tripod's two components: the legs for support and the head for aiming the camera. This last unit can be surprisingly expensive, especially if you tend to use long telephoto lenses. What you get for more money is elimination of any play in the mount or drifting after you think you have locked the lens down.

There are two types of tripod heads available: pan and tilt heads, and ball heads (figure 9-4). Pan and tilt heads are heavier and less expensive and may cost about $65 (Manfrotto 804RC2 3). They allow you to pan the scene (horizontal movement) and tilt the camera (vertical movement). Ball heads are lighter and are more expensive at about $350. They allow you to move the camera on the tripod any way you want in a smooth motion. We started out over 40 years ago with a Bogen 3047 pan and tilt head, but replaced it when we found the speed of working with an Acratech ball head preferable.

We use an older Acratech GV2 ball head for our photography. This

Figure 9-4: Acratech GP-SS ball head. (Photograph courtesy of Acratech, Inc.)

accessory has a nifty design: a gimble slot that can be engaged with a small key by rotating the ball 90 degrees to its side. This allows the head to swing along a vertical plane while the base rotates along a horizontal plane. In essence, the head works like a pan and tilt, with increased stability when tilting the lens up and down along the vertical plane and when rotating the entire head on the horizontal plane. With a long telephoto lens attached, it places the center of the lens closer to the swivel point for much better balance and control. This wonderful feature is carried over into newer Acratech models. When we use our 16-50 mm lens, we do not need to use the gimble design. Instead, we use it as a ball head. There are two tightening knobs for the ball head. One is applied to provide just enough friction so as to position, aim, and keep the camera from drifting. Before taking the picture, we tighten the second knob for locking the head completely. By using the two knobs, one can have a very fast operating system, releasing one knob to allow rapid aiming and then tightening it to ensure the position is locked.

We recommend that you get a quick release clamp for your tripod head. Typically, a basic head has you attach the camera to the tripod head with a ¼-inch threaded screw. Attaching and detaching the camera can become time-consuming and awkward. To speed up the operation, use a tripod head with a quick release clamp (figure 9-5). This clamp engages a plate that is attached to the bottom of your camera. Attaching and detaching the camera from the tripod becomes a fast and simple operation. To attach, simply place the plate into the head's quick release clamp and secure it with a lever. To detach, release the lever.

Figure 9-5: Quick release clamp for attaching the tripod head to the camera. (Photograph courtesy of Acratech, Inc.)

Next to consider are the tripod legs. Fortunately, their connection to the tripod head is standard; a screw secures the head of your choice. The price of tripod legs ranges from $300 to over $600. Premium models are made of light and durable carbon fiber. Typically, the legs collapse for convenient transport. Gitzo makes some of the best legs, which may cost over $500. The legs are built in sections and telescope into each other to shorten their length.

We chose less expensive legs by Manfrotto at about $300 and combined them with an Acratech ball head. Several of our colleagues have told us that they have been satisfied with Velbon, Slik, and Hakaba carbon fiber tripod legs costing between $200-$300.

Buying Tripods

We have acquired several tripods over the years. Our low-cost favorite is a Tiltall tripod purchased 40 years ago. The basic design of this older tripod is impeccable. Its only fault is its seven-pound weight. We typically use this tripod indoors, so we do not have to walk far or set it up quickly. At one time, Leitz sold this high-quality tripod. Now you can buy them used online for under $100. Just beware of functional damage and wobbly legs. The A77 does not come with a quick release head mechanism. Instead, one has to screw the camera on and off the head.

We also have carbon fiber tripod legs from Manfrotto and a tripod ball head from Acratech. Their combined weight is only four pounds. For faster setup, the head is equipped with a quick release clamp. Without this accessory, we would have to turn and tighten a screw to fasten the camera onto the tripod. With the aid of the quick release clamp, we can quickly attach and detach the camera from the tripod.

Telescopes

Long-distance photography fascinates many photographers. The thought of obtaining a close-up of the moon makes some photographers long for a super telephoto lens. The longest telephoto lens made by Sony is 500 mm. This can provide impressive views, but suppose you want something even longer?

We have found that to get a full frame shot of the moon, we need a 2000 mm lens. One way to accomplish this is to attach your camera to a telescope. Mounting can be as simple as removing the camera's lens, replacing it with an adapter (figure 9-6), and inserting the adapter into the telescope's eyepiece holder. An image of the subject will be projected directly onto the camera's sensor—a method known as prime focus photography. Exposure is automated and is done in A mode using the telescope controls.

Figure 9-6: This adapter fits in a 1¼-inch eyepiece holder

The first step is to find a telescope that can be used with your camera. Today, there are a tremendous number of telescopes of varying sizes to choose from. We will restrict our discussion to smaller telescopes that can double for terrestial fieldwork. These telescopes typically have lenses with a front element ranging in diameter from 50 mm to 100 mm (2 to 4 inches). Any smaller than this, and you are talking about an instrument with a performance that can be matched by a telephoto lens. A telescope with an objective larger than 100 mm is difficult to handle for fieldwork. An excellent telescope in the 50 to 100 mm range is expensive; however, its optical performance equals the best telephotos.

One company that makes telescopes with resolving power suitable for photography is Tele Vue. We have used their 60 mm (figure 9-7), 76 mm, and 85 mm telescopes, and they provide exceptionally high resolving power. The 60 mm (360 mm f/6.0) sells for less than $1,000, the 76 mm (480 mm f/6.3) for $2,000, and the 85 mm (700 mm f/7.0) for $2,495. Their optical performance rivals, if not exceeds, that of the finest Nikon or Canon telephoto lenses with their 500 mm optics costing $6,000 to $8,000.

This is not to say that these telescopes can replace a professional telephoto lens. They cannot. They lack an iris diaphragm, so you need to shoot wide open. Also, they are not compact and require a tripod. Finally, focusing is done manually. But, if you want a super long telephoto effect as well as the ability to work with an astronomical telescope, these telescopes do not seem so expensive.

Figure 9-7: Tele Vue 60 mm telescope with a 1¼ eyepiece adapter and Sony A77 . (Telescope courtesy of Woodland Hills Camera and Telescope.)

9

We have tested the Sony A77 extensively on a Tele Vue-85 and a Tele Vue-60. The first telescope has a 2-inch eyepiece holder, while the latter has a 1¼-inch eyepiece holder. Both telescopes can accept camera adapters that fit in the eyepiece tube and have T-mounts for attaching a Sony A-mount. Neither adapter caused vignetting. To use these telescopes with the Sony A77 requires only that the eyepiece be removed and replaced with the adapter. The camera should be set for A mode and manual focusing. To ensure that the camera will fire, set it to: MENU>Custom Menu (1)>Release w/o Lens>[Enable].

Figure 9-8: Photograph of sparrow taken with Tele Vue telescope

We typically use the viewfinder when aiming the telescope at terrestrial objects. Ambient daylight can obscure the LCD screen. Make sure Peaking is active to allow rapid identification of when the camera is in focus.

A Telescope Caveat

The previously mentioned telescopes work well for terrestrial and moon shots, but if you hope to shoot the planets, nebulae, or galaxies, you will have to invest in far more expensive equipment. You will need to mount the telescope on an equatorial mount so you can compensate for the movement of the night sky as the earth rotates. You will need to learn how to carefully align the equatorial mount and also how to take much longer exposures.

9

Recommendations

Thanks to Sony's SLT technology, the electronic first curtain shutter, and the electronic viewfinder, the A77 is remarkably versatile. It can be used effectively on specialized optical instruments such as telescopes and microscopes. The absence of vibration and the ability to precisely focus on the subject lends itself to macro photography. As your expertise increases along with your desire to explore new areas, you may find that the accessories cost more than the camera. Even something as mundane as a tripod may prove to be surprisingly expensive; however, these accessories expand the camera's full potential.

The Sony A77's kit lens is an excellent photographic tool. We recommend mastering the included lens before buying additional lenses. When you're taking pictures and movies, you will find that the appearance of the subject changes radically between a wide-angle focal setting and a moderate telephoto setting. Experiment with choosing a single focal length and then walking up close to the subject or walking away from it.

For example, fishermen prefer the use of wide-angle lenses that magnify the size of their catch. They proudly pose holding the fish in front of them and have the photographer move in close, framing the fish so it appears double to triple its actual size. If you use a moderate telephoto lens instead, step back, and photograph the fisherman holding the fish out front, the fish will appear to have shrunk dramatically. This moderate telephoto provides a more accurate perspective and shows the fish properly—much to the chagrin of a proud fisherman.

The 16-50 mm f/2.8 Sony lens has the quiet SSM motor, an advantage when recording audio along with movie. The 18-135 mm lens with its SAM motor is noticeably louder. Loudest are lenses that use a key drive. For such lenses, you may wish to use manual focus. Alternatively, if you are enthusiastic about movie recording, you may wish to get an accessory microphone.

Get to know the strengths and limitations of your camera's kit lens before you acquire any additional lenses. If you decide to buy more lenses, we recommend Sony lenses (including Zeiss lenses sold by Sony). Optically, these lenses are of high quality, and you can be confident that they are fully functional with your camera. If the price is too high, you can purchase third-party lenses instead: Tokina, Sigma, and Tamron are reputable brands with good quality optics. Generally, these lenses are less expensive, and many photographers view them as providing the maximum return on their money. In some cases, their optical quality is impeccable. The Tamron 90 mm macro is reputed to be one of the best in its class.

However, the risk in buying third-party lenses is that they may not function properly on the newest model camera bodies. If the lens is purchased new, you can rest assured that these companies have good reputations and try to satisfy their customers. You have to be cautious when buying these lenses used. Before purchasing a used lens, check online reviews to make sure that it has a good optical and mechanical reputation.

Chapter 10: Flash Photography

10

Introduction

As sensitive as the Sony A77 is to light, there are times when it requires a little help via additional lighting, such as when photographing indoors. This can be accomplished easily and conveniently with the camera's built-in flash. However, the flash is a low-powered unit and has insufficient output to illuminate a large room. It should be regarded as a supplemental rather than a primary light source. If you anticipate doing much interior work, you should consider getting an attachable external flash unit that fits on the camera's accessory or "hot shoe" (figure 10-1). These units will double, and can even quadruple, your light output depending on the unit's size.

Sony provides several attachable external flash units that will provide the light you need to photograph a group of people. The larger accessory units have greater coverage, and you can control the direction of the light by tilting or rotating the flash head. With this, you can take advantage of what is know as "bounce flash," where you aim the flash toward the ceiling rather than illuminating the subject straight on. These units have enough power so that the reflection off the ceiling (i.e., the bounced light) will provide flattering, soft light.

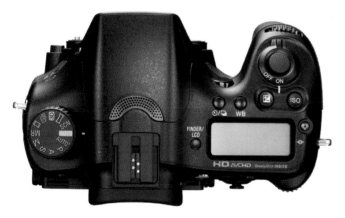

Figure 10-1: Top of the camera showing the hot shoe (photograph courtesy of Sony)

Principles of Electronic Flash

The electronic flash for the Sony A77 uses a small tube filled with xenon gas. When the flash fires, its high-voltage electricity generates a short burst of light (1/1000 second or less). The light's WB approximates daylight; however, its color temperature is a bit cooler. If you use preset WB at its daylight value, you will record an image with a slight bluish tinge. Using AWB or presetting WB to electronic flash will produce a more pleasing color image.

The flash duration is much shorter than the camera's shutter speed and requires that the sensor be fully exposed to light. For the A77, the sensor is fully exposed at 1/250 second (flash synchronization shutter speed) or longer. As a consequence, flash synchronization requires a shutter speed of 1/250 second or slower to be used with the built-in flash. In Auto or Auto+ mode, the camera is set at 1/60 second. At shutter speeds faster than 1/250 second, the shutter opening is a slit passing across the front of the sensor; if the flash were to fire, only a portion of the sensor would be exposed to light and only a part of the sensor will record the light arising from the flash. The recorded image will show only a small fraction of the subject.

Flash exposure is governed by its duration. The maximum light output occurs when the flash lasts 1/1000 second. To illuminate the subject with less light, its duration can be reduced to as little as 1/50,000 second. To determine how much flash is needed, the camera fires a brief pre-flash of known intensity. This light reflects off the subject, allowing the camera to estimate what the exposure should be.

GN and Estimating Exposure: Caveats

The Guide Number (GN) describes the power of a flash. It can be used to calculate what lens opening should be used if you know the distance between the flash and the subject. For example, the flash's GN is divided by the distance of the subject to the flash, which gives the f-stop to be used to obtain a correct exposure.

Today, with automated electronic flash, many photographers are unfamiliar with GN. Two factors should be noted. The first is ISO. If unstated, it is assumed the ISO is 100; a higher ISO will raise the GN value. The second is the unit used to measure the distance from the camera to the subject. Sony specifies the GN for its built-in flash using an ISO of 100 and a distance measured in meters.

If you are interested in exploring flash further, there is a formula for calculating exposure. Each flash has a Guide Number, or GN, that serves as a measure of its intensity. This number is used to calculate the f-stop the camera should use with the flash. For example, when fired at its full duration, the built-in flash has a GN of 12 for ISO 100 and the subject's distance from the camera is measured in meters. The formula is described below:

GN = Distance in meters x f-stop

or

f-stop = GN/distance in meters

Per this calculation, for a subject that is 3 meters (9.6 feet) away, you can use an f-stop of f/4:

f-stop = 12/3 or f/4

This type of calculation is used to help the Sony built-in flash calculate exposure. If you look at the menu for setting flash, you will see the following three options:

MENU>Still Picture Menu (2)>Flash control>[ADI flash], [Pre-flash TTL], [Manual flash]

These three options represent different methods of controlling flash output. The [Manual flash] option is unavailable in Auto and Auto+ modes. Consequently, this selection is grayed out on the camera menu and is not available until you switch to P, A, S, or M mode.

The basis for automatic flash exposure is [Pre-flash TTL], which requires the firing of a low-power flash as a reference beam. This beam is reflected by the subject and passes through the camera lens on its way to the sensor. This light is used to calculate the duration of the main flash, and it is the reason behind the letters TTL (Through The Lens).

While the Pre-flash TTL measurement is a reliable means of controlling the flash, it can be fooled if the subject reflects more light than what can be expected for a typical scene. To provide a more accurate exposure under these conditions, Sony employs ADI (Advanced Distance Integration). When the camera focuses on a subject, the lens has a distance encoder that tells the camera

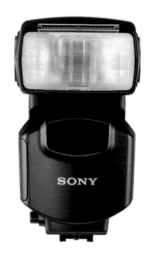

Figure 10-2: External flash that can be attached to hot shoe (photograph courtesy of Sony)

how far away it is. From the GN equation described earlier in this chapter, the camera can calculate what the light output should be to properly illuminate the subject. So, if the return light is too bright—as might be the case if there were a mirror in the picture—ADI will note this, and the camera can compensate for the high light level.

10

It's also good to know about GN because it provides a quick and handy measure for comparing the light output of different flashes. Sony sells several accessory units that attach to the top of the camera's hot shoe (figure 10-2). There is a small compact unit, the HVL-F20AM, which has a GN of 20, meaning that it will cover almost twice the distance of the built-in camera flash. Sony has two other units that are larger and more expensive, with respective GNs of 43 (HVL-F43AM) and 58 (HVL-F58AM). If you prefer to use flash units made by other companies, their GNs can provide a useful comparison.

Flash Artifact: Red-Eye

The Custom Menu contains a flash-related command for reducing red-eye.

MENU>Custom Menu (1)>Red eye reduction>[ON]

This command needs a bit of background to clarify its function. The camera's flash unit sends out light, and if a person—or an animal—is looking into the lens, the light will enter the eye and be reflected off the retina and back to the camera. Since the human eye has a rich vascular structure, the reflected light is red in color; and if a person is staring into the camera, the resulting photograph has the eyes glowing red. As an aside, animals (such as cats or dogs) can have a reflective layer behind their retinas, which causes the animals' eyes to glow yellow rather than red when they look toward an electronic flash. This is significant for pet photographers because automated software removal for red-eye may fail to take the glow out of their subjects' eyes.

When Red eye reduction command is set to [On], the camera's flash sends out several flashes prior to the main flash. Presumably, this makes the subject's pupils constrict and reduces the chance that light from the flash will enter the eyes and reflect back to the camera. This command has three flaws. First, it is not always successful, and therefore you may still have subjects with glowing red eyes. Second, the additional flashes can annoy the subject enough so that they blink or squint. While this reduces red eye, it can spoil the shot. The final problem is that the delay imposed by using these flashes can delay the capture of the image and you may miss a photographic opportunity. The Red eye reduction command's default is [Off] in Auto or Auto+ modes.

10

Alternate Ways of Reducing Red-Eye

The red-eye phenomenon is caused by light reflecting out of the eye and into the camera lens. It occurs when the subject has dilated pupils and the flash is placed close to and in line with the lens. This makes sense if you think about it. If the flash is close to the lens, the chances of light reflecting off a subject's retina and back into the camera are increased when the pupils are wide open.

Although Sony has a Red eye reduction command, the software program is not always 100 percent effective. Use the strategies below to improve your results and you may be able to avoid using the Red eye reduction command.

There are three strategies for eliminating red-eye. The first is to displace the flash away from the camera lens, reducing the chance that light entering the subject's eye will be reflected back into the lens. You can't do this with Sony's built-in flash. However, if you add an external flash unit to the hot shoe, it will raise the flash tube away from the lens and help reduce red-eye.

The second strategy is to constrict the subject's pupils by increasing the surrounding light. To do this, turn up the indoor lighting.

The third strategy is to have the subject look slightly away from the camera. Have them look at a point to the right or left of the camera, thus reducing the chance that their eyes' reflected light will go back to the camera lens.

Flash Function

The Flash function is found in the left column of the Fn button menu. The function has five options (table 10-1). Not all of the options are available in each of the modes.

To maintain the streamlined shape of the camera body, the Sony A77's built-in flash head is folded against the body. It must be raised before it can be used. The camera raises the flash automatically under two conditions. The first is when ambient illumination is low and the sensor needs additional light. In Auto and Auto+ modes, the flash is automatically raised and fired if the camera cannot increase the ISO or open the aperture sufficiently. The second is when there is a dramatic difference in the light coming from the background and foreground—for example, when the backlight is so intense that the foreground will be recorded as a silhouette.

The flash may also be raised in certain SCN predefined scene modes, such as Night Portrait. For the beginner, this is a convenient feature, but eventually you may decide to take control by turning the mode dial to P, A, S, or M. In these modes, the flash is always off unless you raise it by depressing a small button on the side of the camera. In Auto or Auto+ modes, this button is inoperative.

10

Flash Option	Option Name	Description
⚡ (Flash Off icon)	Flash Off	Prevents the flash unit from firing. Option is disabled in P, A, S, M and SCN's Night Scene, Hand-held Twilight, Night Portrait modes.
⚡ AUTO	Autoflash	The camera decides when the flash is needed. The flash unit pops up automatically and fires at low light levels. If the flash is up in Auto or Auto+, it may not fire if you go to a brighter lighting condition and the camera decides no more light is needed. The flash may also fire if the subject appears as a silhouette because of intense backlighting. This option is enabled only in Auto, Auto+, and SCN's Portrait, Macro and Night Portrait modes.
⚡	Fill-flash	The flash will always fire, providing light to the subject. In Auto or Auto+, if the flash unit is down, it will pop up immediately upon applying slight pressure to the shutter button. This option is available only in P, A, S, M, Auto, Auto+, and SCN's Portrait, Sports Action, Macro, Landscape, and Sunset modes.
⚡ REAR	Rear Sync.	Use this option with a slow shutter speed. The flash will go off at the end of the exposure just before the second shutter curtain closes. If there is movement during the exposure, the resulting picture will record the subject frozen in its last position right before the exposure ended. If there is enough ambient light, the subject's movement during the exposure will be captured as a blur. This option is only available in P, A, S, and M modes.
⚡ WL	Wireless	This option triggers an external Sony flash unit. When the camera's built-in flash is raised, it emits small bursts of light that signal the external flash to fire. This option is only available in P, A, S, and M modes.

Table 10-1: Available Flash function options

10

Using Flash in Auto and Auto+ Modes

Only the first three Flash options are available in the Auto and Auto+ modes: [Flash Off], [Autoflash], and [Fill-flash].

The flash commands in Auto and Auto+ modes are pretty straightforward. With [Autoflash], you let the camera decide whether it should use flash. With [Flash Off], you tell the camera never to use the flash. With [Fill-flash], you tell the camera to use the flash all the time.

What You Can Do with Flash in Auto or Auto+

The first option you should consider is [Autoflash]. This option allows the camera to decide whether the flash is needed or not. In Auto or Auto+ mode, the flash unit pops up from the closed position and fires. The flash remains upright until you decide to close it.

There are conditions when you do not want the flash to fire under any circumstances, such as during a live stage production. To accommodate this situation while in Auto or Auto+, set the Flash option to [Flash Off]. When this option is selected, the flash will not fire.

The opposite situation arises when you want the flash to fire all the time. For example, this can occur if you are shooting indoors with brilliant sunlight coming in through a window behind the subject. The background lighting renders the subject as a silhouette (figure 10-3). In this situation, there is a lighting imbalance, and you want the flash to fill in the shadows by selecting the [Fill-flash] option. In figure 10-4, you have a brightly lit scene with a lamp in silhouette by a window. By using [Fill-flash], you can illuminate the front of the lamp and fill in its shadow.

Figure 10-3: An imbalance between foreground and background lighting renders a lamp as a silhouette

Figure 10-4: [Fill-flash] balances the lighting, revealing the lamp's surface

10

What You Can't Do with Flash in Auto or Auto+

As you gain experience, you may realize that you are constrained by lack of control over the flash. First, when the flash is used for interior shots, the lens is set at its largest aperture. If you wish to increase the depth of field, you will find you cannot close the aperture. This reflects the automatic nature of the camera as it tries to capture the image with available light.

When in Auto or Auto+ mode under low light conditions, the first thing the camera does is open its aperture to admit more light, slows its shutter speed, and raises its ISO. When the shutter speed becomes so slow as to result in a blurred picture, the built-in flash pops up and the camera uses it to take the picture. Unfortunately, it does so at 1/60 of a second with a large lens opening. This is a disadvantage if you want to capture a detailed view of people scattered throughout a room. Since the lens is wide open, the depth of field is minimal, causing many of the people to be recorded indistinctly. To render the people sharply, you would need to close down the lens aperture; however, this is not an option in Auto or Auto+.

Secondly, you may notice that when you use the [Fill-flash] option, the foreground may not be exposed the way you like. When photographing under bright sunlight, the flash can be used to illuminate the shadows. However, if too much light is applied the flash can give your subject an unnatural appearance by removing all the shadows. The image may look better if you decrease the flash output so that subtle shadows are still present, thereby sculpting the subject and giving it a three-dimensional appearance. You cannot control the flash intensity in Auto or Auto+ mode.

Finally, you may decide that you need more power to take interior photographs in a large room. Here, the built-in flash is inadequate. To gain additional power, you will have to purchase an accessory flash unit. Many of the Sony units allow you to use bounce lighting. We will discuss this later.

Flash Options in P, A, S, or M Modes

When you switch over to P, A, S, or M mode, your built-in flash becomes more controllable. First off, the little flash release button on the top of the camera becomes functional. When pressed, this button will pop up the flash unit and force it to fire with each shot. Basically, it sets the camera to Fill-flash mode. When you press the Fn button and select Flash, you will also notice that the [Autoflash] and [Flash Off] options are grayed out. Instead, the flash will never fire when it is folded against the camera body (replaces the [Flash Off] option). When you raise the flash head, it will always fire (replaces the [Fill-flash] option). The [Autoflash] command is unnecessary because you decide when you want to use the flash.

10

The Flash control command's third option, [Manual flash] (figure 10-5) becomes active when you go into P, A, S, or M mode:

MENU>Still Picture Menu (2)>Flash control>[Manual flash]

Along with this, another command now makes its appearance (figure 10-6a):

MENU >Still Picture Menu (2)>Power ratio>[1/1], [1/2], [1/4], [1/8], [1/16]

Now the flash no longer provides automatic exposure. Instead, you specify the amount of light intensity that it provides. A Power ratio of [1/1] means the flash is firing at its maximum intensity (figure 10-6b). The other values indicate a fraction of the power that is being provided. This setting seems archaic when you consider all of the automation that is available to you. However, it is advantageous to have this capability if you decide to use the camera in a studio lighting situation. Here automatic exposure is not needed (remember, you can calculate the needed exposure based on the GN number). Since the A77 does not have to calculate the flash intensity by using a preflash, you gain a camera that responds quickly to the shutter button. The camera and flash both fire as soon as you depress it.

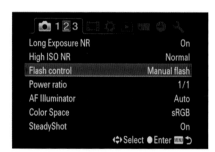

Figure 10-5: Manual flash menu becomes available in P, A, S, or M mode

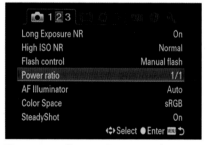

Figure 10-6a: Power ratio command becomes available in P, A, S, or, M mode

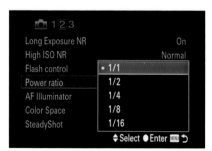

Figure 10-6b: Power ratios available for built-in flash

10

There are two additional Flash function options available in the semi-automatic and manual modes: [Rear Sync.] and [Wireless]. The former is used for special effects and coordinates the firing of the flash to the movement of the camera's internal shutter. Normally, the flash is timed to fire at the beginning of the camera's internal shutter. However, you can synchronize the flash to fire at the completion of the shutter instead. You can use this feature to record so-called "writing" with light, which is a technique where someone takes a lighted flash-light and waves it about. You record an image of the tracks of light glowing in space and the person holding the flashlight. To acquire this type of image, set the flash to fire on [Rear Sync.]

Fn button>Flash (left)>[Rear Sync.]

Once set, follow the instructions below:
1. Pose a person in a blackened room with a lighted, colored LED flashlight.
2. Set the camera to S mode and choose a shutter speed of 5 seconds.
3. Press the shutter to start the long exposure.
4. Have the person move the lighted flashlight, using it as a pen to "write." The camera will capture this as a trail of light.
5. At the end of the 5-second exposure, the flash will fire, illuminating the subject and capturing an image of the person holding the flashlight at the end of his glowing script. It will appear as if the person has written glowing letters in midair.

The [Rear Sync.] option is often used to photograph a moving car with glowing headlights. This results in an image of the car followed by the streak of light from the headlights and taillights.

The [Wireless] option allows you to fire an external flash unit that is not physically attached to the camera. This option affords you all kinds of different lighting, which would not be available to you if the flash unit had to be physically tethered to the camera. We will discuss this further later in the chapter.

10

Using the Flash in P, A, S, or M Mode

Switching to P, A, S, or M mode provides you greater control when using either an external or internal flash. Specifically, you can close down the lens aperture and move away from its maximum aperture. Table 10-2 illustrates the active controls when you move out of Auto or Auto+ mode.

Mode	Shutter Speed	Aperture
P	1/60 second	Camera selects
A	1/60 second	User-selectable
S	User-selectable from 1/250 second or slower	Camera selects
M	User-selectable from 1/250 second or slower	User-selectable

Table 10-2: Shutter Speed/Aperture in P, A, S, and M modes

As you can see, P mode does not differ much from Auto or Auto+. The camera sets the shutter speed to 1/60 second and attempts to use a large aperture for the lens. If you want to use a narrower aperture and increase the depth of field, A mode is better; it allows you to increase the depth of field by closing down the lens aperture, though you are still forced to use a shutter speed of 1/60 second. S mode allows you to select the shutter speed, but the maximum shutter speed can be shortened to only 1/250 second. Sadly, this mode tends to use the maximum aperture of your lens.

M mode is the prize. It allows you to control both lens aperture and shutter speed. Most importantly, it opens up using a flash synchronization shutter speed higher than 1/60 of a second and it enables you to use smaller apertures. This is critical in that it increases your ability to use the flash outdoors as a fill light.

If you recall, the camera's normal ISO is 100. For a sunny day, the base exposure is 1/100 second at f/16. But suppose you want less depth of field and an aperture of f/8. You cannot do this in Auto, Auto+, P, or A mode because the shutter speed is locked at 1/60 second. Nor can you accomplish this in S mode; while you can get a 1/200 second shutter speed, you cannot change the aperture. The solution is to use M mode, switching the lens aperture to f/8 and the shutter speed to 1/200 second.

This higher flash synchronization speed gives you greater flexibility when using your flash in daylight; it actually increases the potential range of your flash unit. As covered in the section on GN, the primary determinants for flash exposure are the distance from camera to subject and the lens opening for a given ISO. With a higher synchronization speed, you can open your lens aperture by slightly more than two f-stops.

Another advantage of the higher synchronization speed becomes evident if your subject has some movement. To freeze movement, a shutter speed of 1/250 second is more effective than a shutter speed of 1/60 second.

When using the flash for fill work, we routinely use M mode. Remember, this does not prevent you from using slower shutter speeds. Indeed, not only can you still take flash exposures at 1/60 second, but you can also use longer shutter speeds such as a full second!

M Mode and Viewfinder Brightness: A Note for Studio Photographers

When we adjust aperture and shutter speed in M mode for interior photography, we sometimes run into a problem. Our viewfinder and LCD screens become so dark as to be unusable. This is a complaint that studio photographers reported on earlier SLT camera models. It results from having a live preview that attempts to show your image before you press the shutter button. This works well when you use the camera in a semi-automatic exposure mode (P, A, or S) with ambient lighting because the camera is always adjusting its settings to ensure you have a recordable image. But when you choose M mode and select an aperture or shutter speed that will be very underexposed, the viewfinder turns black. This can be annoying if you are using the camera for flash photography.

To keep the viewfinder and LCD screen bright when doing flash photography, set the following menu command:

MENU>Custom Menu (2)>Live View Display>[Setting Effect OFF]

The default for this command is [Setting Effect ON], which allows you to see the effects of Exposure Compensation as well as the special enhancement effects of Creative Style and Picture Effect. However, if you are using your camera only for flash photography, this is an incredible useful command—one that studio photographers should have in their repertoire.

Controlling Flash Output

In a scene where the flash is a supplemental light source, you will want to adjust the lighting ratio between regular and flash illumination. There are several controls to do this. The Exp. Comp. set command keeps flash exposure constant and then adjusts the exposure of the ambient lighting.

MENU>Custom Menu (4)>Exp. Comp. set>[Ambient&flash], [Ambient only]

This command allows you to brighten or darken the image when using Exposure Compensation. [Ambient&flash] option takes both light sources into account when applying or taking away exposure. [Ambient only] adjusts the external lighting and leaves the flash intensity unaltered. You can also apply Exposure Compensation to the flash, taking away or adding more light. This is achieved by using the Fn button (figure 10-7 a–b).

Fn button>Flash Comp. (right)>Toggle left or right for exposure compensation.

The final method of controlling the flash is to set the Flash control command to [Manual flash]. Once this is active, select the Power ratio. As mentioned earlier, if you decide to use this, there will be no pre-flash—just a single flash for exposing the picture.

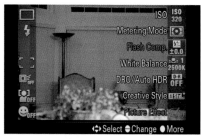 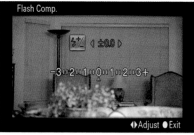

Figure 10-7 a–b: Selecting flash compensation and entering compensation by pressing multi-selector button.

Figure 10-7cd: Toggle right to increase flash exposure, press multi-selector button. Note exposure compensation value entered for flash.

10

Sony Accessory Flash Units

Sony sells accessory (external) flash units for the A77. Table 10-3 summarizes the models and their pricing.

Flash Model	GN	Zoom Head	Max Wide Angle with Diffuser	Weight (oz.)	Bounce Capable	Battery Power	Price (Sony Store)
HVL-F20AM	20	No Telephoto setting	27 mm	3.2	Yes	2 AAA	$149.99
HVL-F43AM	43	Yes: 24-105 mm	15 mm	12	Yes	4 AA	$349.99
HVL-F58AM	58	Yes: 24 mm-105 mm	16 mm	15.6	Yes	4 AA	$499.99

Table 10-3: Sony A77-compatible external flash units

As you can see, there is a flash for most everyone, ranging from the family photographer who needs a bit more power for his interior shots to the professional who needs to work with a unit that provides considerably more light. All of the flashes have their own internal power source, either AA or AAA batteries, ensuring that you will not drain your camera batteries when doing flash photography.

Focal Length and Variations in Flash Head Focal Length

Sony offers two flash units (model numbers HVL-F43AM and HVL-F58AM) with a zoom lens system for focusing light into a smaller area when you use a moderate telephoto setting. This elegant system tells the flash head what zoom is set on your lens. As you zoom in or out with your lens, you can hear a motor within the flash unit drive its lens system. This is all done automatically. Essentially, when you use a telephoto setting, it provides a more efficient use of the flash, matching its light distribution to the coverage of the lens.

10

A nice feature of the Sony accessory flash units is that they use inexpensive batteries that can be purchased at the corner drugstore. However, it would not be remiss to talk about recycle time when using these units. Typically, when the flash is used in an automatic mode for relatively short distances, it fires a very brief burst of light that is much shorter than the maximum duration. This short burst will help conserve battery power, and the capacitor recharges very rapidly. Rather than fire the flash at full power every time, the flash conserves the unused energy and uses it for the next flash. So instead of having to fully recharge, it needs to only partially recharge to reach full capacity.

But once you start using the flash in a large room and it fires at maximum duration, you will note that the recycle time increases. You can check this in the viewfinder of your camera, where you will see an orange circle. If it is flashing, it means the flash is recharging and it cannot be fired. As you drain the batteries, the recharge time becomes progressively longer.

However, there are situations where you want the flash to fire more quickly. If this is the case, you might consider replacing the flash's normal disposable alkaline batteries with rechargeable nickel metal hydride batteries. These batteries have a lower internal resistance and reduce the recycle time between flashes. Since they can be recharged, they can be an economical choice if you do a lot of flash photography. If they have any disadvantage, it is that they do not hold as much energy as the alkaline batteries. But this is of little concern when the recycle times for the alkaline batteries become unacceptably long, since you would replace them before their full charge is utilized.

Sony's smallest and least expensive external flash unit is the HV-20AM (table 10-3). It can be a handy little unit to keep in your camera bag. It gives you the ability to aim the flash directly at the subject or to adjust the head so that it fires a beam at a 75-degree angle toward the ceiling. This provides bounce or indirect lighting and reduces the harsh lighting that may result if the flash is aimed directly at a person. Bounce flash tends to produce a more flattering portrait, providing soft light that hides wrinkles. This unit's only disadvantage is its low intensity flash—about one third to half the power of Sony's more expensive units.

Figure 10-8: Dog photographed with direct flash

Figure 10-9: Dog photographed with bounce flash

10

We prefer the two larger, more expensive units—the HVL-F43AM and the HVL-F58AM. While they are bigger and heavier, they have more power, giving us more range. Both of them have heads that can be angled toward the ceiling for bounce lighting, and their greater power makes them more useful for this application. Both flashes have what Sony describes as a Quick Shift Bounce: when you take a vertical shot with your camera, the shoe-mounted flash can swivel its head so that it remains horizontal. Other manufacturers' flash heads shift to a vertical orientation. Sony's clever design ensures that their flash units provide the most efficient coverage for bounce lighting, whether you hold your camera in a vertical or horizontal position.

The HVL-F43AM and the HVL-F58AM both have a motorized zoom. The lens system distributes the light so it matches the zoom setting of your lens. This provides efficient coverage of your subject when you aim the flash directly at it, and also increases the maximum range of the flash. If we use the GN as a rough approximation of maximum distance, the HV-20AM provides a 1.7X increase, the HVL-F43AM provides a 3.6X increase, and the HVL-F58AM provides a 4.8X increase.

Of the three flash units, we found the HVL-F43AM best suited for our needs. It provided sufficient power for our applications, and we felt that the additional cost of the HVL-F58AM was not justified.

Bounce or Indirect Lighting: Flash Accessories

One of the benefits of an accessory flash with a tilting and rotating head is the ability to use bounce flash. When the flash is aimed directly at your subject, the light can be unflattering. The lighting is described as harsh (figure 10-8) and displays facial wrinkles and strands of hair—or in this case strands of fur—with distressing clarity.

One simple strategy for reducing this effect is to swivel the flash head; instead of aiming it directly at the subject, aim it at a ceiling or an adjacent wall. The light will bounce from these areas onto the subject. Such light has had a chance to become diffused. As a result, the lighting is softer, masking wrinkles and deemphasizing individual strands of hair to provide a more pleasing image. In figure 10-9, the diffused lighting softens the dog's appearance.

One reason we do not use the inexpensive Sony HVL-F20AM flash unit is because it lacks power required for bounce illumination. In addition, while the lighting can be angled up at a fixed angle of 75 degrees, we do not have the flexibility to stop down the lens as much as we would like. The higher output of the HVL-F43AM flash unit allows considerable flexibility in closing down the aperture if we so desire.

One caveat on using a bounce flash is that if you have the camera set for red-eye reduction, the flash will emit small bursts of light prior to the exposing light. This is not needed with bounce flash, so make sure you turn red-eye reduction [Off].

If you use external flashes for much of your photography, you will want additional ways of diffusing the light. Although we like bounce lighting, it is not always

usable. For example, if the ceiling or walls are heavily colored, they will impart the color to the reflected light, destroying the white balance.

One helpful accessory is a little plastic diffuser that attaches directly to the flash head. Sto-Fen makes the Omni-Bounce that attaches directly to the front of the Sony flash head. It is fitted by friction, which is advantageous since you don't need tape to keep it affixed to the flash. The device is small enough so you can keep it in your camera bag, and it does diffuse the light—though if there is one problem with the Omni-Bounce, it may not diffuse the light enough.

There is no substitute for using large reflectors and/or diffusers, but they can be cumbersome and expensive accessories. If you wish to experiment with them, you can assemble your own for pennies. Below is a website that has several tutorials for assembling your own flash accessories:

www.digital-photography-school.com/
diy-flash-and-lighting-hacks-for-digital-photographers

Also, check out Rocky Nook's *Low Budget Shooting* by Cyrill Harnischmacher for loads of ideas on do-it-yourself studio gear and accessories.

On occasion, we tilt our flash head vertically and attach a white sheet of heavy paper with tape. By folding the top of the sheet over the flash head and arranging it so it directs the light forward onto the subject, we have an inexpensive reflector/diffuser that can be discarded as soon as the session is over.

Sony Wireless Flash

You will need an accessory Sony flash to take advantage of the Flash [Wireless] option.

Fn button>Flash Mode (left)>[Wireless]

This option enables your Sony built-in flash to serve as a trigger (Master) to fire your external accessory flash (Slave) wirelessly. The first step involves pairing the two units so they can communicate to one another. This is done by the following sequence:

1. Turn the mode dial to P, A, S, or M.
2. Take the accessory flash and mount it on the camera's flash auto lock accessory shoe.
3. Turn both the external flash and the camera on.
4. Press the Fn button and toggle to the Flash function. Press the multi-selector button to select it. Toggle to the [Wireless] option and press the multi-selector button again to select the option.

10

5. Remove the flash unit. You should see a red light slowly flashing on it, indicating that the flash is ready to use as a slave.

6. To test whether the two flashes are communicating:
 - a. Raise your built-in flash.
 - b. Press the AEL button.
 - c. The built-in flash will emit a small burst of light.
 - d. In response, the slave flash will fire a burst of light to confirm the two flash units are communicating.

Once you complete this operation, you can position your accessory flash (slave) so it can see the light from the built-in flash (master). This light can be a reflection, so the slave need not be pointed at the camera. It takes surprisingly little light to activate the signal, and it can operate from light reflected off the subject or a wall. You can check to see if this communication link is active by pressing the AEL button.

The advantage of the [Wireless] option is that you do not have to have your external flash connected to your camera body. You can position it in a variety of places. For example, you may notice that some photographers have camera brackets for holding the flash unit away from the camera body. You can use such devices to ensure flattering lighting and reduce the chances of red-eye. Or, you can put your Sony flash on its pedestal (supplied) and position it well away from the camera body.

One trick we use at family gatherings is to mount the flash on the pedestal, place it on a strategically located table, and aim it at the ceiling. We then use the wireless flash to fire the flash for our group shots. The lighting can be very flattering, and you can move about as you fire the camera without carrying the weight of the flash unit.

Slow Flash Synchronization

When photographing someone against a scenic background at night, you may wish to record both the person and the background. If you use the standard synchronization speed of 1/60 of a second or shorter, this may be impossible. But you might be able to record the background with a longer exposure—perhaps an exposure of one or two seconds, or more.

To accomplish this, you can use your AEL button. With the built-in flash up, press the AEL button while pressing the shutter. This forces the camera to take a longer exposure of the background scene. When properly done, the foreground subject is exposed by the flash and the background scene is exposed by the slower shutter speed. This command is unavailable when the mode dial is set to M or S.

10

Recommendations

Although the built-in flash can be used in Auto, Auto+, or SCN mode, we urge you to use it in P, A, S, or M mode. Especially important, in our opinion, is learning to use the flash with the camera set to M mode. This allows you to adjust both the camera's shutter speed and the lens aperture. You can increase your depth of field dramatically if you adopt this strategy. If you use the flash as a fill light outdoors, set the shutter speed to 1/250 second rather than 1/60 second to use the flash to fill in shadows.

If you are doing a lot of interior photography, you may wish to consider getting an external flash unit. In our opinion, the HVL-F43AM has an excellent feature set for its cost. Bounce and wireless flash lighting can be exploited with this flash unit.

One feature we did not yet mention with the HVL-F43AM is that it is possible to use shutter speeds shorter than 1/250 second. This model and the HVL-F58AM have a feature called HSS (High-speed synchronization). HSS allows you to set the shutter speed at 1/250 second or faster; you can set a shutter speed up to 1/8000 second. This is an advantage when you use the flash as a fill light and you wish to open the aperture to ensure a shallow depth of field.

10

Chapter 11: Recording Movies

Introduction

The Sony A77 is a hybrid, capable of taking both excellent still pictures and movies. As such, it allows you to carry one camera to do two tasks. To switch from taking still shots to shooting movies is as easy as pressing the Movie button to begin recording (figure 11-1). Moreover, the movies are of excellent quality and can be played on HDTVs or recorded to DVD discs.

In this chapter, we introduce the movie operation of the Sony A77 and approach the topic at a beginning level for users who are more familiar with still photography. We also provide an explanation of file formats as well as the commands that are used to record movies.

Figure 11-1: Movie button (photograph courtesy of Sony)

There are two ways to take movies. One is to let the Sony A77 make all the decisions, including focusing. This is what happens when you press the Movie button on the back of the camera while the mode dial is set to an option other than Movie. If you want to exert more control and adjust the aperture or the shutter speed, turn the mode dial to Movie mode (the icon that looks like a film strip, figure 11-2). This allows you to control the shutter speed and the aperture, but at the expense of automatic focusing. You will have to use the camera in manual focusing mode, but this is not as much of a hardship as you might think. Thanks to the Peaking feature, you can adjust focus precisely and quickly. The color fringes provide an immediate indication of when and where you are in focus. Moreover, if you own a lens that has a noisy focusing motor, you will need to use manual focus to avoid recording the grinding noise of the focusing motor.

Figure 11-2: Movie mode on mode dial

One thing that may surprise you is the amount of preparation that is needed to take a high quality movie. It is necessary to preplan the scene and spend time to ensure camera stability and correct lighting.

As popularized in some professionally made movies, there is a technique of shooting handheld movies where the videographer rapidly shifts position to provide diverse vantage points. This is not typically the best way to record a short clip. While such techniques can have a powerful effect when conveying fast, tension-filled action, they are unsuitable when recording a family birthday party. Such events require smooth panning so the subject does not appear to be jittering within the frame. You may be disappointed in your results if you handhold the camera and unnecessary movement distracts your audience.

Just as with still pictures, recording a good movie usually involves a tripod and some careful planning. Pay attention to your lighting source. If your framed image

11

has areas that are extremely bright or dark, you may need to sacrifice details in either the highlights or shadows. Consider whether you intend to create a certain mood. For example, dark shadows can add an ominous feeling to a clip. However, if that is not your intent, adjust your lighting so that there is a balance between lighting extremes. Unlike still photography, you will not be working with RAW files. You cannot compensate later for errors in exposure, nor can you control regional contrast. What you capture is pretty close to what you will have to show. Remember, the DRO functions on the Sony A77 can help you balance out the extremes in shadows and highlights. While we tend to avoid using them in still pictures, we tend to make use of them when recording movies.

Glossary of Movie Terms

To introduce the still photographer to movies, we provide an initial table defining many of the terms we use (Table 11-1). You can refer to this table while reading this chapter.

Term	Description
Aspect Ratio	A ratio of height to width that defines the dimensions of an image. For example, 16:9 represents a 1.78:1 ratio of height to width. 4:3 represents a 1.38:1 ratio of height to width.
AVCHD	Advanced Video Coding High Definition. This is a file format for recording and saving high-definition videos. It provides a high degree of video compression and is typically not edited in its native format. Instead, the file must be translated, or transcoded, before it can be edited.
Frame Rate	The number of still pictures (frames) recorded per a unit of time, generally expressed as frames/second.
Bit Rate	The rate that data is processed per a unit of time.
Interlaced Scanning	Captures or projects movie images by creating two "fields" per frame. Together the two fields contain the full number of lines for the frame; individually, each field contains only half the number of lines. To view the complete image, the two fields are combined—so when capturing 30 fps, you are actually capturing 60 fields per second (fps).
Mbps	Megabits per second. It is a measure of data content via the rate of information being processed. Higher quality videos are recorded at higher Mbps values.
MP4	A multimedia format based on the QuickTime file format for storing digital video files.
NTSC	National Television System Committee. This is a U.S. television and video standard that uses 525 vertical lines of resolution. For video, it is associated with collecting images at approximately 30 fps.
PAL	Phase Alternating Line. This is a European and Asian television and video standard that uses 625 vertical lines of resolution. For video, it is associated with collecting images at approximately 25 fps.
Progressive Scanning	Captures a movie image in its entirety with a single scan, unlike Interlaced Scanning, which requires two scans.

Table 11-1: Movie-related terms

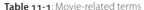

Keep in mind that taking a movie provides some restriction on your lighting conditions. Frequently, the Sony A77 records at a frame rate of either 30 or 25 frames per second (fps), and for very high quality work a videographer may shoot at a frame rate of 60 or 50 fps. You will note there are variations in this frame rate (e.g., 30 vs. 25 or 60 vs. 50). The number is dependant on the camera's country of origin. The 30 fps is a NTSC (National Television System Committee) standard utilized in the U.S., and 25 fps is a PAL (Phase Alternating Line) standard used by cameras used outside of the U.S. As a matter of convenience, we will use the NTSC standard.

Since you are shooting a sequence of shots, you will find that you cannot use the slow shutter speeds available to the still photographer. Obviously, when shooting at 30 frames per second, you cannot maintain this rate if you set the shutter speed to ¼ second. So you are limited when recording in low light levels. Further, having too fast of a shutter speed is not desirable either. If you use a fast shutter speed of, say, 1/1000 second and you play it back at 30 fps, rather than having a smooth motion, your audience may feel that the moving subjects seem to move in a strobe-like fashion. This appearance comes from having too sharp an individual frame. Since they are only being displayed at 30 fps, a crisp edge exaggerates the fact that you are seeing a series of individual frames being projected. Ironically, if you were making a movie for surveillance, this crisp rendering is desirable. For instance, it can be used for reading the numbers and letters off the license plate of a speeding car. However, for most videographers, a good starting place for setting your shutter speed is about 1/60 second if you are shooting a 30 fps or 1/120 second if you are shooting at 60 fps.

Choosing a File Format

The first step before taking a movie is to determine how you intend to use it. There are two file formats available: AVCHD or MP4 (table 11-2). Choose AVCHD if your goal is to record and/or view the movie at its highest resolution on your HDTV, or if you intend to create DVDs that can be used on your DVD player. Choose MP4 if your goal is to process and view your movie on a computer or send it as an email attachment.

We recommend that you choose MP4 if you are just starting out and are unfamiliar with shooting movies. This file format is easy to work with and there are several free viewing and editing software packages available. On the other hand, if you want to get the highest quality images possible, then choose AVCHD.

To select the file format, retrieve the following command:

MENU>Movie Shooting Menu (1)>File Format>[AVCHD 60i/60p], [MP4]

When you use this command, if you purchased your camera outside of the U.S., you will see [AVCHD 50i/50p] option instead of [AVCHD 60i/60p].

11

File Format	Use
AVCHD	Provides the highest quality videos. Can be viewed directly when the camera is coupled to a suitable HDTV. PMB can translate AVCHD files for burning onto a disc and playing on a HDTV.
MP4	Provides lower quality videos that can be easily attached to emails or inserted in web documents. Can be worked on easily with older, slower computers.

Table 11-2: Sony A77 file formats

Table 11-2 characterizes the use of the two formats. At least two camera manufacturers recommend using AVCHD for direct viewing from the camera to your TV or making playable DVDs for HDTV. Their recommendation is very conservative. You should disregard it if you want to work with your movie files on your computer. After all, Sony does provide PMB, which can serve as a rudimentary movie player and editor.

If you do decide to work with AVCHD, you will eventually want to buy a more capable software package. On our MacBook Pro we use iMovie '11, an inexpensive movie editor that works with most of our AVCHD files. Whatever software you choose, just make sure it can transcode the files so you can work on them. At the time of writing, the Sony A77's highest quality mode, 60p 28Mbps, was not read by iWorks '11 or Final Cut Pro X.

AVCHD
AVCHD files provide the highest fidelity and smoothest perception of movement for your movie. However, they make greater demands on your computer and software. Although you can work with these files on older computers, newer computers with plenty of RAM and large, fast hard drives handle these files better.

We have edited our AVCHD clips using iMovie and PMB. Both of these software packages are basic, inexpensive editors: PMB comes free with your camera, and Apple users can download iMovie '11 for $14.99. If you decide to work with a higher-end movie editor such as Final Cut Pro X or Adobe After Effects for Windows, you will have to pay considerably more, $300 and $560 respectively.

MP4
This movie file format is the easiest one to work with, since it can generate data files that are read easily by other software programs. You can get free programs for opening and viewing MP4 files, such as Apple's QuickTime. If you decide you want more power in your movie editing, you can buy QuickTime Pro from Apple for only $29.95 using the following url: http://store.apple.com/us/product/D3381Z/A.

The vertical number of pixels is the same for both MP4 and AVCHD, so if you choose MP4 format, you do not give up much in regards to resolution. What you do lose is some width in the image, which becomes a concern if you want to display

11

the movie in a widescreen 16:9 format. Also, you can save MP4 files only in a 640 by 480 pixel display, the smallest file size for saving your movies. This is an advantage if you intend to attach the movie file to an email.

Movie Quality

Several things determine the quality of the movie: number of fps, bit rate, and format type. We have talked about the format type already: AVCHD or MP4.

The number of fps determines whether enough frames were recorded to produce a sequence that plays back smoothly as if you are watching a live event. Too few fps, and the movie will look like a series of still pictures put together to simulate movement.

The number of bits being processed determines how fine the details are within the movie. Too few, and the movie will not have satisfactory definition and detail.

Interlaced Scanning

Older analog cameras and displays for broadcast television relied on forming an image by interlaced scanning. This was due to technological limitations. In order to display enough images sequentially for a smooth perception of movement, a television camera would use two fields to make a single frame. This strategy would allow the viewer to see an object moving smoothly across the screen. The interlaced scanning method is an option still used by many cameras, including the Sony A77.

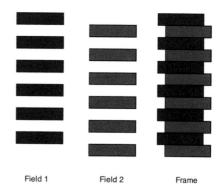

Field 1 Field 2 Frame

Figure 11-3: A diagrammatic representation of an interlaced scan were two fields are collected separately and combined to make one frame

In this method, a recording device with a spatial resolution of 600 horizontal lines actually collects only 300. It starts with the top line and then collects every other line to create an image with 300 horizontal lines (figure 11-3). If you define the top line as number one, the sensor collects every odd line for the first field. Then the sensor collects the remaining 300 lines, starting with the second line from the top, to form the second field. Combining the two fields yields a single frame of 600 lines. In essence, to display movie at 30 fps, a camera or television has to collect and display 60 fields per second.

If you see the letter "i" with an fps number in your Sony A77's viewfinder or LCD screen, it stands for interlaced scanning, indicating that two fields were taken and combined to form the single frame. If one field had a moving object, its edges would display an offset artifact because the first field collected the image before the second field. This would blur the edges of the moving object, but due to how the human eye works, the motion would be perceived as smoother.

11

Progressive Scanning

Progressive scanning is the modern way of recording and playing back movies. All computers use this method to display images on their monitors. The newest cameras, such as the Sony A77, also have the progressive scanning option. If you see the letter "p" with an fps number on your Sony A77's viewfinder or LCD screen, it stands for progressive scanning.

This method is pretty straightforward. Basically, the movie camera and the display projector collect all the vertical lines of a frame in sequence and then display them at once (figure 11-4). For a moving object, this provides a sharper display of its edges. If you had to deal with a single frame, that frame would provide the highest definition for regions that move from frame to frame. For image processing, this is the preferred image type.

Frame 1 Frame 2 Frame 3

Figure 11-4: Progressive scanning format

Progressive scanning is viewed as the ultimate in image quality. However, it has one peculiarity. Because of the sharpness of the individual images, the playback may not appear as smooth as with interlaced scanning. If you were to look at a single frame of a clip captured with progressive scanning, a moving subject would show finer details and cleaner edges.

So, which one to use; interlace or progressive? One rationale for using interlaced scanning is that a slight blurring of the individual frames helps hide the transition from frame to frame. However, the individual frames of a progressive scan are a tad sharper. Experiment with each method and decide which you prefer. For video editing you will probably opt for movies obtained by progressive scanning. If you are just viewing the movies and are not interested in using the freeze frame to study fine details, then most people will be satisfied with using interlaced scans.

Bit Rate and Frame Rate

AVCHD and MP4 files are highly compressed. How much data is preserved is determined by the amount of data being processed: the more data processed, the greater the fine detail. In computing, the measure of data being processed is its bit rate (bits/second). In the case of a movie, so such information is processed that you need to express the data in terms of millions of bits per second, or Mbps (Megabits Per Second). The Sony A77's highest quality movies are processed at 28 Mbps, while the lowest are processed at only 3 Mbps.

11

These data rates reflect the fact that movies are a sequential series of images recorded at different frame rates. AVCHD files recorded at the highest frame rate, 60, generate the greatest amount of data and have the highest Mbps value.

So, which file format should you chose? There is no clear answer to this question, simply because it depends on what you intend to do with your movies. If you intend to view the files directly on your TV or make them into playable DVDs, then by all means chose AVCHD and use the highest recording quality your playback device will support. If you like to use the freeze frame to carefully study the details in the individual frame, then you should use the highest Mbps data. Also, the highest values are useful for video editing.

Remember, if you decide to use PMB and record your movie to disk, there will be some degradation in image quality. The playback quality will not match the quality you can attain if you use your camera to play back the movie on a TV capable of handling this format. If you choose AVCHD 60i or 60p and use PMB to create your disk, Sony reports that your disk will not display the full image quality recorded by your camera.

If you are a new to movie making and want to record movies quickly and make clips to playback on your computer, we suggest the MP4 format. It is easy to use and requires a minimal investment in hardware and software.

AVCHD Record Setting Command

This is one of the more complicated commands. When you select the AVCHD file format, you will see an extensive range of options. The command for selecting movie quality for U.S.-sold cameras is:

MENU>Movie Shooting Menu (1)>Record Setting>[60i 24M], [60i 17M], [60p 28M], [24p 24M], [24p 17M]

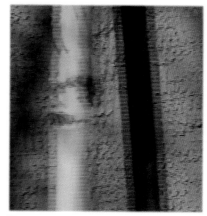

Most of these options appear rather cryptic to the still photographer, but the selections can be summarized by their bit rates (table 11-3). Maximum quality is 28 Mbps, which is described as [60p 28M]. Referring to the glossary earlier in the chapter, this translates into a format that is recording at 60 fps in progressive mode. You may wish to contrast [60p 28M] with the next highest resolution

Figure 11-5: Artifact of interlaced scanning showing the blurring of the edges when the camera is panning a stationary object

11

mode, [60i 24M]. The difference between these file formats can be subtle if your goal is to observe the movie stream on your television. The individual frames will have sharper edges on moving objects in 60p versus 60i (figure 11-5). Remember, "i" stands for interlaced scanning where two fields are taken and interlaced to form a single frame.

The frame rate 24p is referred to as cinematic because it is used in movies. If your subjects are rapidly moving about—for example, at a sports event—we would not recommend this frame rate. You will be more pleased by capturing at 60 fps, which renders rapid motion more realistically by gathering more images. At 24p, you may find that the playback appears jittery. This may become even more apparent if you select a very short shutter speed in Movie mode, which freezes the subject's motion in the individual frame.

File Format = [AVCHD 60i/60p]/[AVCHD 50i/50p]		
Record Setting Value	**Average Bit Rate**	**Movie Recording Size and Frames/second (fps)**
60i 24M(FX) / 50i 24M(FX)	24 Mbps	Records high quality videos, 1920 x 1080 pixels at either 60i/50i fps
60i 17M(FH) / 50i 17M(FH)	17 Mbps	Records standard quality videos, 1920 x 1080 pixels at either 60i/50i fps
60p 28M(PS) / 50p 28M(PS)	28 Mbps	Records the highest quality videos, 1920 x 1080 pixels at 60p/50p fps
24p 24M(FX) / 25p 24M(FX)	24 Mbps	Records high quality videos, 1920 x 1080 pixels at 24p/25p fps (cinema-like movies)
24p 24M(FH) / 25p 24M(FH)	17 Mbps	Records standard quality videos, 1920 x 1080 pixels at 24p/25p fps (cinema-like movies)

Table 11-3: AVCHD file recording settings

MP4 Record Setting Command

When you select MP4 for your file format, you will have two Record setting options to choose from. The one you select depends on the number of pixels you wish to display.

MENU>Movie Shooting Menu (1)>Record Setting>[1440x1080 12M], [VGA 3M]

File Format = [MP4]		
Record Setting Value	**Average Bit Rate**	**Movie Recording Size**
1440 x 1080 12M	12 Mbps	Records 1440 x 1080 movies
VGA 3M	3 Mbps	Records 640 x 480 movies

Table 11-4: MP4 Record setting values

The first option, [1440x1080 12M], is easy to understand; your pixel array will be 1440 x 1080 pixels. The second option, [VGA 3M], is a bit cryptic because of the letters VGA. This refers to an old monitor resolution standard, Video Graphics Array, and means the movies will be shown as a pixel array of 640 x 480. So VGA provides a much smaller movie frame, generating a small movie file that can be used as an email attachment.

Additional Movie Controls

There are some additional controls available when recording movies. The first question to ask yourself is whether to record sound with your movie. Normally, the answer is yes. Since audio tracks can be removed later on through editing, you can always go ahead and capture the audio, and then decide later whether or not to keep it. To select audio recording, use the following command:

MENU>Movie Shooting Menu (1)>Audio Recording>[On], [Off]

If you are recording on a windy day, the camera microphone can pick up the distracting sound of the wind. To reduce this annoyance, you can invoke a wind noise reduction feature. Use the following command:

MENU>Movie Shooting Menu (1)>Wind Recording Reduct.>[On], [Off]

The final control option is the SteadyShot command. For handheld movies, this command should be set to [On], but for tripod work, set it to [Off].

MENU>Movie Shooting Menu (1)>SteadyShot>[On], [Off]

This SteadyShot command is separate from the one in the Still Picture Menu and works independently. You can have SteadyShot set [On] for movies and [Off] for still pictures, or vice versa.

Framing and Starting the Movie

The Sony A77 Live View is set at a 3:2 aspect ratio for still photography. When you press the Movie button, you will find that your display screen changes appearance. Basically, the field of view becomes smaller, and your frames can drop to a 16:9 aspect ratio. This can be disconcerting if you have already framed your subject. To ensure that you get accurate framing before you press the Movie button, change your screen so it shows grid lines as discussed in chapter 3. If you do this, you will see a set of four marks within the display that mark the corners of your

11

movie screen. If you carefully frame your subject within these marks, you will have an accurate frame when you start your movie.

Once you frame your scene, you can start recording with a single press of the Movie button. The maximum length of a single recording session is 30 minutes.

Movie Mode

If the camera's mode dial is set to an option other than Movie, and you press the Movie button to start taking a movie, the camera automatically adjusts the shutter speed and the aperture. One peculiarity is that the aperture is always set to its maximum opening, providing a very shallow depth of field that causes much of the scene to be out of focus. This is intentional in that the accuracy of the automatic focus sensors is best when using the widest aperture. However, when taking a movie on a sunny day, the shutter speed can reach 1/1000 second. This will affect your movie recordings; if you recorded using 24 fps, you will see rapid, jerky motion during the movie playback.

You can remove such effects by controlling the camera's aperture or shutter speed manually. To do this, execute the following steps.

1. Turn the focus mode dial to MF.
2. Turn the mode dial to Movie.
3. The screen will show Movie mode options with a brief description of each mode.
4. Toggle the multi-selector up and down to choose [P], [A], [S], or [M].

Figure 11-6: Fn button menu showing Movie option

Figure 11-7: Fn button menu showing a Movie mode P selected

Note: if you do not see the Movie mode options with a description of the mode, press the Fn button.

Fn button>Movie (left)>[P], [A], [S], [M] (figure 11-6, 7)

As you highlight P, A, S, or M, you will see a screen describing the selection's function and purpose. Basically, P mode is fully automated where the camera selects both the aperture and the shutter speed. The A mode (Aperture-Priority) is used

for selecting lens aperture and controlling the depth of field. S mode (Shutter-Priority) is used for selecting shutter speed and determining how tightly you wish to freeze the motion in the movie frame. The M mode (Manual) is used to adjust both the aperture and shutter speed.

Changing the shutter speed can be useful to avoid the flickering caused by recording under fluorescent lights. Fluorescent bulbs have a cyclic output with a frequency that can, at certain shutter speeds, cause a distracting brightening or fading of the movie. Try selecting a shorter or longer shutter speed to remove this effect. You might find that adjusting the shutter speed to 1/100 or 1/125 second will record a more uniform lighting.

So what do you give up when you use the camera in the Movie mode? It is the loss of automatic focusing. You will have to use manual focusing mode only. The one exception is P mode. If you set the camera to Auto ISO, the camera will still focus automatically even though you will see an error message that says only manual focus is available in this mode. To minimize the inconvenience, make sure the Peaking feature is activated. This will enable you to rapidly identify the areas that are in focus. While this is not as convenient as automatic focusing, it has one advantage when you use older or less expensive lenses: you will eliminate the sound of the automatic focus motor.

Recommendations

We enjoy taking movies with the Sony A77. In some cases, we have planned carefully prior to recording and meticulously executed our shoot with the camera mounted on a tripod. In other cases, we have acted on an impromptu desire to record an event by handholding the camera. In both cases, the Sony A77 has performed well.

For the most satisfying and professional-looking movies, you should mount the camera on a tripod. While you certainly can create a pleasing movie without this accessory, failing to use a tripod may result in a movie where the subject appears to bounce up and down within the frame. The resulting movie may look unpolished and unprofessional, especially if you intend distribute the results.

Do not be afraid to work with AVCHD. If you take short movie recordings, you should be able to easily edit these files on your computer. In the case of Mac computers, you will have to buy additional software; however, the cost is nominal. iMovie '11 can be downloaded for $14.99; however, at the time of writing, this program would not read the highest quality recording from the Sony A77, the 60p 28 Mbps. If you own a PC, be sure to load Sony's supplied program, PMB, and use it to work with AVCHD files and create DVDs.

If you simply want to dive in and play and edit your movies on your computer, then use the MP4 file format. Using this format is straightforward and requires the minimum upgrades in software and hardware as compared to the AVCHD format.

11

Appendix A—Menu Commands

This appendix lists all of the Sony A77's menu commands in order of their appearance within the menu structure.

Use this list as a dictionary and quick reference of a command's function and location. Many of the commands are covered in detail in previous chapters, so think of this as an index for reviewing your commands.

The list is broken into sections with the menu name and page number identified at the beginning of commands residing on the menu's page. Each command is listed along with a description and useful information. The commands' available options and their descriptions are listed below the command. Note the commands' default option is bolded. Example 1 below is the first command in the Setup Menu's page 1. The Menu start command has two options: [Top] and [Previous], where [Top] is the default option.

A few of the commands have subcommands. The subcommand options are listed and then further broken out with their individual options. Example 2 shows part of the Slide Show command. Note the command has a subcommand called Repeat, which has two options: [On] and [Off], where [Off] is the default.

Example 1

Command	Description	
Menu start	Determines the location displayed when the MENU button is pressed	
	Top	Displays the menu beginning at MENU>Still Shooting Menu (1)>Image Size
	Previous	Displays the menu beginning at the last displayed command

Example 2

Slide Show	Allows you to display still images stored on the memory card in sequence as a slide show		
	Repeat	Determines if the slide show runs through the images once or loops continuously	
		On	Slide show loops continuously through the images
		Off	Plays the images once and stops

Sony A77 Menu Commands

Still Shooting Menu – Page 1	
Command	**Description**
Image Size	Defines the image size in pixels. Different values are presented based on the selected Aspect Ratio value. Works only on JPEG files. RAW files size is consistent at 6000 x 4000 pixels.

When Aspect Ratio = [3:2]	
L:24M	6000 x 4000 equivalent pixels
M:12M	4240 x 2832 equivalent pixels
S:6.0M	3008 x 2000 equivalent pixels

When Aspect Ratio = [16:9]	
L:20M	6000 x 3376 equivalent pixels
M:10M	4240 x 2400 equivalent pixels
S:5.1M	3008 x 1688 equivalent pixels

Command	Description	
Aspect Ratio	Specifies the image's width to height ratio	
	3:2	Represents a width of 3 units to a height of 2 units. This is the typical still picture ratio size.
	16:9	Represent a width of 16 units to a height of 9 units. This is the typical movie frame ratio size.
Quality	Sets the still image's file format. RAW files contains all of the image data with minimal to no changes. JPEG files are compressed, modified, and/or changed image data. Note that the Image Size command for individual image sizes and equivalent pixels is only for JPEG files.	
	RAW	The data is stored with minimal digital processing. Contains more data than JPEG file types. File extension is .ARW.
	RAW & JPEG	Two files are created: RAW and JPEG Fine. The RAW file is stored with minimal digital processing. The JPEG file is more compressed than RAW, and its image reflects the results of the camera's digital processing. File extension is .ARW and .JPG.
	Extra fine	Extra fine has the lowest compression rate of the three JPEG file types and retains the most image detail. File extension is .JPG.
	Fine	Fine is the JPEG default compression rate, with an intermediate degree of compression and retention of image detail. File extension is .JPG.
	Standard	Standard has the highest compression rate of the three JPEG file types and can lose fine detail. File extension is .JPG.

Still Shooting Menu – Page 1 (con't)		
Command	**Description**	
Panorama: Size	Determines the size of a panoramic picture. Command is enabled only when mode dial is set to Sweep Panorama.	
	Standard	[Right]/[Left]
		[Up]/[Down]
	Wide	[Right]/[Left]
		[Up]/[Down]
Panorama: Direction	Defines the direction to pan the camera when executing a Sweep Panorama. Command is enabled only when mode dial is set to Sweep Panorama.	
	Right	Pan the camera from left to right
	Left	Pan the camera from right to left
	Up	Pan the camera upward from the bottom
	Down	Pan the camera downward from the top
3D Pan.: Image Size	Determines the size of a 3D panoramic picture. Command is enabled only when mode dial is set to 3D Sweep Panorama.	
	16:9	1920 x 1080 equivalent pixels
	Standard	4912 x 1080 equivalent pixels
	Wide	7152 x 1080 equivalent pixels
3D Pan.: Direction	Defines the direction to pan the camera when executing a 3D Sweep Panorama. Command is enabled only when mode dial is set to 3D Sweep Panorama.	
	Right	Pan the camera from left to right
	Left	Pan the camera from right to left

A

Still Shooting Menu – Page 2		
Command	**Description**	
Long Exposure NR	Controls noise reduction for pictures taken with exposures of one second or more. The camera takes two pictures, uses Dark Frame Subtraction to reduce noise, and saves a single processed picture. Camera should be mounted on a tripod.	
	This command executes only for long exposures when the shutter speed is one second or longer. Since two pictures are taken and then processed into one, the time needed to accomplish this increases more than twofold. Be prepared to wait.	
	This command does not execute if set to [On] in the following modes: Sweep Panorama, 3D Sweep Panorama, Continuous Advance Priority AE, and SCN [Sports Action] or [Hand-held Twilight]. It also does not execute when the camera is set to Continuous Shooting or Bracketing, or when the ISO is set to [Multi Frame Noise Reduct.].	
	The command is automatically set to [On] in Auto, Auto+, and SCN predefined scene modes, excluding [Sports Action] and [Hand-held Twilight].	
	On	Enables the noise reduction process
	Off	Disables the process
High ISO NR	Assigns noise reduction processing for high-sensitivity JPEG still image shooting. Although noise can occur at lower ISOs, we have noticed that noise starts showing up consistently at ISO 1600.	
	Noise reduction processing occurs after taking the image. Processing must be complete before the camera is available to take another picture. The [High] and [Normal] options reduce image sharpness. This command is not available for RAW images or in Auto, Auto+, Sweep Panorama, 3D Sweep Panorama, and SCN modes.	
	High	Reduces the greatest amount of noise and takes the longest time to complete the process
	Normal	Reduces an average amount of noise
	Low	Reduces the least amount of noise and takes the shortest time to complete the process
Flash control	Sets the method on how the camera determines the intensity of flash output. The amount of light the flash should emit is determined by the following:	
	ADI flash	(Advanced Distance Integration) – Measures both the amount of light passing through the lens and the distance from the camera sensor to the focused subject
	Pre-flash TTL	(Through the Lens) – Measures only the amount of light through the lens
	Manual flash	Adjusts the flash to emit light based on the Power ratio command value

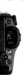

Still Shooting Menu – Page 2 (con't)	
Command	**Description**
Power ratio	Controls the amount of light the built-in flash emits when the Flash control command is set to [Manual flash]. This command is disabled when the Flash Control command is set to [Pre-flash TTL] or [ADI flash].

	1/1 1/2 1/4 1/8 1/16	1/1 = full power, scaling down to 1/16 of full power

AF Illuminator	Controls the emission of a beam of red light from the AF Illuminator to facilitate auto focus on dimly lighted subjects. The light emanates from either from the camera body or from an attached external flash unit. The AF Illuminator does not work when the AF area is set to [Local] or [Zone], when autofocus mode is set to AF-C, when the subject is moving in AF-A, or when Smile Shutter is [On].

Auto	AF Illuminator turns on when in low-light environment
Off	AF Illuminator never turns on

Color Space	Allows you to select one of two preset color spaces for reproducible colors.

sRGB	Common standard for most electronic display and recording units
AdobeRGB	Common standard for CMYK four-color professional printing

SteadyShot	Enables internal camera stabilization. Allows you to obtain sharp still pictures at slower shutter speeds when handholding the camera. The camera will compensate for small movements caused by hand tremors. Do not use if your camera is mounted on a tripod; the camera's SteadyShot software will try to compensate, which can make a sharp image blurry.

On	Enables SteadyShot
Off	Disables SteadyShot

Still Shooting Menu – Page 3

Command	Description	
Exposure step	Selects Exposure Compensation scale's f-stop increment size. Each f-stop is divided into three parts on the scale represented by tick marks. Each tick mark equals 1/3 f-stop. Toggle the multi-selector right or left to move the EV (Exposure Value) value.	
	0.5 EV	Changes EV by 0.5
	0.3 EV	Changes EV by 0.3
AF-A setup	Determines whether to allow manual focusing when the focus mode is [AF-A]. Regardless of this command's value, SSM lenses allow manual focusing and SAM lenses do not.	
	AF-A	(Autofocus Automatic) – Allows the camera to determine if it should autofocus singly or continuously. Does not allow manual focus.
	DMF	(Direct Manual Focus) – Releases the focus ring (once focus is locked) to allow manual focus.
Priority setup	Determines whether the camera needs to have the image in focus to take the picture When the camera is in MF mode, setting this command to [AF] has no effect, and the camera operates as if [Release] was chosen.	
	AF	Requires image to be in focus for the shutter button to fire
	Release	Does not require image to be in focus for the shutter button to fire. Allows out-of-focus shots even in Auto or Auto+ modes.
AF w/ shutter	Determines whether pressing the shutter button halfway starts the autofocus process.	
	On	Initiates autofocus when you press the shutter button halfway
	Off	Does not initiate autofocus when you press the shutter button halfway
Memory	Allows you to store a current group of camera commands and function values in one of three memory slots for future recall and utilization. Recall occurs when the mode dial is turned to MR and a specific memory group is selected.	
	1	Memory Group 1
	2	Memory Group 2
	3	Memory Group 3

Movie Shooting Menu – Page 1		
Command	**Description**	
File Format	Defines the file format for storing movie files. Note: your camera will either show [AVCHD 60i/60p] or [AVCHD 50i/50p] but not both, depending on the country where your camera was made.	
	AVCHD 60i/60p (or AVCHD 50i/50p)	**(U.S. Standard)** Records movies in AVCHD using either interlace or progressive scanning at either 60 frames/second (fps) or 24 fps.
		(European Standard) Records movies in AVCHD at either 50 frames/second (fps) using interlace or progressive scanning (50i) or 25 fps using progressive scanning (25p).
	MP4	Records movies in MPEG-4 format at about 30 frames/second. These MP4 AVC (non-high definition) movies are suitable for attaching to emails and uploading to the web.
Record Setting		
	When File Format = [AVCHD 60i/60p]/[AVCHD 50i/50p]	
	60i 24M(FX) (or 50i 17M(FH))	Ave. Bit Rate = 24 Mbps. Records high quality movies, 1920 x 1080 pixels at either 60i/50i fps.
	60i 17M(FH) (or 50i 17M(FH))	Ave. Bit Rate = 17 Mbps. Records standard quality movies, 1920 x 1080 pixels at either 60i/50i fps.
	60p 28M(PS) (or 50p 28M(PS))	Ave. Bit Rate = 28 Mbps. Records the highest quality movies, 1920 x 1080 pixels at 60p/50p fps.
	24p 24M(FX) (or 25p 24M(FX))	Ave. Bit Rate = 24 Mbps. Records high quality movies, 1920 x 1080 pixels at 24p/25p fps (cinema-like movies).
	24p 24M(FH) (or 25p 24M(FH))	Ave. Bit Rate = 17 Mbps. Records standard quality movies, 1920 x 1080 pixels at 24p/25p fps (cinema-like movies).
	When File Format = [MP4]	
	1440 x 1080 12M	Ave. Bit Rate = 28 Mbps. Records 1440 x 1080 movies.
	VGA 3M	Ave. Bit Rate = 3 Mbps. Records 640 x 480 movies.

A

Movie Shooting Menu – Page 1 (con't)		
Command	**Description**	
Audio Recording	Determines whether audio is included when recording a movie	
	On	Audio sound records with the movie
	Off	No audio records with the movie
Wind Noise Reduct.	Reduces the effects of wind noise on captured audio	
	On	Reduces wind noise on captured audio
	Off	Does not reduce wind noise on captured audio
SteadyShot	Enables internal camera stabilization. Allows you to obtain sharp movies at slower shutter speeds when handholding the camera. The camera will compensate for small movements caused by hand tremors. Do not use if your camera is mounted on a tripod; the camera's SteadyShot software will try to compensate, which can make a sharp image blurry.	
	On	Enables SteadyShot
	Off	Disables SteadyShot

Custom Menu – Page 1

Command	Description		
Eye-Start AF	Initiates autofocusing when the eye approaches the viewfinder.		
	Eye-Start AF is great if you need autofocusing to occur as quickly as possible. However, autofocusing occurs regardless of what object the viewfinder senses—maybe your hand or the camera resting against one's chest while carrying it by the neck strap. Turning this function on can eat up a lot of battery power due to continuous autofocusing.		
	If Eye-Start AF is [On] and the camera is in sleep mode, it will not try to autofocus if something is close to the viewfinder. You will have to activate the LCD screen and go back to viewing through the viewfinder to reactivate Eye-Start AF.		
	On	Turns function on	
	Off	Turns function off	
FINDER/ LCD Setting	Controls how the camera switches between the viewfinder and the LCD screen		
	Auto	Activates the LCD screen unless the camera senses something close to the viewfinder. When the camera no longer senses something close to the viewfinder, it reactivates the LCD screen.	
	Manual	Activates the LCD screen when the camera is turned on and then requires you to push the FINDER/LCD button manually to switch between the two display screens.	
		Switching between the LCD screen and the viewfinder only works if the LCD screen is seated in the camera. If it is open and pulled away from the camera, only the LCD screen will be active, regardless of this command's setting or pressing the FINDER/LCD button.	
Red Eye Reduction	Activates software to reduce red-eye caused by flash		
	On	Activates red-eye reduction functionality	
	Off	Deactivates red-eye reduction functionality	
Release w/o Lens	Allows you to shoot pictures and movies when a Sony or Minolta AF lens is not attached to the camera.		
	Set this command to [Enable] when the lens is attached to a telescope or microscope.		
	Enable	Enables the camera to shoot without a lens attached	
	Disable	Prevents the camera from shooting without a lens attached	

Custom Menu – Page 1 (con't)		
Command	**Description**	
Auto+ Cont. Shooting	Allows the camera to shoot either one image or a set of continuous images that improve the odds of capturing at least one good image. Auto+ Image Extract. controls the outcome when continuous images are taken.	
	Auto	Camera determines whether it should shoot one image or continuous images to improve the odds of obtaining excellent results
	Off	Camera shoots only one image
Auto+ Image Extract.	Controls whether or not the camera saves all of the continuous images taken when the Auto+ Cont. Shooting command is set to [Auto]	
	Auto	Camera selects and saves the best image from a set of multiple shots
	Off	All images from a set of multiple shots are retained

Custom Menu – Page 2		
Command	**Description**	
Grid Line	Superimposes a grid pattern on the display screen in Live View as an aid for composition	
	Rule of 3rds Grid	Pattern consists of a 3 x 3 array of rectangles
	Square Grid	Pattern consists of a 6 x 4 array of squares
	Diag. + Square Grid	Pattern consists of a 4 x 4 array of rectangles overlaid with diagonal lines radiating from the center to each corner
	Off	No grid pattern is superimposed on the display screen
Auto Review	When activated, displays the recorded picture immediately after it is taken and before you take the next picture. Movies are not displayed after being recorded.	
	10 Sec	Displays captured image for 10 seconds
	5 Sec	Displays captured image for 5 seconds
	2 Sec	Displays captured image for 2 seconds
	Off	Does not display captured image
DISP Button (Monitor)	Allows you to select from a list of six data display formats that can be applied to the LCD screen to preview your images	
	Graphic Display	Displays image plus two scales—shutter speed and aperture—each with its current setting indicated as a vertical bar
	Display All Info.	Displays only the image
	No Disp. Info.	Displays image with the camera settings superimposed around the image's border
	Level	Displays image plus the digital level gauge tool in the center of the screen. The digital level gauge's indicator turns green when the camera is level both horizontally and front to back.
	Histogram	Displays image plus the live white histogram in the lower right of the display screen
	For viewfinder	Displays only the camera settings

Custom Menu – Page 2 (con't)		
Command	**Description**	
DISP Button (Finder)	Allows you to select from a list of five data display formats that can be applied to the viewfinder when previewing an image.	
	Graphic Display	Displays image plus two scales—shutter speed and aperture—each with its current setting indicated as a vertical bar
	Display All Info.	Displays image with the camera settings superimposed around the image's border
	No Disp. Info.	Displays only the image
	Level	Displays image plus the digital level gauge tool in the center of the screen. The digital level gauge's indicator turns green when the camera is level both horizontally and front to back.
	Histogram	Displays image plus the live white histogram in the lower right of the display screen
Peaking Level	In Live View adds a color fringe to borders that have high contrast and therefore are in focus. Available for still pictures and movies.	
	High	Adds maximum size fringe to in-focus areas
	Mid	Adds mid-size fringe to in-focus areas
	Low	Adds smallest-size fringe to in-focus areas
	Off	Turns off the Peaking function
Peaking Color	Determines the color used to identify high-contrast areas	
	Red	High-contrast areas superimposed with red
	Yellow	High-contrast areas superimposed with yellow
	White	High-contrast areas superimposed with white
Live View Display	Determines if Live View will show the effects of your camera settings. Available in P, A, S, M, and Advance Priority Continuous AE modes only.	
	Setting Effect ON	Gives a real-time view of how your image will look. Live View displays the subject with the current lighting, exposure, white balance, and other selected effects such as Creative Style, and Picture Effect
	Setting Effect OFF	Live View does not take into account any changes to the camera's settings that affect the resulting image. This option keeps the Live View image at a constant brightness.

Custom Menu – Page 3

Command	Description			
Func. of AEL button	Allows you to reassign the AEL button to one of the functions listed below			
	Exposure Comp.	Metering Mode	Image Size	AF/MF Control Toggle
	Drive Mode	Flash Comp.	Quality	Object Tracking
	Flash Mode	White Balance	AEL hold	AF lock
	AF area	DRO	AEL toggle	Aperture Preview
	Face Detection	Auto HDR	*Spot* AEL hold	Shot. Result Preview
	Smile Shutter	Creative Style	*Spot* AEL toggle	Smart Telecon.
	ISO	Picture Effect	AF/MF Control Hold	Focus Magnifier
ISO Button	Allows you to reassign the ISO button to one of the functions listed below			
	Exposure Comp.	Metering Mode	Image Size	AF/MF Control Toggle
	Drive Mode	Flash Comp.	Quality	Object Tracking
	Flash Mode	White Balance	**AEL hold**	AF lock
	AF area	DRO	AEL toggle	Aperture Preview
	Face Detection	Auto HDR	*Spot* AEL hold	Shot. Result Preview
	Smile Shutter	Creative Style	*Spot* AEL toggle	Smart Telecon.
	ISO	Picture Effect	AF/MF Control Hold	Focus Magnifier
AF/MF button	Allows you to reassign the AF/MF button to one of the functions listed below			
	Exposure Comp.	Metering Mode	Image Size	AF/MF Control Toggle
	Drive Mode	Flash Comp.	Quality	Object Tracking
	Flash Mode	White Balance	AEL hold	AF lock
	AF area	DRO	AEL toggle	Aperture Preview
	Face Detection	Auto HDR	*Spot* AEL hold	Shot. Result Preview
	Smile Shutter	Creative Style	*Spot* AEL toggle	Smart Telecon.
	ISO	Picture Effect	**AF/MF Control Hold**	Focus Magnifier

Custom Menu – Page 3 (con't)		
Command	**Description**	
Preview Button	Determines how the Preview button will operate: showing only depth of field, or showing depth of field plus shutter speed	
	Shot. Result Preview	Previews depth of field plus the effects of shutter speed to see how a slow shutter increases image blurring
	Aperture Preview	Previews only depth of field to help you adjust the aperture so more or less of the image is in focus
Focus Hold Button	Determines how the Focus Hold button (found on some Sony or Minolta lenses) operates: only holding focus, or holding focus plus showing depth of field	
	Focus Hold	Holds focus when button is pressed
	D.O.F. Preview	Holds focus when button is pressed, plus displays the image with depth of field applied
Smart Telecon. Button	Determines how the Focus Magnifier button operates: digitally zooming into the image or magnifying the image	
	Smart Telecon.	Digitally zooms into the image. This process reduces the image's number of pixels. First press magnifies approximately 1.4 times. Second press magnifies approximately 2 times.
		You can press the shutter button at any stage to capture the picture at its zoomed-in version. Pressing the shutter button halfway returns the preview to its original unmagnified version. Note the 1.4x creates an M-size picture; 2.0x creates an S-size picture. This option works only with JPEG files.
	Focus Magnifier	Magnifies the image approximately 5.9 times with the first press of the button and approximately 11.7 times with the second press.
		You can press the shutter button at any stage to capture the picture, which will be recorded non-magnified. Pressing the shutter button halfway returns the preview to its original unmagnified version. This option works with both RAW and JPEG files. Files retain the original size setting and are not resized.

Custom Menu – Page 4

Command	Description	
Ctrl dial setup	Allows you to customize which control dial (front or rear) handles shutter speed and f-stop adjustments	
	SS **F/no.**	Front control dial handles shutter speed; rear control dial handles f-stop
	F/no. **SS**	Front control dial handles f-stop; rear control dial handles shutter speed
Dial exp. comp.	Allows you to customize either the front or rear control dial to handle the Exposure Compensation tool	
	Off	Exposure Compensation tool is not available through either the front or rear control dial
	Front dial	Exposure Compensation tool assigned to front control dial
	Rear dial	Exposure Compensation tool assigned to rear control dial
Exp. comp. set	Determines if the Exposure Compensation tool adjusts for ambient light only, or ambient light plus flash	
	Ambient & flash	Adjusts the exposure using the combination of available ambient light plus flash
	Ambient only	Adjusts the exposure using only available ambient light
Bracket order	Assigns the order in which the camera shoots bracketed images	
	0 ⇨ - ⇨ +	Shoots normal exposure, underexposure, and then overexposure
	- ⇨ 0 ⇨ +	Shoots underexposure, normal exposure, and then overexposure
AF drive speed	Selects autofocusing speed.	
	Fast	Performs autofocusing faster
	Slow	Performs autofocusing slower

Custom Menu – Page 5

Command	Description	
Lens Comp.: Shading	Enables automatic adjustment to eliminate vignetting. The results are applied only to the image's JPEG file.	
	Auto	Automatically adjusts JPEG images to hide lens-induced vignetting
	Off	Disables function. Any vignetting from the lens is retained in saved JPEG images.
Lens Comp.: Chro. Aber.	Enables automatic adjustment to eliminate chromatic aberration. The results are applied only to the image's JPEG file.	
	Auto	Automatically adjusts JPEG images to hide chromatic aberration
	Off	Disables function. Any chromatic aberration is recorded in saved JPEG images.
Lens Comp.: Distortion	Enables automatic correction of lens distortion. The results are applied only to the image's JPEG file.	
	Auto	Automatically corrects any lens distortion in JPEG images
	Off	Disables function. Lens distortion is uncorrected in saved JPEG images.
Front Curtain Shutter	Determines whether the shutter opens using the electronic first curtain shutter or whether the shutter opens mechanically. Using the electronic first curtain shutter speeds up the shutter release time and eliminates camera vibrations due to the movement of the mechanical shutter during exposure.	
	On	Initiates use of the electronic first curtain shutter
	Off	Initiates use of the mechanical shutter
Face Registration	Allows you to register and maintain up to eight faces in the camera for autofocus preferences	
	New Registration	Allows you to register new faces one at a time up to eight total
	Order Exchanging	Allows you to change the registered faces' prioritization
	Delete	Allows you to delete a single registered face
	Delete All	Allows you to delete all registered faces at one time

Playback Menu – Page 1			
Command	**Description**		
Delete	Allows you to delete one, many, or all unprotected images within a selected folder. The selected folder is determined by the last viewed or recorded image's file type. To change the selected folder, use the MENU>Playback Menu (1)>View Mode command.		
	Multiple Img.	Displays one image at a time with its associated delete check box. Toggle right or left to scroll through the individual images, and press the multi-selector button to check or uncheck the delete boxes.	
	All in Folder	Displays a confirmation screen to delete all of the images in the folder. Select [Delete] to delete; select [Cancel] to exit the process.	
View Mode	Enables you to select a specific type of image folder		
	Folder View(Still)	Still Picture folder	
	Folder View(MP4)	MP4 folder	
	AVCHD View	Movie folder	
Slide Show	Allows you to display still images stored on the memory card in sequence as a slide show		
	Repeat	Determines if the slide show runs through the images once or loops continuously	
		On	Slide show loops continuously through the images
		Off	Plays the images once and stops
	Interval	Controls the time each still picture is displayed	
		1 Sec	Displays each picture for 1 second
		3 Sec	Displays each picture for 3 seconds
		5 Sec	Displays each picture for 5 seconds
		10 Sec	Displays each picture for 10 seconds
		30 Sec	Displays each picture for 30 seconds
	Image Type	Controls the type of still pictures to be played back in the slide show. [Display 3D Only] is enabled only if there are 3D images saved on the memory card.	
		All	Displays all types of still pictures
		Display 3D Only	Displays 3D still pictures only. Option enabled when camera is connected to a 3D-compatible TV.
	Enter	Initiates slide show using [Repeat], [Interval] and [Image Type] values.	

Playback Menu – Page 1 (con't)	
Command	**Description**
3D Viewing	Allows you to play back 3D pictures recorded in 3D Sweep Panorama mode on a 3D-compatible TV or computer. Command is enabled when the camera is connected to a 3D-compatible device.

	Enter	Initiates playback
	Cancel	Exits the command process

Protect	Allows you to protect or unprotect saved images on the memory card. Protected images cannot be erased through the camera's Delete command or button but can be removed by using the Format command. This command displays only images within the selected View Mode.	
	Multiple Img.	Displays one image at a time with its associated protect check box. Toggle right or left to scroll through the individual images. Press the multi-selector button to check or uncheck an image's protect box.
	Cancel All Images	Displays a confirmation screen to unprotect all protected images in the selected View Mode. Select [Enter] to unprotect; select [Cancel] to exit the process.

Specify Printing	Allows you to identify and check an image's print indicator. You can also specify whether you want the image's date imprinted on the picture.
	To print identified images, connect the camera's memory card directly or through a computer to a Digital Print Order Format (DPOF)-compliant printer or send it to a photo printing service. Note: the print indicator/date imprint information is retained even after the pictures have been printed.

	Enter		Processes the selected values
	Cancel		Exits the Specify Printing command
	DPOF Setup	Option controls the selection and deletion of images for printing	
		Multiple Img.	Displays one image at a time with its associated print check box. Toggle right or left to scroll through individual images, and press the multi-selector button to check or uncheck each print box.
		Cancel All	Deletes all DPOF print indicators
	Date Imprint	Option controls if recorded date will be included on printed images	
		On	Image's recorded date will be included on the print of the selected images
		Off	Does not allow the recorded date to print on the pictures

Playback Menu – Page 2	
Command	**Description**
Volume Settings	Allows you to set the volume level for playing back movies. This does not affect the volume at which movies are recorded.
	Available options range from [0] to [7], with **[2]** as default – [0] is mute, and [7] is the loudest setting
Playback Display	Determines whether images are displayed with landscape or portrait orientation during playback. To rotate an image while reviewing it, press the Fn button. A rotate icon displays. Press the multi-selector button to change the image's orientation.

	Auto Rotate	Vertically oriented recorded images are played back vertically on the display screen. Vertical images are displayed smaller than horizontal images, but you don't have to turn the camera to view them properly.
	Manual Rotate	Displays vertical images horizontally, filling the screen during playback

Memory Card Tool Menu – Page 1	
Command	**Description**
Format	Quickly erases all images from the card, including protected still pictures and movies, by reformatting the memory card. Does not erase stored, registered faces. A confirmation screen is displayed.
	Do not turn off the camera or remove the memory card while reformatting. Do not reformat the memory card outside the camera.

	Enter	Reformats the card
	Cancel	Exits the process
File Number	Determines how file numbers are assigned and maintained.	
	Series	Assigns file numbers in sequence starting with 0001 up to 9999. Does not reset file numbers even if the folder is changed, images are deleted, the memory card is reformatted, or a new memory card is inserted.
	Reset	Assigns file numbers in sequence starting with 0001 up to 9999, but starts over at 0001 if the folder is changed, the memory card is reformatted, or a new memory card is inserted. Does not reuse file numbers when individual files are deleted.

Memory Card Tool Menu – Page 1 (con't)		
Command	**Description**	
Folder Name	Allows you to choose between two folder name structures for storing your images	
	Standard Form	Folder number + MSDCF (Example: 100MSDCF where MSDCF is a file naming convention created by JEI-TIA (Japan Electronics and Information Technology Industries Association)
	Date Form	Folder number + last digit of year + month + day (Example: 10020210)
Select REC Folder	Allows you to choose from a displayed list of folders used to hold still images on the memory card. Scroll through the list. Press the multi-selector button to select a folder. Note: folders with AVCHD and MP4 files cannot be selected.	
	Displays available REC folders	
New Folder	Allows you to create a new folder on the memory card to hold new still pictures. The newly created folder is the default for any new still pictures. Press the multi-selector button to create a new folder.	
	OK	Creates a new still picture folder on the memory card
Recover Image DB	Attempts to recover a corrupted image database on the memory card. Execute this command if you receive the error message "Image Database File error. Recover?" Make sure you have a fully charged battery when executing this command.	
	Enter	Initiates recovery
	Cancel	Exits the process
Display Card Space	Displays an estimate of how many available images and how much movie time remains on the memory card. The calculations are only for the current Still and Movie Quality command values and varies depending on the complexity of the scene being photographed.	
	OK	Displays available space on the memory card

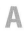

Clock Setup Menu – Page 1		
Command	**Description**	
Date/Time Setup	Sets the camera's date, time, and location. Use the right and left toggles to move through the following fields and the up and down toggles to move through the available values within each field.	
	Daylight Svg.:	Daylight savings indicator. [On] indicates Daylight Savings is currently in effect. [**Off**] indicates Daylight Savings is not currently in effect.
	Date	Order of month, day, and year is determined by Date Format
	Time	Contains current time in hours and minutes
	Date Format	Select [Y-M-D], [D-M-Y], or [M-D-Y]
Area Setting	Lets the camera know what time zone you're in based on the selected location on the world map. Use the right or left toggle to select your current zone. As it changes, the date and time will also change to conform to the selected location.	
	World map is broken into time zones	The current selected time zone is highlighted on the map

Setup Menu – Page 1		
Command	**Description**	
Menu start	Determines the location displayed when the MENU button is pressed	
	Top	Displays the menu beginning at MENU>Still Shooting Menu (1)>Image Size
	Previous	Displays the menu beginning at the last displayed command
LCD Brightness	Controls the LCD monitor's brightness either automatically or manually. LCD monitor must be active when setting this command.	
	Auto	Camera adjusts the LCD monitor's brightness on the basis of ambient lighting. Make sure you do not cover the light sensor in the lower left of the LCD screen.
	Manual	Allows you to set the LCD monitor's brightness between –2 and +2, where –2 is less bright and +2 is the brightest setting

Setup Menu – Page 1 (con't)			
Command	**Description**		
Viewfinder Bright.	Controls the viewfinder's brightness automatically or allows you to set it manually. Viewfinder must be active when setting this command.		
	Auto	Relies on the camera to determine the viewfinder's brightness	
	Manual	Allows you to set the viewfinder's brightness between –1 and +1, where –1 is the dimmest and +1 is the brightest setting	
GPS Settings (SLT-A77V only)	Allows GPS to be turned on and applies returned GPS values to stored images.		
	The camera's software initiates retrieving the GPS location as soon as GPS On/Off is set to [On], and each time you turn the camera on as long as this command remains [On]. Retrieving GPS information can take several minutes. Make sure you turn this command [Off] when you are traveling and the camera is on but not in use. Otherwise, the camera constantly retrieves GPS information which uses battery power.		
	GPS information is stored with saved images. You can view the saved GPS data when you import your images into the PMB software. If you record an image prior to the camera retrieving the location's GPS information, your image will be tagged with either previously stored GPS information or no information.		
	You may have difficulty retrieving accurate information when indoors or near structures that block satellite access.		
	GPS On/Off	Controls activation of the camera's GPS function	
		On	Enables the GPS function as soon as you exit the command
		Off	Disables the GPS function
	GPS Auto Time Cor.	This option is enabled when GPS On/Off is [On]	
		On	Uses the most recently retrieved GPS location to adjust the clock to local time
		Off	Doesn't adjust the clock to local time
	Use GPS Assist Data	This option displays the period this data is valid. Shortens the time needed for the camera to retrieve GPS data during the valid period. Outside of the valid period, full GPS retrieval is mandatory.	
		OK	Displays the period the currently stored GPS Assist data is available

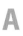

A

Setup Menu – Page 1 (con't)		
Command	**Description**	
Power Save	Determines the amount of time before an inactive camera is placed into sleep mode	
	30 Min	Camera enters sleep mode after 30 minutes of inactivity
	5 Min	Camera enters sleep mode after 5 minutes of inactivity
	1 Min	Camera enters sleep mode after 1 minute of inactivity
	20 Sec	Camera enters sleep mode after 20 seconds of inactivity
	10 Sec	Camera enters sleep mode after 10 seconds of inactivity
HDMI Resolution	Determines what the camera uses for HDMI resolution when connected to a compatible TV	
	Auto	Leaves it up to the camera to choose between 1080p and 1080i resolution
	1080p	Selects 1080p resolution
	1080i	Selects 1080i resolution
CTRL FOR HDMI	Allows you to play stored images from your camera on a Bravia Sync-supported TV. Once the camera is connected to a compatible TV and the command is set to [On], use the TV's remote control to control the playback. You can play slide shows, display images one at a time, view 3D images, switch View Modes, and delete images through your TV.	
	On	Plays camera-stored images on a compatible TV
	Off	Does not play camera-stored images on a compatible TV

Setup Menu – Page 2		
Command	**Description**	
USB Connection	Determines the type of connection your camera establishes with your computer or with a USB device when using a USB cable	
	Auto	Leaves it up to the camera to choose between Mass Storage and MTP
	Mass Storage	Selects USB Mass Storage Class, which is useful for drag-and-drop file transfers. Supported by Mac OS and utilized by Microsoft OS.
	MTP	Selects Media Transfer Protocol used by Windows operating systems and PICT Bridge-compatible printers

Setup Menu – Page 2 (con't)			
Command	**Description**		
Audio signals	Creates audio beeps when focus is achieved or during self-timer operations		
	On	Allows audio beeps	
	Off	Does not allow audio beeps	
Cleaning Mode	Executes the sensor cleaning process by applying ultrasonic vibration to the sensor to loosen dirt and dust particles		
	Enter	Initiates cleaning process	
	Cancel	Cancels the process and returns you to Live View	
Delete confirm	Determines which option, Delete or Cancel, is enabled in the Delete confirmation step		
	"Delete" first	Delete option is enabled	
	"Cancel" first	Cancel option is enabled	
AF Micro Adj.	Allows you to obtain optimum focus if the lens is either back or front focusing. The camera registers up to 30 lenses and allows you to save a fine adjustment setting for each registered lens, which will be automatically applied when the camera senses the lens has been mounted to the camera body and AF Adjustment Setting is set to [On].		

	AF Adjustment Setting	Controls the adjustment process activation	
		Off	Disables the adjustment process
		On	Enables the adjustment process
	Amount	Displays a scale ranging from [-20] to [+20] in increments of 1, with [+-0] as default. This option is enabled only when AF Adjustment Setting is set to [On].	
	Clear	Displays all registered lenses and asks if you want to clear all adjustments	
		Enter	Clears the adjustment with the lens name. There is a second confirmation step to complete the clearing process: [Enter], [Cancel], with [Cancel] as default where [Enter] completes the clearing process and [Cancel] exits the process without clearing anything.
		Cancel	Exits the process without clearing anything

Setup Menu – Page 3		
Command	**Description**	
Version	Displays your camera's currently installed firmware version	
	Firmware's current version display	
Language	Displays a list of available languages in which the menu and function commands, values, help information, and error and warning messages are displayed	
	Displayed options depend on the camera's country of origin	
Mode Dial Guide	Controls the display of an additional screen with help information when a mode dial option is selected. This does not affect the information screen for individual SCN modes.	
	On	Displays the help information screen when a mode dial option is selected. Press any button to return to Live View.
	Off	Does not display the help information screen; camera goes directly to the selected mode dial option
Demo Mode	Conversations with Sony Tech support produced multiple explanations of what this command does. It enables the camera to play a demo video for potential customers. It appears to be disabled starting with firmware version 1.04.	
	On	Enables the demo mode
	Off	Disables the demo mode
Initialize	Allows you to reset the camera's command and function values back to the defaults. Each reset has a confirmation step: [OK], [Cancel], with [Cancel] as default.	
	Reset Default	Resets almost all command and function values back to the original defaults. Excludes: memory groups, clock, face registration, and any protect and print indicators you have set.
	Rec. mode reset	Resets only recording-related command and function values, such as quality, image size, white balance, etc.
	Custom reset	Resets only custom-related command values, such as button assignments, peaking colors, etc.

Appendix B—Common Error/Warning Messages and Resolutions

The Sony A77 displays error/warning messages and icons as you utilize the camera's functions. The following tables contain common messages and icons whose meaning may not be obvious. Note: many error/warning messages and icons are displayed when you try to select a command or function that is not available in the current mode. Such error messages are very explicit and are not included in this appendix.

Message	Description	...
Camera Error System Error	This is a non-specific error message. Something is wrong.	
Camera overheating. Allow it to cool.	The camera normally generates heat when in use. Excessive heat can build up when recording long videos or when rapidly recording still pictures, as in Continuous Advance Priority AE mode. In addition, camera temperatures can be exacerbated by use in high temperature environments.	
Cannot create more folders	This occurs when you try to create a new folder on the inserted memory card and the camera finds a folder name beginning with 999, indicating it has reached the maximum number of folders on the card.	
Check the lens attachment. If the lens is not supported, you can permit use of the lens in the custom menu.	The camera is not registering an attached standard lens.	
Could not shoot panorama. Move camera quickly.	Panned too slowly.	
Could not shoot panorama. Move camera slowly.	Panned too quickly.	
Could not shoot panorama. Move straight in the direction of the arrow.	This message appears if you: • Didn't pan all the way • Didn't keep the camera level horizontally or vertically • Panned in the wrong direction	
Custom WB Error	When setting a custom WB value, the calculated value is beyond an acceptable range. The camera will still store the white balance value in the custom repository, and it is usable, but when selected, the Custom WB icon will display orange in the preview screen. The camera will have trouble determining the proper white balance setting if the selected object appears to be monotone. This can occur if the subject is excessively illuminated or appears to be of one color.	

...	Resolution
	Turn the camera off. Remove the battery pack and reinsert. If the message persists or over time appears frequently, consult your Sony dealer or local authorized Sony service facility.
	Stop recording and turn the camera off to allow it to cool.
	Download the memory card's files to a computer and reformat the card in the camera.
	Check to see if the lens is attached properly. If attached properly and the lens is not a standard Sony lens or the camera is attached to a microscope or telescope, set MENU>Custom Menu (1)>Release w/o Lens>[Enable].
	Reshoot picture panning a bit faster.
	Reshoot picture panning a bit slower.
	Reshoot picture making sure you pan completely to the end, hold the camera level (use a tripod if you are having problems), and pan in the direction of the arrow.
	Choose a different subject that contains more color variety and reset the Custom WB.

B

Message	Description	...
Image Database File error. Recover?	The memory card's Image Database File is damaged. This message can appear when you try to record or play back an AVCHD movie. Processing saved images on the computer and then saving them onto the memory card can damage the Image Database File. In addition, playing AVCHD movies on a computer directly from the camera can cause damage to the file.	
Memory Card Error	The inserted memory card is incompatible with the camera.	
Power insufficient.	The cleaning mode, MENU>Setup Menu (2)>[Cleaning Mode], was executed when the battery level was too low.	
Recording is unavailable in this movie format.	When you are recording a movie and the memory card is close to full, the camera displays this message to warn you to replace the card.	
Reinsert memory card.	The camera cannot recognize the memory card due to damage or dirty terminal connectors.	
Set Area/Date/Time.	The camera's area, date, and time are not set. There are two explanations: 1. The camera's area, date, and time information have never been set. 2. The camera's internal battery is drained and can no longer maintain the information.	
Unable to display.	Only Sony A77 images recorded and maintained can be displayed on the camera. This message indicates that the inserted memory card has images recorded and/or modified from another medium or camera.	
Unable to magnify. Unable to rotate image.	Sony A77 saved images are capable of being magnified and/or rotated within the camera. This message indicates that the currently displayed image was recorded by another camera and therefore cannot be magnified or rotated.	
Unable to print.	Selected image's RAW format is not compatible with a DPOF mark.	
Unable to use memory card. Format?	The memory card was not formatted via the Sony A77, and/or the memory card's file format was modified outside the camera.	

...	Resolution

The camera will prompt you with instructions to recover the data. Ensure that the camera's battery is sufficiently charged. Executing these instructions with an insufficiently charged battery can cause further damage to the files.

Two resolutions:
1. Utilize a compatible memory card
2. Reformat the memory card

Charge the battery fully or plug in an AC adapter, then execute the Cleaning Mode command.

The error message is displayed with some remaining memory available. If you are shooting AVCHD movies, switch to MP4. MP4 files take up less space on the memory card. You will still have to free up space on the memory card, either by moving files onto your computer and reformatting the card or by deleting individual files.

Two resolutions:
1. Replace memory card (memory card is damaged).
2. Clean memory card's terminal connectors. Reinsert. If message persists, replace memory card.

Two resolutions:
1. Set the camera's area, date, and time information using MENU>Clock Setup Menu (1)>[Date/Time Setup] and MENU>Clock Setup Menu (1)>[Area Setting]
2. Recharge the camera's internal battery by inserting a charged battery pack or by connecting the camera to a wall outlet with the AC adapter for a 24-hour period.

Two resolutions:
1. Delete all of the memory card images by reformatting the memory card.
 Note: You may want to save the files onto your computer prior to reformatting the card.
2. Delete only the memory card images which cannot be displayed. Download the affected files to your computer first and then reuse the memory card in your camera.

Chose another image to display. To magnify and/or rotate image, download the affected file to your computer and use third-party software to magnify and rotate.

If image is also saved in JPEG (MENU>Still Pictures Menu>Quality (1)>[RAW & JPEG]), select the JPEG for print instead. Otherwise, download the RAW image to third-party software, save in a printable format, and print.

Reformat the memory card via the Sony A77.

Note: If the memory card has files you wish to save, save them on your computer first.

If the message persists, use a different memory card.

B

Message	Description	...
[!⊡]	Temperature Error – The internal camera temperature is too high.	
FULL	Database Error – The database's maximum number of images has been reached.	
ERROR	File Registration Error – Unable to register the still image file in the database.	
((📷!))	Camera Shake Warning – Occurs when the camera senses movement and the shutter speed is too long to obtain a sharp image.	
((ERROR))	SteadyShot Error – The SteadyShot function does not work.	
--E-	Memory Card Error – Memory card error has occurred.	
📶!	Status Communications Error – Eye-Fi communications error has occurred.	
Pntg MID ! Rich BW !	Picture Effect Error – Selected [HDR Painting] or [Rich-tone Mono.] Picture Effect does not work with the current scenario. This occurs when there is insufficient contrast within the image or when the selected Picture Effect cannot determine how to rebuild the image from the series of three shots. Insufficient contrast can occur in low light, very bright light, or monotone light. Inability to rebuild the image can be caused by camera movement, making it impossible for the camera's software to align the subject.	
⊏⊐	Drained Battery Warning – The camera's battery is drained.	
HDR!	Auto HDR Warning – This occurs when there is insufficient contrast within the image or when the HDR function cannot determine how to rebuild the image from the series of three shots. Insufficient contrast can occur in low light, very bright light, or monotone light. Inability to rebuild the image can be caused by camera movement, making it impossible for the camera's software to align the subject.	
ERROR	GPS Error – Problem has occurred with the GPS feature.	
● ...Flashing green	Focus Error – Cannot obtain focus. Occurs in autofocus mode.	

B

...	Resolution
	Stop recording and turn off the camera. Allow the camera to cool down prior to using it again.
	Download all of the images to a computer and reformat the memory card.
	Download all of the images to a computer and reformat the memory card.
	Mount the camera on a tripod, brace the camera better to reduce the shaking, or turn on the SteadyShot function.
	Turn the camera off and on. If the SteadyShot error continues to appear, contact Sony technical support.
	Remove the memory card and insert it again. Make sure the contacts are clean. If the problem persists, reformat the memory card. Note: Reformatting the card will delete all files! If the memory card has files you wish to save, download them to your computer first. If the memory card error continues after reformatting, use a different memory card.
	Two resolutions: 1. Remove the memory card and reinsert it. 2. Turn the camera's power off and then on. If the error persists, the Eye-Fi card may be damaged.
	Adjust the lighting, reframe the image, or reduce camera movement. Reshoot the image.
	Recharge the battery.
	Adjust the lighting, reframe the image, or reduce camera movement. Reshoot the image.
	Turn the camera off and back on.
	Resolutions: • Change one or more of the camera settings to obtain focus. • Change the metering mode to another setting and target a specific part of the image. • Switch to manual focus.

Index

Symbols

3D Panorama 159

A

accessories 172
AEL Hold 94
AEL toggle 94
AF Area 94
AF lock 94
AF/MF control hold 94
AF/MF control toggle 94, 95
A-mount lenses 176
aperture 38, 95
aperture preview 94
Aperture-Priority (A) 130
APS-C 3
aspect ratio 210
Autofocus Fine Tuning 146
Auto HDR 94
Auto HDR function 126
automatic focus detector 3
automatic focusing 124
Auto Mode 84
Auto+ Mode 84
Auto Review 54
Auto+ Scene Modes 86
 – Baby 86
 – Backlight 86
 – Backlight Portrait 86
 – General 86
 – Hand-held Twilight 86
 – Landscape 86
 – Low Brightness 86
 – Macro 86
 – Night Portrait 86
 – Night Scene 86
 – Portrait 86
 – Spotlight 86
 – Twilight Night Scene 86
Auto+ Scenes 89
AVCHD 212

B

battery
 – using non-Panasonic 9
battery charger 9
B (Bulb Mode) 140
bit Rate 210
bracketing and dynamic range 147
burst rate 5

C

cable release 181
cleaning the sensor 24
Clock Setup menu 240
Continuous Shooting 42
contrast detection 5
Creative style 94, 95, 98
 – Autumn Leaves 98
 – Black & White 98
 – Clear 98
 – Deep 98
 – Landscape 98
 – Light 98
 – Neutral 98
 – Night Scene 98
 – Portrait 98
 – Sepia 98
 – Standard 98
 – Sunset 98
 – Vivid 98
Custom menu 228

D

data display formats 49
 – Display All Info 50
 – For Viewfinder 50
 – Graphic Display 50
 – Histogram 50
 – Level 50
 – No Disp. Info. 50
date and time 25
daylight saving time 26
deleting saved pictures 62
diopter adjustment dial 27
Display menu 104
downloading pictures and movies 64
Drive mode 94, 95

Drive mode button 40
Drive mode function 72
Drive mode option 41
- Continuous 41
- Single 41
DRO 94
DRO/Auto HDR 95
DRO Bracket 148
DRO (dynamic range optimization) 126
DRO function 127
DSLR camera 3
dual viewing system 26

E

electronic first curtain shutter. 5
error/warning messages 246
exposure 38, 60
Exposure Comp. 94
exposure compensation 95, 109
Exposure mode 95
exposure value (EV) 110

F

face detection 37, 94, 95
face detection and registration function 76
file formats 31
- AVCHD 33
- JPEG 31
- MP4 33
- RAW 31
Fill-flash 194
fine adjustment option 99
- contrast 99
- saturation 99
- Sharpness 99
Flash Comp. 94
flash compensation 95
flash function 74
Flash mode 94, 95
flash photography 188
Fn button 19
focusing 35
focus magnifier 94
focus magnifier button 53
Focus mode 112
- Local 113
- Spot 113
- Wide 113
- Zone 113
frame rate 210
front control dial 17
F-Stop 38

G

GPS 165
GPS command 165
guide number (GN) 190

H

HDR 126
HDR painting 102
High Contrast Mono. 102
histogram 60, 111
HVL-F20AM 202
HVL-F43AM 202
HVL-F58AM 202

I

image data converter 9, 65
image size 94
imaging sensor 3
In-Camera Guide button 23
InfoLITHIUM battery 9
interlaced scanning 210
ISO 38, 94, 95, 114
ISO and noise 116

K

kit Lens 173

L

LCD display panel 48
LCD screen 45
lens compensation 145
Local AF Area's position 95

M

magnifying images during preview 53
Manual Exposure mode 137
manual focus 125, 142
memory 94
memory card 10
memory command 94
MENU button 14
menu commands 220
menu name 15
menu navigation 16
Metering mode 94, 95
Metering modes 141
- Center weighted 141
- Multi segment 141
- Spot 141
microscopes 178
miniature 102

Mode dial 82
Mode dial guide 105
Mode dial option 95
movie 4
Movie button 209
Movie mode 218
Movie quality 213
movies 42, 208
Movie Shooting Menu 226
MP4 210
Multi Frame Noise Reduction 117
multi-selector 16

N

noise reduction 140
NTSC 210

O

object tracking 37, 94, 95
object tracking function 75
ON/OFF power switch 14

P

PAL 210
panorama 155
partial color 102
phase detection system 5
Picture Effect 94, 95
Picture Effect function 101
Picture Motion Browser 9
Picture Motion Browser (PMB) 65
Playback menu 236
playing back MP4 or AVCHD movies 55
Pop Color 102
posterization 102
pre-defined color schemes 97
preview images 52
printing your pictures 67
Program (P) 130
Progressive Scanning 210
protecting saved pictures 62

Q

quality 94

R

rear control dial 17
Rear Sync. 194
recording movies 42
red-eye reduction 192
retro photo 102
Rich-tone Mono. 102

S

SCN Predefined Scene modes 89
– Hand-held Twilight 90
– Landscape 90
– Macro 90
– Night Portrait 90
– Night Scene 90
– Portrait 90
– Sports Action 90
– Sunset 90
SDHC memory card 10
SD memory card 10
SDXC memory card 10
setting memory group values 96
Setup menu 220, 240
Shot. Result Preview 94
shutter button 35
shutter-priority (S) 130
shutter speed 38, 95
single shooting 41
Slow Flash Sync 206
SLT camera 3
Smart Telecon. 94
Smile Shutter 94, 95
Smile Shutter function 80
soft focus 102
soft high-key 102
Sony A33 3
Sony A55 3
Spot AEL hold 94
Spot AEL toggle 94
still shooting 15
Still Shooting menu 223
Still Shooting menu items 95
Sweep Panorama mode 155

T

telescopes 184
third-party lenses 178
toy camera 102
translucent mirror 3
tripod 181

V

video 4
viewfinder 46

W

WB (white balance) 118
white balance 40, 94, 95
White Balance Bracket 147
wireless flash 205

Get in the Picture!

c't Digital Photography gives you exclusive access to the techniques of the pros.

Keep on top of the latest trends and get your own regular dose of inside knowledge from our specialist authors. Every issue includes tips and tricks from experienced pro photographers as well as independent hardware and software tests. There are also regular high-end image processing and image management workshops to help you create your own perfect portfolio.

Each issue includes a free DVD with full and c't special version software, practical photo tools, eBooks, and comprehensive video tutorials.

Don't miss out – place your order now!

Get your copy:
ct-digiphoto.com